THE SANDS
OF TIME *Revisited*

AN
INTRODUCTION TO THE
SAND DUNES
OF THE SEFTON COAST

PHILIP H. SMITH

AMBERLEY

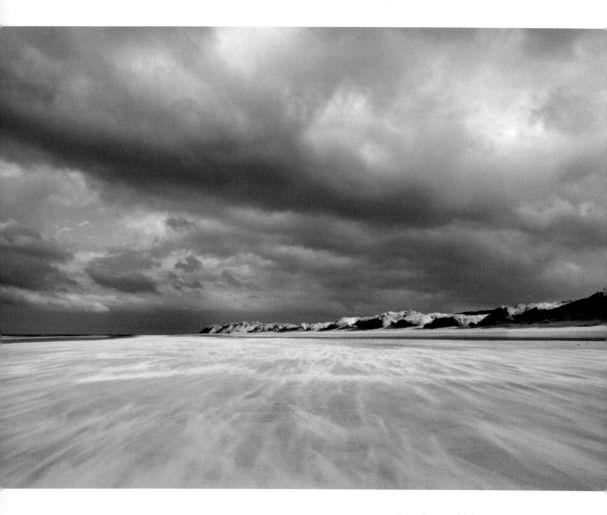

Beach sand-blow, Ainsdale.

This edition first published 2009

Amberley Publishing
Cirencester Road, Chalford,
Stroud, Gloucestershire, GL6 8PE

www.amberleybooks.com

ISBN 978 1 84868 454 6

Typesetting and Origination by Amberley Publishing.
Printed in Great Britain.

CONTENTS

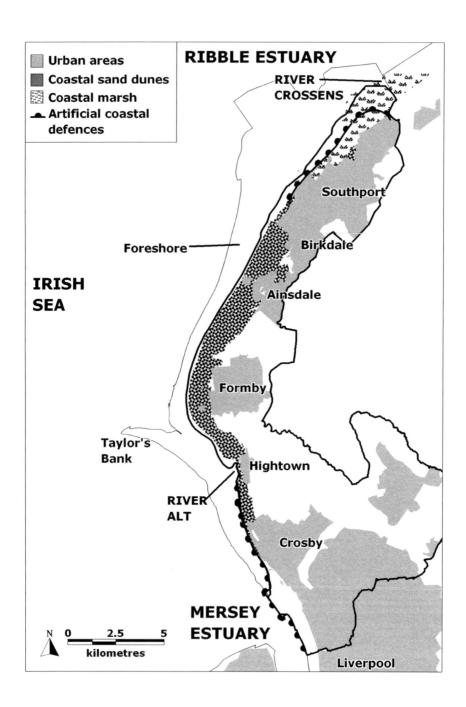

Legend:
- Urban areas
- Coastal sand dunes
- Coastal marsh
- Artificial coastal defences

RIBBLE ESTUARY

RIVER CROSSENS

Southport

Foreshore

Birkdale

IRISH SEA

Ainsdale

Formby

Taylor's Bank

Hightown

RIVER ALT

Crosby

MERSEY ESTUARY

Liverpool

N

0 2.5 5
kilometres

Map of the Sefton coast.

FOREWORD

"There is no pleasure so entertaining as a day spent on the sand dunes; here to the eye of the casual observer nothing but a barren waste of sand can be seen, but to the naturalist the hills teem with life and your senses must be keenly on the alert to see and behold everything."

F. W. Holder, 11th May 1913

This book is a celebration of the natural wonders of the Sefton Coast sand-dunes which lie between Liverpool and Southport on Merseyside. It has been written by an enthusiastic biologist who has had a close affinity with the area for over 60 years. Lavishly illustrated with photographs, maps and diagrams, the book introduces the interested general reader to the origin and land-use history of this coast and shows how sand-dunes are formed and develop over time. It goes on to describe the special plants and animals of the sand-dunes and examines how this internationally important area is being conserved and managed for the future.

Appearing originally in 1999 as *"The Sands of Time: an introduction to the Sand Dunes of the Sefton Coast"*, the present book follows a similar format to the first but has been extensively revised, rewritten and lengthened to include a great deal of new information collected over the last decade.

The author, Dr Phil Smith, was born at Crosby, Liverpool and lived from the ages of two to nine at Ainsdale where he developed an early interest in sand-dunes and kept pet Natterjack Toads. After graduating in Zoology from University College London, he conducted post-doctoral research at Grange-over-Sands, Cumbria. Returning to Merseyside in 1968 as a Lecturer in Applied Biology at Liverpool Polytechnic (now John Moores University) he made extensive use of the Sefton Coast for both teaching and research. Phil joined the Lancashire Naturalists' (now Wildlife) Trust in 1970, serving on many committees, including the Council, of which he is still a member and Trustee. As an Honorary Conservation Officer for 15 years, he was actively involved in the many background studies needed to establish nature reserves on the coast and the Sefton Coast Management Scheme. Retiring from lecturing in 1992 enabled Phil to continue monitoring and photographing wildlife on the dune coast. During the late 1990s, he was an Advisor to the Sefton Coast LIFE project and now serves on the Nature Conservation and Shoreline Management Task Group of the Sefton Coast Partnership. In the New Year Honours of 2002, he was awarded an MBE for services to nature conservation.

The author recording dragonflies.

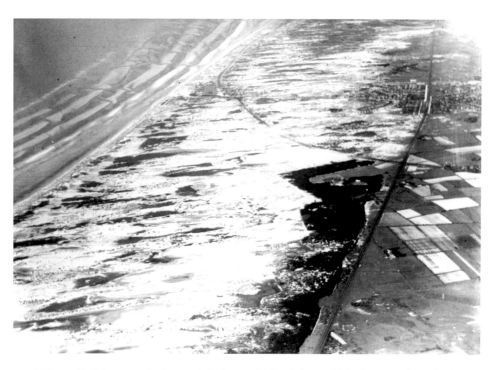

"Unprofitable waste". An aerial view of Ainsdale *c.*1920 showing how little vegetation was present on the dunes.

PREFACE

Most modern visitors to the coast probably view sand-dunes as a convenient spot for sun-bathing but they have, in fact, a long history of human use and settlement. Their light soils were easy to cultivate, they provided grazing for livestock, including the Rabbit which was kept in warrens, while one of the dune grasses, Marram, could be used for thatching and matting. However, in the early 20th century, these traditions declined and dunes began increasingly to be viewed as waste land to be planted with commercial forests, allocated for housing and industrial development or taken over by the military.

Thus, in 1910 the Formby family (one of the big land-owners on what became the Sefton Coast) described the dunes as follows:

> "*A sea boundary belt between the mouth of the Mersey and the mouth of the Ribble, a boundary belt peculiar in its nature, and impassable but to the foot of man or horse and forming an elbow of land apart from any communication between town and town; unvisited, untrodden, and, by the general public uncared for and mostly unknown – a desolate and barren tract; a desert (do you say?), an unprofitable waste?*

In more recent times, the pendulum has swung again, with an increasing recognition of the value of intact dune areas for coast protection, recreation and perhaps, above all, for wildlife and landscape conservation.

Dunes form wherever there is a suitable supply of material blown up from sandy beaches but their present form and extent have been greatly modified by man. In Great Britain, dunelands are scattered at intervals around much of the coastline, covering, in total, about 54,500ha. They have proved vulnerable to development for buildings, roads, airfields, caravan sites and golf-courses, as well as pine plantations. Also important have been sand-extraction and various recreational activities. Fortunately, more sympathetic uses, including the setting up of nature reserves, have come to the fore in recent years.

One of the best known of British and European dunelands is the Sefton Coast in northwest England. With its western extent at Formby Point, the dune coast runs for about 20km in a gentle arc between the estuaries of the Mersey and Ribble. Presently covering about 2100ha, this is the largest dune

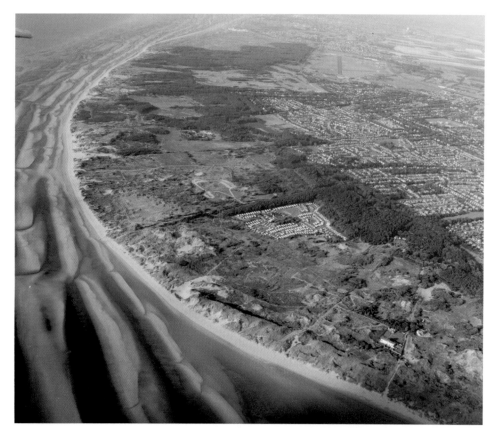

"Gentle Arc". An aerial view of Formby Point.

complex in England and is one of a number of important dune systems in the northern Irish Sea region.

The Northwest is one of the most heavily industrialised and urbanised parts of England. It is not surprising, therefore, that a significant proportion of the original Sefton Coast sand-dunes, claimed in the early 19th century to cover not less than 22 square miles (5700ha), has been lost to development. The towns of Bootle, Crosby, Hightown, Formby, Ainsdale, Birkdale and Southport were all built on sand. Other areas have been altered by military use, agriculture, forestry, quarrying, and recreation, including the playing of golf. It is all the more remarkable, therefore, that an important stretch of dunes has survived in a more-or-less natural state.

Despite being adjacent to a large metropolis, one of its modern values is as an area of great landscape interest. Writing in 1953, the geographer R. K. Gresswell was impressed by the inner dunes at Birkdale.

Coast protection – sand-dunes are a self-sustaining barrier against the sea.

"...one may look seaward over an expense of dunes a mile in depth, with the sea beyond, and extending across an angle of vision well over ninety degrees. From this viewpoint, the fact that there are golf courses is scarcely detectable. This is probably the most stimulating natural landscape available for forty miles and the finest view of any kind for many miles."

This coast lies within an hour's journey of about 5 million people. It is hardly surprising, therefore, that it attracts large numbers of visitors – over a million every year.

The sand-dunes play an important and increasing role in preventing flooding along the coast. They keep the sea out of about 77 square kilometres of the highest quality agricultural land, most of it drained peat mossland that lies at or below the level of the highest tides. During storms, sand is washed out of the frontal dunes to reinforce the beach and reduce the power of the waves. In fine weather, the tides wash sand back onto the shore and

the wind returns it to the dunes. This dynamic form of sea defence involves little or no cost to the tax-payer, in contrast to sea-walls which are expensive to construct and maintain and can be overtopped or undermined by severe storms.

This coast protection function of the dunes has long been recognised. Thus, P. Whittle writes in 1831:

> *"The sand hills present to the stranger a very singular and unique appearance, not unaccompanied with wishes for their removal, when personal, monetary convenience, is alone considered. But these barriers are most essential, during the storms and high tides in the winter months, at which season of the year, the scene is, at times, really terrific. Rising higher as they approach the shore, the waves dash their impetuous head against the sand hills, placed most providentially, as preservatives from inundation and ruin."*

This is also an area with a particularly rich wildlife heritage. A classic example of a west-coast, hindshore dune-system, with a relatively high lime content (mainly from seashell fragments) in the sand, the Sefton Coast supports a dazzling variety of wild plants and animals, including species with both northern and southern distributions in Britain. There are many rarities, some of which are rated as internationally important. This gives the dune belt an extremely high nature conservation value, both in national terms and in the wider European context. Indeed, this duneland is arguably the most biodiverse of its type in Britain and to reflect this, most of the system is protected by conservation designations.

In 1978, the Sefton Coast Management Scheme (now the Sefton Coast Partnership) brought together the main land-owners and users to pursue common policies to protect and enhance the coast. In 1991, the Scheme hosted a conference leading, two years later, to the publication of a book *The Sand Dunes of the Sefton Coast*, summarising our scientific knowledge of the duneland. Since then, research has continued and the European significance of the area was further recognised during the late 1990s through the Sefton Coast LIFE-Nature programme, part-funded by the European Commission, to support action for nature conservation, including land-purchase and habitat management. This programme also supported the publication of *The Sands of Time: an introduction to the sand-dunes of the Sefton Coast* in 1999. Another major conference, *Sefton's Dynamic Coast*, designed to update scientific information on the coast, took place in September 2008, with the proceedings published in 2009.

Philip H. Smith, March 2009

ACKNOWLEDGEMENTS
AND PICTURE CREDITS

A great many people have contributed ideas and information to this book. I would like to thank particularly Christine Bennett, Andrew Brockbank, Richard Burkmar, Ron Cowell, Derek Clarke, Ruth Critchley, Steve Cross, Mike Downey, Tony Duckels, Dave Earl, John Edmondson, Sally Edmondson, Peter Gahan, Peter Gateley, John Gramauskas, Malcolm Greenhalgh, Eric Greenwood, Nicholas Haigh, Dave Hardaker, Catherine Highfield, David Holyoak, John Houston, Stan Irwin, Graham Jones, Steve Judd, Alice Kimpton, Inger Kristiansen, Patricia Lockwood, Graham Lymbery, Dave McAleavy, Pauline Michell, Ken Pye, Gordon Roberts, Paul Rooney, John Somerville, Paul Thomas, Matthew Tinker, Fiona Whitfield, Steve White, Chris Whittle, Paul Wisse, Mike Wilcox, Ian Wolfenden, Reg and Barbara Yorke and Steve Young.

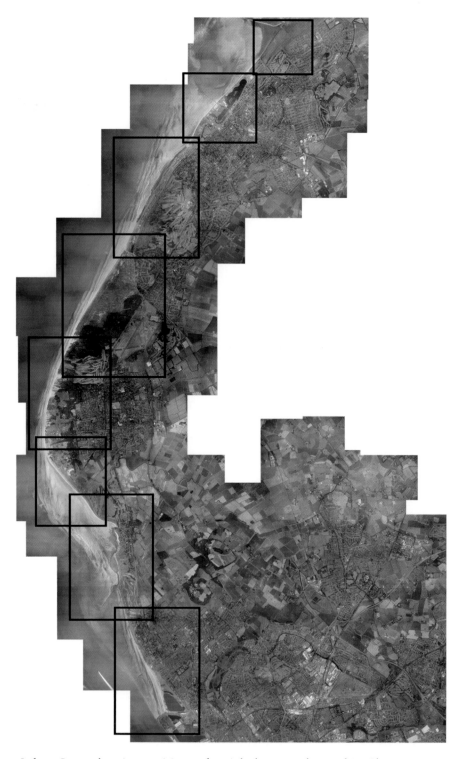

Sefton Coast showing positions of aerial photographs used in Chapter 1.

CHAPTER ONE

A BRIEF DESCRIPTION OF THE DUNE COAST

The southern end of the dune system once began at Sandhills, just north of Liverpool city centre, but now starts at the northern fringe of Seaforth Docks where there is a narrow dune ridge behind the seawall at the reclaimed Crosby Marine Park. About 1600m long and covering 8.5ha, this strip of dunes is rich in plants, including a large colony of the rare Isle of Man Cabbage (*Coincya monensis* ssp. *monensis)*. In recent years, a new ridge (800m long; 2.2ha) has formed on the foreshore west of the promenade, onto which sand-blow is a constant problem. The famous iron men of Anthony Gormley's *"Another Place"* stalk the beach here and can be viewed from the promenade.

For the next 2km to Hall Road, Blundellsands, what used to be dunescape has been tipped on, levelled and converted into mown amenity grassland behind a promenade. About 200m inland, an isolated fragment of duneland 7.8ha in extent, with a woodland fringe, survives in Blundellsands Key Park. This is notable for its abundant, sweetly scented Burnet Rose (*Rosa pimpinellifolia*).

Dunes begin again north of the Coastguard Station at Hall Road as a100m-wide strip between a tipped rubble embankment and the West Lancashire Golf Course (75ha), itself built on sand-dunes. Interesting plants hereabouts include the Isle of Man Cabbage and several orchid species. At the northern end of the golf-course, the dune belt widens to form the Hightown Sand-dunes (41ha), a rich and complex area with a history of much human activity, and which is open to the public despite having several owners. Here, the dunes are backed by the Hightown Meadows, formerly cultivated damp, sandy fields with a diverse wildlife. These fields extend for some distance east of the railway line where they become dryer with a more acidic soil type.

The dune frontage is partly faced by a rubble embankment which is eroding to produce a unique "shingle" beach, with characteristic plants such as the spectacular Yellow-horned Poppy (*Glaucium flavum*). However, the northern section is unprotected at present and subject to a low rate of coastal

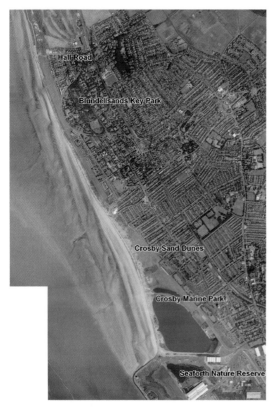

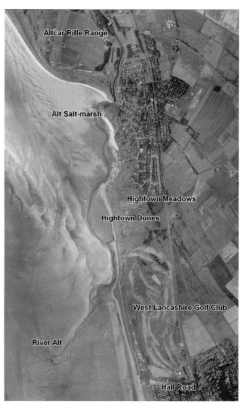

erosion. The River Alt meanders across the foreshore, before being diverted westwards into the Mersey by a stone revetment. There are fascinating peat-beds, the remains of a post-glacial forest complete with tree-trunks thousands of years old, exposed on the beach near the Blundellsands Sailing Club. To the north, is a small, species-rich salt-marsh, backed by a reed-bed. This is one of few areas on the coast where there are uninterrupted views from the shore inland.

North of the River Alt lies the Altcar Rifle Range (204ha), owned by the Reserve Forces and Cadets Association for the North West of England & the Isle of Man. Although public access is restricted for safety reasons, several guided walks are organised every summer by the Altcar Conservation Group. The frontal dunes here are the least disturbed of any on the coast and have little bare sand. To the east, the estate is much modified into large, flat, mown ranges but, nevertheless, is rich in plants, including a huge population of the rare and beautiful Green-winged Orchid (*Orchis morio*). The training area north of the ranges proper has a more varied topography with small wet-slacks, some of which contain scrapes dug for Natterjack Toads (*Bufo calamita*). This duneland is also known for its breeding bird population and

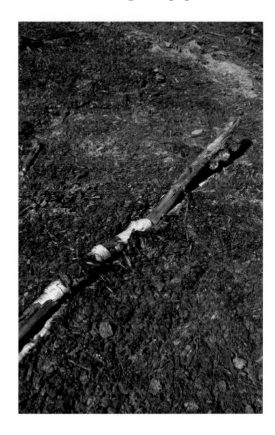

Opposite page; *top left*, vertical air photo Crosby and Seaforth; *top right*, vertical air photo Hightown and Altcar; *Bottom*, Crosby Dunes close to industry.

This page; Birch branch, 5000 years old, Hightown peat-bed.

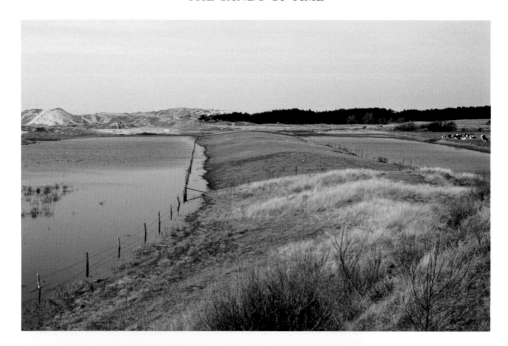

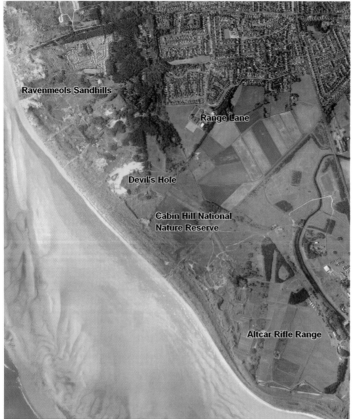

Top, Cabin Hill flood barrier bank in 1981.

Bottom, Vertical air photo Altcar to Ravenmeols.

invertebrates. Since 1990, one million trees (mostly conifers) covering about 29ha (71 acres) have been planted here.

Immediately to the north is the 30ha Cabin Hill National Nature Reserve, managed by Natural England (formerly English Nature), a diverse area including former sand-quarries, traversed by a 780m-long flood-defence bank. The low-lying areas from which sand was dug to create the bank in 1970/71 are now seasonally-flooded slacks rich in wildlife. Along the shoreline new dunes are forming and the whole site supports a great range of special dune flora and fauna, 350 different plants being listed. There is open access for the public, except to an area fenced for conservation grazing by Herdwick Sheep from the Lake District.

A rough track, Range Lane, forms an approximate boundary with the next landholding, Ravenmeols Sandhills (132ha), purchased by Sefton Council in 1995. Most of this land is designated as a Local Nature Reserve and is open to the public on foot. Like Cabin Hill, Ravenmeols has been affected by past sand-winning. There are also large abandoned asparagus fields colonised by patches of scrub, separated from the dunes by a narrow belt of planted conifers. Nearby is Firwood, the oldest plantation on the coast, consisting of both conifers and broad-leaved trees. The woodlands are currently being managed as part of the Sefton Coast Woodlands Forest Plan with large areas of new planting.

Most of the dune frontage here is accreting and demonstrates some of the best examples of embryo and mobile dunes on the entire coast. A huge blow-out, known locally as Devil's Hole, is the most spectacular wind-eroded feature of its type in the dune system. This area also has many built reminders of past uses, including relics of wartime and a failed speculative development in the late 19th century.

To the north of Ravenmeols is Lifeboat Road, Formby Point (70ha), also owned by Sefton Council and one of the chief recreation hot-spots. There is a large car-park, built on former sand-extraction areas, and a private caravan site where asparagus once grew. Extensive pine woodland, with a Red Squirrel walk, separates the dunes from the urban area of Formby. On the shore, at the end of Lifeboat Road, are the remains of Britain's first Lifeboat Station. The coast here is being washed away by the sea at rate of several metres a year revealing, from time to time, layers of silt with footprints thousands of years old. Another interesting feature is Wicks Lane Lake, a former sand-winning site which was deepened in the late 1970s and was used for recreation for several years before being converted into a wildlife sanctuary.

The next estate (168ha) at Formby Point belongs to the National Trust and is also heavily used for recreation, via the large Victoria Road carpark.

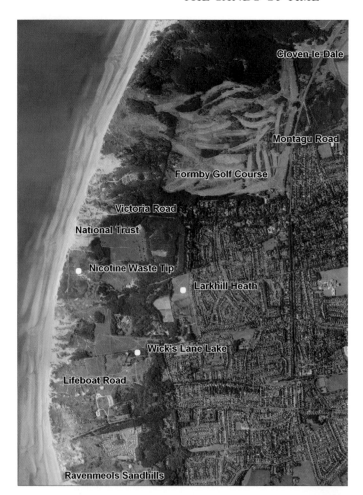

Cloven-le-Dale

Montagu Road

Formby Golf Course

Victoria Road

National Trust

Nicotine Waste Tip

Larkhill Heath

Wick's Lane Lake

Lifeboat Road

Ravenmeols Sandhills

Left, vertical air photo Formby. *Below*, Freshfield dune heath in 1989.

As at Lifeboat Road, the frontal-dunes are being rapidly cut back by the sea and prehistoric footprints can sometimes be found on the beach. Levelling of the land in the past for asparagus cultivation means there are few natural slacks in this duneland. South of the carpark is situated the "tobacco dump", a nicotine waste tip developed in the 1960s and 1970s and now largely colonised by nettles. Another notable feature is the "Squirrel Reserve", part of the large area of pines behind the open sand-dunes, where the famous but sadly declining Formby Red Squirrels (*Sciurus vulgaris*) have become accustomed to visitors and can be fed from the hand. At Larkhill Lane, Formby, the National Trust manages small but interesting areas of heathery dune-heath and flower-rich meadow on former farmland.

Immediately to the north are situated the Formby Golf Course (119ha) and Formby Ladies Golf Course (37ha). The western part of these has not been wholly developed for golf but includes some fixed-dunes and slacks, albeit much affected by pine plantations and scrub growth. A new section of the Sefton Coastal Path traverses this area. To the east, the golf dunes become flatter and more acidic (as the original lime in the sand is washed out by rainfall), with patches of dune-heath near the railway line.

North of this part of the golf course is Cloven-le-Dale stud farm with 9ha of sandy fields supporting acid grassland and dune-heath. Just east of the railway, at Montagu Road, is a triangular area of accessible, but privately-owned dune-heath, bordering Woodvale Aerodrome. Over the past thirty years, this land has become badly scrubbed-up, but Natural England has a management agreement from the owners to restore its heathland character. The airfield itself, built on a former golf course, has important areas of dune-heath, damp grassland and scrub around its fringes. In 2004, the Lancashire Wildlife Trust purchased 35ha from the Ministry of Defence to establish the Freshfield Dune Heath Nature Reserve, with public access to this previously out-of-bounds area.

Formby Golf Course forms the southern boundary of Ainsdale Sand Dunes National Nature Reserve (339ha of dunes and pinewoods), this being the finest wildlife area on the coast. The reserve has over 100ha of pine plantations but the northern and western parts consist of open dunes with large slacks, though much colonised by scrub until the 1990s when a dune-restoration scheme was introduced. This included clearance of scrub and some pine woodland, with follow-up grazing by Herdwick Sheep. As a result, the wildlife interest of the managed area has improved spectacularly. Much of the dune frontage is under attack by the sea and this has damaged one particularly interesting feature, Massams Slack, a 2km-long seasonally-flooded valley between dune ridges formed by land-reclamation in the late

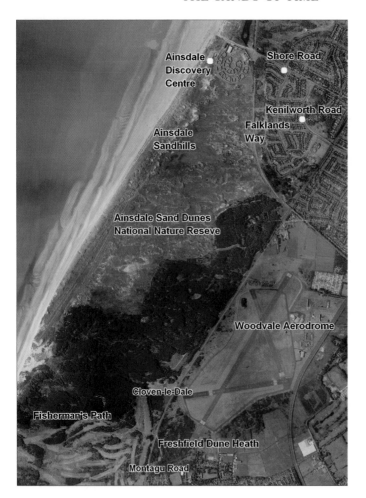

Vertical air photo
Ainsdale and
Birkdale

19th century. Access to much of the reserve is by free permit from Natural England but there is an extensive network of tracks open to the public, including the east-west Fisherman's Path, a popular walk to the sea. A series of guided walks is organised by Natural England staff and volunteers throughout the year for the interested visitor.

Lying to the north of the NNR, is the Ainsdale and Birkdale Sandhills Local Nature Reserve, owned and managed by Sefton Council. Ainsdale Sandhills (88ha) is a pristine area of dunescape with perhaps the best sequence of embryo, mobile and fixed-dunes and slacks to be found anywhere. The reserve was much threatened by scrub invasion until a major control programme was introduced in the early 1990s. Latterly, part of the site has been grazed by sheep in winter. Access on foot is straightforward from Ainsdale beach or the Lido, where Sefton's Coast & Countryside Service has its base and visitor facilities at the Ainsdale Discovery Centre. There is a way-marked dune trail,

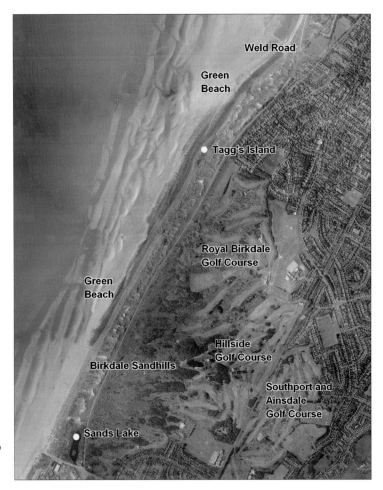

Vertical air photo
Birkdale and
southport

from which the area's rich wildlife may be appreciated. Alternatively, the
rangers lead guided walks which are advertised in advance.

East of the coast road at Ainsdale is Falklands Way (21ha), a way-marked
trail though a strip of Council-owned duneland between the road and
Southbeach Park housing estate. Despite much scrub invasion, this is an
attractive area, rich in plants and butterflies, and including one of the highest
surviving sand-dunes on the coast, known as Big Balls Hill. Nearby, is an
isolated fragment of dunescape (6ha), surrounded by housing, at Kenilworth
Road, Ainsdale. Also affected by scrub, this is an interesting site biologically,
though many of its plants have escaped from nearby gardens.

Birkdale Sandhills (210ha) is situated to the north of Shore Road, Ainsdale
and includes the narrow strip of dunes between the coastal road and the shore.
Here is another fascinating area, unaffected by past conifer planting, but
much invaded by scrub, especially the introduced Sea Buckthorn (*Hippophae*

rhamnoides), gradually being controlled. There is a high density of large wet-slacks with an important series of ponds, originally dug for Natterjack Toads but now noted more for aquatic plants and a wealth of dragonflies. One of the most intriguing parts of the site is the "Green Beach" developing on the foreshore. Originating in 1986, this spectacular linear feature is now (2009) about 4km long and covers more than 60ha (150 acres). Compensating for erosion losses at Formby Point, it consists of a mosaic of newly-formed dunes, freshwater wetland (recently named "Smith's Slack") and salt-marsh. This is a real biodiversity hotspot, with remarkable numbers of plants, rare insects and a large population of Natterjack Toads.

The dune strip between the beach and the coastal road has a number of small but rich slacks which have recently been cleared of Sea Buckthorn by the local authority. They have a diverse flora, including the Baltic Rush (*Juncus balticus*), Birkdale being its only locality in England.

The whole area has free public access, a useful starting point being Sands Lake in the southwest corner. The lake is a former slack ("Bulrush Slack"),

Young dune landscape, Birkdale Green Beach.

which was deepened for recreational use in 1911. It has many waterfowl, especially Tufted Ducks in winter, as well as interesting plant-life and summer dragonflies.

To the east of the reserve, the dunes have been converted into the famous golf-courses, Royal Birkdale (94ha), Hillside (66ha) and Southport & Ainsdale (58ha), though much of the dunescape has been retained and there are significant wildlife habitats in the extensive "roughs". Southport & Ainsdale, lying inland of the railway line, has some of the oldest sandhills remaining on the Sefton Coast and supports one of the largest populations in the country of the rare Grey Hair-grass (*Corynephorus canescens*). There are also some fine areas of dune-heath on the course.

Situated north of the Weld Road roundabout is the 9ha Queen's Jubilee Nature Trail established by Sefton Council and Birkdale Civic Society in 1991/92. Although cut off from the rest of the dunes and the beach by the coastal road, it has a number of attractive features and provides an easily accessible introduction to sand-dune natural history.

Dune fragments can be found, here and there, along the Southport seafront as far north as Marshside but, most notably along the western edge of the Marine Lake. Here, sand-blow over the coastal road maintains good-quality dune vegetation including a large colony of Isle of Man Cabbage and a great rarity, the Early Sand-grass (*Mibora minima*). This is the only place in the world where these two plants grow together!

Finally, the eastern half of Hesketh Golf Course (54ha) was built on sand-dunes and although few areas of slack vegetation survive, it retains in its "roughs" several good plants, as well as a colony of Sand Lizards (*Lacerta agilis*), the most northerly naturally occurring in Britain.

At this point, the sand-dunes give way to the salt-marshes, mud-flats and reclaimed land of the Ribble Estuary, including the 4700ha Ribble Estuary National Nature Reserve, one of the largest in England. In many ways, this is an equally fascinating area for wildlife and is currently proposed as a Regional Park; but that's another story!

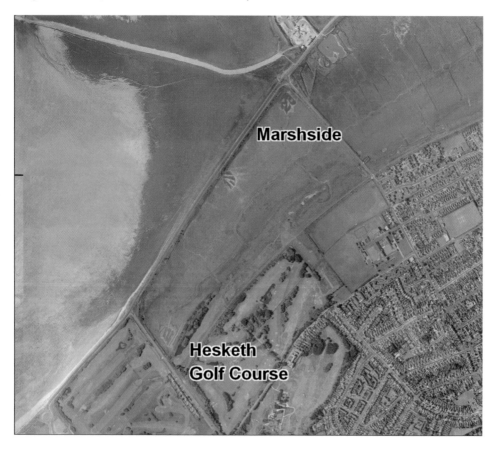

Vertical air photo Hesketh Golf Course

CHAPTER TWO

DUNE FORMATION AND DEVELOPMENT

ORIGINS

The evolution of the Sefton Coast and its hinterland since the last Ice Age has fascinated scientists for over 150 years; so much so that the geomorphology of this area has probably been more intensively studied than any comparable region in the UK. Nevertheless, significant questions remain unanswered and research is continuing to unearth new information.

With the final retreat of the ice over 10,000 years ago, most of southern Britain had a cold climate with tundra vegetation and an arctic fauna. However judging from studies of beetle remains, there seems to have been a rapid increase in temperatures so that, by about 9500 years ago, the region had a climate at least as warm as it is now. This trend continued until, between 8000 and 5000 years BP (Years BP are years "before present" with present taken to be 1950 AD.), average summer temperatures were 2-3°C higher than currently. Pollen analysis shows that the open tundra vegetation was progressively replaced by heathland, scrub and woodland.

As the ice melted, releasing huge quantities of water into the oceans, the sea level rose rapidly towards, and even beyond, the present day coastline onto the low-lying coastal plain. In north-Merseyside, there were at least four lengthy inundations, known as marine transgressions, between about 8000 and 4500 years ago. These deposited layers of estuarine blue clay, the Downholland Silt, which underlies much of the Sefton Coast dune-system and extends to the east under the peat mosslands.

When dunes began to form on the coast is not accurately known but it is likely there was an offshore sand-bank or barrier beach in this area from at least 8400 BP to provide the quiet water conditions needed for the deposition of Downholland Silt and other sediments. There is good evidence from core samples that the offshore bank was well-established by 6000 years ago and that dune formation had begun by 5100 years BP. However, to account for the presence of the Natterjack Toad and Sand Lizard, sand-dunes may have been here much earlier. These two species colonised Britain soon after the ice

melted and before sea-level rose sufficiently to cut us off from the continent. Thus, a Natterjack shoulder-blade, dated at 11,080 years BP, has been found in a south Devon cave. Also, Natterjack remains 8800 to 10,000 years old are known from a site near Boseley, east Cheshire. Natterjack Toads and Sand Lizards must have spread northwards as soon as the climate was warm enough and before the countryside became forested. Both species need open, treeless, sandy or heathland habitats and it has been proposed that they reached northwest England by about 9500 years ago. Afterwards, these creatures would have been restricted by increasing woodland cover to the few naturally open habitats, such as coastal dunes. That is not to suggest, of course, that the present dune system existed then, but it can be reasonably inferred that suitable sandy habitat for Natterjacks and Sand Lizards, either coastal dunes or inland heaths, was present in the area from about 9500 years BP.

Samples taken by drilling cores show that the first main phase of dune-building on the present-day Sefton Coast took place between about 4600 and 4000 years ago, corresponding to a period of lower sea-level when extensive sand-flats would have been exposed. As this time, large quantities of sand were blown inland, burying peat mossland at, for example Hightown and Little Crosby. Between 4000 and 800 years BP, there were alternating periods of dune stability and instability. Stable periods coincided with higher sea-level and the development of slack soils and woodland. Dune instability was associated with lower sea-levels and sand-blow inland.

Unstable conditions have continued intermittently until the present, though on a smaller scale. Consequently, much of the dune landscape we see today has a fairly recent origin; in particular, the high dunes in the central and western parts of the system are considered to date from a period after the Middle Ages (1200-1400 AD) and possibly as recently as the 17th century.

DUNE FORMATION

A sand-dune is little more than a mound of sand, piled up and moulded by the wind, then fixed in place by plants. Sefton Coast sand comes from the bed of the Irish Sea where it was dumped by retreating glaciers at the end of the last Ice Age, about 10,000 years ago.

Research in Liverpool Bay has shown that there is a net movement of sediment in an easterly direction towards the coast. Material washed up onto the foreshore by tides and currents form extensive sand-flats which are uncovered twice daily at low-tide.

This gently shelving coast experiences the second highest tidal range in Britain of over 9m. Therefore, there is a great expanse of sand exposed at low-tide. Once the surface dries out, all that is needed is a breeze above 4.5m per second (10mph) to start the sand moving. As most winds on this coast are between north-west and south-west, the sand usually blows up the shore in a roughly easterly direction. The quantity of sand moved is proportional to the cube of wind speed. This means that enormous amounts of sand can be shifted during storms. However, most gales occur during the autumn and winter when the sand surface is often damp and cannot blow; so in practice, more sand is moved during the summer months.

Sand grains move by saltation (jumping), a process in which individual grains are picked up by the wind and then drop back to the surface under the influence of gravity. They then bounce back into the wind, at the same time dislodging other grains which do the same. This creates a "chain reaction" so that, under the right conditions, the whole beach surface appears to drift downwind.

The critical factor is wind speed at the sand surface and this depends on "surface roughness". Bare sand is fairly smooth and has a low surface roughness, so wind speeds only a little above the threshold of 4.5m/sec will set the sand in motion. However, anything sticking up above the sand surface will increase surface roughness, reduce wind speed and cause the sand grains to be deposited. This is most easily seen on the high-tide line where tidal litter readily traps sand and is soon buried up to the height of the objects concerned.

The process of dune formation begins in this way but such accumulations are often temporary, being washed away by the next sequence of high tides. However, in summer, the tides tend to be lower and this gives an opportunity for plant seeds to germinate and grow on the strandline. Once plants become established, they can grow up through accumulated sand and cause further deposition, thereby forming an embryo dune. By the time that higher tides return in the autumn, the young dune may be too large to be washed away. The embryo dune continues to grow as its plants trap more sand, in effect winning new land from the sea and pushing back the high-tide line. This new drift line can then trap sand in the same way and, over a few years, a series of parallel ridges may form. Eventually, as new dunes grow up nearer the beach, sand-supply to the older ridges is cut off and their upward growth slows.

On the Sefton Coast, this typical process of dune formation can be observed, for example at Ainsdale Sandhills or Cabin Hill. But, because the fore-dunes are inherently unstable, the pattern of parallel ridges is often obscured by later sand-blow. The rate of dune development is well shown by

Strand-line and embryo dunes, Birkdale 2005.

the strip of sandhills west of the coastal road at Birkdale. The road was built along the line of a railway constructed on the top of the beach in 1884. A new dune belt up to 220m wide has developed in the 120 years since then, most of it in the first 50 years. Similarly, G. O. Case describes a belt of small dunes that formed on the seaward side of Birkdale Esplanade between 1884 and 1903 at a remarkable rate of 24 feet (7.3m) per annum.

Another method of dune initiation, the "green-beach", can also be seen at Birkdale which is situated on the outer fringe of the Ribble Estuary. Here, the natural build-up of sand and silt has caused the foreshore to become wider and higher over recent decades. Therefore, as the tide comes in the energy of the waves is reduced so that plants can grow on the beach itself and are not washed away during winter storms. These scattered patches, mainly of the Common Saltmarsh-grass (*Puccinellia maritima*) trap both silt from the water at high-tide and blowing sand at low-tide. A series of low, sandy hummocks is formed, extending out 100m or more from the dune front. Having a greater sand supply, the outermost of these mounds form a line of embryo dunes, eventually high enough to support sand-dune grasses.

As a method of coastal dune formation, this process seems to be relatively rare. However, it has happened here before. E. R. Beattie, writing about his memories of Southport in around 1862 states:

Birkdale Green Beach
proto-dunes formed around
Common Saltmarsh-grass.

"From now onwards I watched the gradual growth of sandhills and marsh at the Birkdale end of the town, embryo sandhills in little hummocks forming about opposite the site of the Palace Hotel, and on the shore tufts of marsh grass began to appear, spreading and joining each other until what was a level expanse of tide-ribbed sand became a green expanse of marsh, and it was only on a spring tide that the sea reached the Promenade."

There is also a detailed description by M. J. Allen of a "sea-beach flora" that developed between Ainsdale and Freshfield in 1930/31. By June 1931, three parallel strips, mainly of Common Saltmarsh-grass, up to 400 yards long had formed on the shore and showed "an uprising of regular little hillocks." The feature survived until at least the following winter but must have been washed away shortly afterwards, as was one which appeared at Ainsdale in the late 1940s. More recently, by the same process, "Tagg's Island" began to form on Birkdale beach in 1974 as a 200m-long ridge 50m out from the foredunes. The present Green Beach has developed since 1986 as a much larger structure, extending south from Weld Road almost to Ainsdale, a distance of about 4km. These features demonstrate how quickly changes can take place on a dune coast (see Fig. 1).

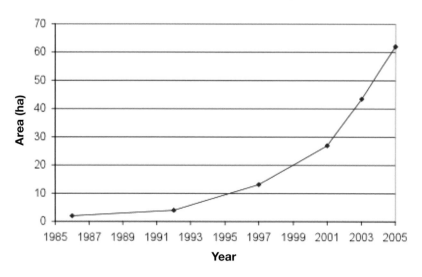

Fig. 1. Changes in the area of Birkdale Green Beach, 1986 to 2005.

MARINE EROSION

Major changes can also result from the sea washing away the dunes. Marine erosion has been taking place since 1906 at Formby Point and now occurs over a 5km stretch.

It has been estimated that the Point lost 700m between 1920 and 1970 with a further 200m eroded in the next 35 years. This has more than accounted for the 220m of new dune formation that is known to have occurred at Victoria Road, Freshfield between 1845 and 1906. Erosion takes place when high spring-tides coincide with strong to gale onshore winds. The effect can be spectacular. For example, during the storm-surge around 26th February 1990, up to 13.6m of dunes were washed away at Victoria Road, sand-cliffs 8 – 10m high formed at Fisherman's Path and the south end of Massams Slack was flooded with seawater. Luckily, such conditions occur infrequently and periods of several years may elapse with relatively little erosion. Even so, the average rate of loss is 3.7m a year and this has been consistent since the 1950s.

Several scientific studies have looked into possible reasons for erosion at Formby Point. It seems to be linked with dredging and the building of training walls along the shipping channel into the Mersey completed at the turn of the 20th century. This may have reduced sand-supply to the foreshore

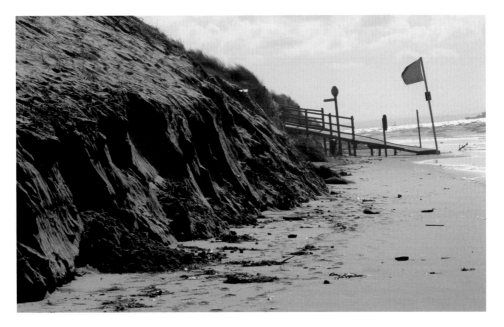

Above, marine erosion at Formby Point on a 10.5m tide. *Below*, Coastal change at Formby Point, 1909-2005.

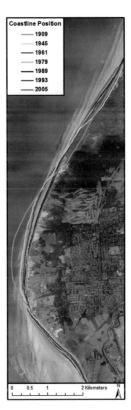

and stimulated the growth of Taylor's Bank, south of Formby Point, which has focused more wave energy onto the Point. A key factor seems to be the narrowing and steepening of the beach at Formby which allows the waves to attack the dune frontage.

Much of the sand washed from the Point has moved north to Ainsdale and Birkdale and south to Altcar and Cabin Hill where active dune building is taking place, more rapidly to the north. Thus, over 100m of new dunes were formed at Range Lane, between 1958 and 1991, while at Ainsdale the high-water mark lies up to 1km seaward of its position in 1890. It is thought that this accretion has roughly balanced the erosion losses at Formby Point.

Marine erosion is also occurring, though at a much lower rate, between Hightown and Blundellsands. Here, a rubble embankment tipped along the shore after the Second World War is slowly eroding away to produce a section of shingle beach, the only example of this habitat on the Sefton Coast. From 1913 to the mid-1930s there was severe erosion at

Blundellsands caused by the landward migration of the River Alt channel. Losses of up to 11.5m a year led to eight large houses being demolished. This problem was halted by the construction of a training wall in 1936 to divert the course of the river to the west. Sefton Council is currently working on a strategy to protect the coastline between Hall Road and Hightown.

WIND EROSION

Dune building is promoted by the wind with the help of plants. But wind can also destroy dunes. Fore-dunes often have at best a patchy cover of protective vegetation and a gale rapidly exploits any weakness in the surface. Similarly, in the more heavily vegetated older dunes, anything that damages the plant cover, such as burrowing by Rabbits (*Oryctolagus cuniculus*) or the trampling of human feet, can lead to wind erosion. This is often first seen as an armchair-shaped hollow or "blow-out" on the windward side of the dune crest. Once it reaches a critical size (about 4m across), a blow-out can become increasingly unstable due to wind turbulence within the hollow and it may continue to deepen until the water-table is reached. The sand is then

Devil's Hole blow-out, Ravenmeols, in spring 2008 following a wet winter.

too wet to blow.

Aerial photographs of "Devil's Hole" at Ravenmeols show that this began to form some time before 1945 as two adjacent blow-outs, perhaps caused by military activity. These later merged and enlarged from an area of 0.44ha in 1945 to 2.55ha in 1993. By the latter year, the main blow-out was 295m long, having grown in an easterly direction at an average rate of 4.5m a year. Sand from the blow-out is gradually engulfing a small pine plantation and, by the early 1990s, Devil's Hole was so deep that the floor began to flood in winter, enabling Natterjack Toads to breed in wet years. Recently, a new "proto-dune" has begun to grow in the bottom of the blow-out.

On particularly exposed coasts like Sefton's, dune ridges can be set in motion by the wind, forming U-shaped parabolic dunes that march landwards leaving behind a low-lying area which can blow down to the water-table. The damp sand is then stable enough for plants to take hold and an embryo dune ridge can grow in the dune gap. This was demonstrated in the 1960s and 70s at Lifeboat Road, Formby, where sand-winning and recreational pressure destroyed the surface vegetation, resulting in an enormous fan-shaped area of moving sand between the car-park and the beach. By the end of the decade, the water-table was exposed and a new embryo dune ridge had formed above the high tide-line. Stabilisation of the migrating dune was achieved during the 1980s by techniques described in Chapter 6. Such large-scale sand movement is now rare on the Sefton dunes, the system having become much more stable than it was in the past.

SLACK FORMATION

Wind erosion of dunes down to the water-table creates wet areas known as slacks which provide a contrasting habitat to the surrounding dry dunes. E. R. Beattie provides an evocative description of these features in the mid-19th century:

> *"After the autumn rains little lakes, locally called slacks, were formed; sometimes slack after slack, separated from each other by narrow bars of sand, stretched in a long chain for great distances, each one reflecting the yellow slopes of the dunes and the blue sky above. And then as night approached they were none the less beautiful, as standing on some hill and looking seaward one beheld a long line of hills dark and purple, their serrated edges sharply cut against the sunset sky of amber and gold and shimmering tender greens and opalescent greys and blues, all repeated in the still waters of the miniature lakes."*

Slack newly formed by wind erosion at Ainsdale, 1979.

Even today, the Sefton Coast is particularly well endowed with wet-slacks, my survey of 1978 mapping 207 of them with a total area of 56.5ha. Indeed, a 1994 report shows that we have about 39% of all the slack vegetation in England, making the Sefton Coast hugely important nationally for dune wetlands. Most of the old slacks at Ainsdale and Birkdale have an east-west orientation, showing that they were created by wind erosion. One slack at Ainsdale Sand Dunes NNR, studied by taking cores and by pollen analysis, dates back to 1890, a period when there was great instability in the dune system.

A few slacks have developed in other ways. For example, the large Massam's Slack complex in the western part of the Ainsdale NNR, occupies a trough or "swale" between successive dune ridges aligned roughly north-east/south-west. Such a feature is known as a "primary" dune slack. Massam's Slack was formed when sand-trapping fences were built on the beach in the late 19th century to create a new dune ridge. The slack that was created behind the ridge was cut off from the sea as recently as 1900. It used to be nearly 2 miles (3.2km) long, but much of its southern end has been lost to coastal erosion and sand-blow. Interestingly, the first and second strips of vegetation on the 1931 green-beach feature at Freshfield, mentioned earlier, were separated by a *"large pool of nearly fresh water in which a good many*

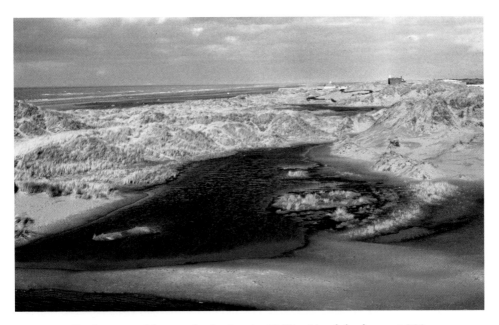

Slacks created by sand-winning in 1950s, Ainsdale dunes, 1982.

species of algae have been found ..." This was undoubtedly a primary dune slack, as is "Smith's Slack" on the current Birkdale Green Beach and some small slacks nearby in the Birkdale frontal dunes.

Many other wetlands in the dunes have been formed by human activity. Several large slacks in the Ainsdale Sandhills frontal dunes and smaller ones at Ravenmeols were created by sand-winning for industry before and after World War II. Elsewhere, there are vehicle tracks, bomb-craters, borrow-pits (where sand was dug out to form banks or to spread on the land) and, on the golf courses, ponds and irrigation reservoirs, all of which hold water of varying depth. Finally, there are over 70 scrapes (shallow excavations) and ponds dug for conservation purposes since about 1970. Most of them provide habitats for specialised water-plants and animals, such as Natterjack Toads and dragonflies. These water bodies are colonised remarkably quickly. For example, Peter Robinson found two aquatic bugs, the Water Measurer (*Hydrometra stagnorum*) and Water Scorpion (*Nepa cinerea*) in ponds on Freshfield Dune Heath only 18 months after they were excavated.

It will be apparent from what has already been written that slacks vary in depth and therefore in wetness. Most, however, fall within a relatively simple classification scheme proposed by the coastal ecologist, Derek Ranwell, in 1972.

Ainsdale NNR scrape in 1979 only three years after it was dug.

SEMI-AQUATIC

The water-table is never more than 0.5m below the soil surface and floods the slack from autumn to spring, or later. Plant roots are almost permanently waterlogged.

WET-SLACK

The water-table never falls lower than 1m below the soil surface and plants have their roots within reach of adequate moisture at all seasons.

DRY-SLACK

The water-table lies between 1 and 2m below the surface at all seasons. Shallow-rooted plants are beyond the influence of the water-table but deeper-rooted species benefit from its presence in summer droughts.

In 2006, A. J. Davy and his co-workers put forward another system for classifying slacks based on water relations. They recognise five types (A to E),

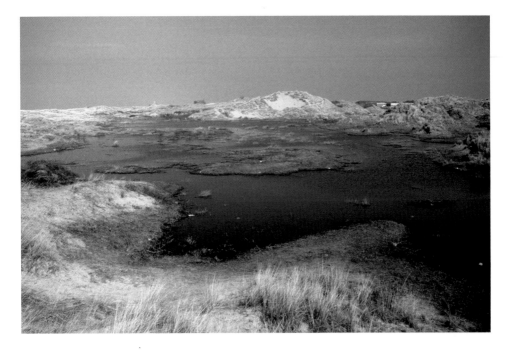

Ainsdale slack during exceptionally high water-level, spring 1995.

four of which seem to occur on the Sefton Coast. Type A is a young slack near to the shore with some saline influence. "Smith's Slack" on Birkdale Green Beach is a good example. However, most of our slacks appear to belong to type B, in which groundwater fed by rainfall flows into the slack and is lost by evaporation. Type C slacks are large and gently sloping; groundwater enters at the inland side and flows slowly towards the sea. The former Ainsdale NNR warden, Keith Payne, called this type the "wet bryophyte slack". Their plant-life includes lots of mosses and liverworts (bryophytes), hence the above term. A few slacks in Ainsdale NNR and Birkdale Sandhills LNR are wetter at the seaward end and may therefore belong to this group. Finally, type E is a slack perched high in the dunes, kept damp by water rising by capillary action and flooded only in very wet years. Possible examples include six small slacks on Royal Birkdale Golf Course.

Excavation of slack floors at Ainsdale and Birkdale has revealed layers of blown-sand and organic material derived from the decay of plants growing in the slack. This shows that slacks begin to fill in as soon as they are formed. Infilling occurs at rates of between 3 and 20mm a year, depending on how close the slack is to the shore and/or supplies of blown sand. Thus, the floor of the 1890 slack at Ainsdale, mentioned above, was 75cm below the surface in 1976, representing an average infill of about 10mm a year.

Clearly, then, slacks become dryer with time and, to maintain a continuity of wet habitats in the dune system, new slacks are required at regular intervals. However, during the second half of the 20th century, the growth of pine plantations and introduced species of shrub and the decline of Rabbits led to increasing sand stability. Therefore, there has been a low rate of natural slack formation for many decades. The few young slacks are restricted to sites such as Devil's Hole and the Birkdale frontal dunes, though the recent development of the Birkdale Green Beach has given a welcome boost to the extent of this habitat on the coast.

DUNE HYDROLOGY

Regular visitors to the dunes know that the water-level in the slacks changes through the year and that the maximum level varies from year to year. In some years, the slacks can remain dry throughout, in others they can be so deeply flooded as to be almost impossible to wade through. Why is this? First, most of the dune area is underlain by deposits, such as Downholland Silt, that are impermeable to water, so rain falling on the surface drains down through the sand and is trapped to form a natural aquifer. This is roughly dome-shaped, higher in the middle of the dune system than at the edges and, under dune ridges, may be several metres below the surface. But, where there are hollows, the water can be at, or even above, the sand surface, thus producing a wet-slack.

To account for flooding in slacks it was claimed, many years ago, that there were impervious layers just below the surface caused either by peat or a calcium carbonate "pan". These ideas were discounted by R. K. Gresswell who writes in 1938:

> "*The high level of the water-table is entirely caused by the low level of the ground. The sand is exceedingly porous and most of the rainfall sinks into it. Some of course is used by the roots of the vegetation but much remains in the ground and slowly drains through it westwards towards the sea. As the fall is very slight, the flow is correspondingly slow and the ground becomes saturated.*"

The hydrology of the Sefton Coast dunes has been studied by Derek Clarke for over 30 years at Ainsdale NNR, using a network of observation wells in which water-levels are recorded each month. The Environment Agency has also established a series of 15 boreholes more recently and is actively engaged

in detailed research which is intended to help the management of dune water resources. It is known that the water-table rises and falls by a metre or more during the year and that the slacks are much more flooded in some years than in others. As was shown as early as 1952 by Barbara Blanchard, these trends are closely linked to rainfall, particularly that which falls in winter.

Most summer rainfall evaporates quickly, either directly from the surface, or as transpiration from actively growing plants. This evapotranspiration is much higher than rainfall between April and September, so that the dune water-table falls and even the deepest slacks generally dry up in late summer. In contrast, during autumn, winter and early spring, rainfall exceeds evapotranspiration and the water-table rises, usually reaching a peak in early March. In an average year, the difference is about 60cm. However, if a dry winter follows a hot summer, the water-table is not fully recharged and the slacks may be dry the following season. These variations can be surprisingly large. For example, the water-table in August 1976, after the famous drought, was 155cm lower than in March 1981, following a wet winter. In contrast, the exceptionally high rainfall of June/July 2007 caused slacks to flood to winter levels, something I had never seen before in mid-summer.

Over the last 30 years or so, water-table highs and lows have occurred at roughly six or seven-year intervals. These fluctuations are important because they have a major impact on slack plants and animals, especially the breeding of the Natterjack Toad. Also, in dry years, blow-outs can erode more deeply, producing wet-slacks when the water-table rises again.

Although rainfall is by far the most important factor affecting the dune water-table, other phenomena can have some effect. The domed nature of the water-table means that water drains off both seawards towards the beach and landwards into the drainage system feeding the Alt and Crossens catchments. Thus, freshwater can "leak" onto the beach from the dunes nearest the sea. Indeed, when levels are high, a flow of water westwards between slacks is noticeable in the Ainsdale frontal dunes. Also, it is now known that evapotranspiration from the thirsty pine plantations can lower the water-table by up to 50cm in slacks within 100m of the woodland. There is recent evidence that the growth of scrub may have a similar effect. Water abstraction and drainage on the golf courses could also have a localised impact and this is currently under investigation by the Environment Agency. Although licensed golf course abstraction amounts to about 60,000m^3 a year, this is less than 1% of water-table recharge by rainfall. However, because course use is increasing, some clubs are keen to use more water and are adopting a new system of irrigation known as a horizontal wellpoint. This involves entrenching a long, permeable pipe deep into the water-table. Studies

suggest that more water can be obtained in this way than from traditional open reservoirs and that drawdown effects are less severe.

Early in the 20th century, slacks at Ainsdale were drained by a network of ditches and pipes to aid the establishment of pine plantations. According to J. Walmesley-Cotham, by the early 1930s: "*...the whole area was practically free from stagnant water and no eels have been seen, although they were evidently noticed in former years, chiefly on the shore when discharged through the outlet pipes.*" However, these drains were blocked soon after the NNR came into being to keep water in the slacks.

DUNE SOILS

As all gardeners are aware, a knowledge of soil conditions is crucial to an understanding of what will grow and where. The surface of recently formed embryo and fore-dunes consists of little more than raw sand which is relatively alkaline (pH between 8 and 9), low in organic matter (1% or less) and also low in plant nutrients such as nitrogen and phosphorus. The sand is constantly on the move, has a limited ability to retain moisture and contains a lot of calcium carbonate (4 – 8%) derived mainly from broken sea-shells. With the exception of the last mentioned, these characteristics make it a poor medium for plant growth.

Over time, these conditions slowly change and a recognisable soil begins to develop. The main factors responsible for this are an increase in organic material derived from the growth and decay of plants and a reduction in alkalinity and calcium content due to rain, which is slightly acid, washing chemicals out of the surface layers. Thus, after perhaps 200 years, the dune soil has up to 30% organic matter near the surface, giving the sand a greyish appearance and enabling it to store more water and nutrients. Meanwhile pH has fallen to 5.5 – 6.0 and calcium carbonate to 3 – 4% or less. However, these changes only take place in the top 10cm or so; below this depth the conditions remain similar to raw sand. Of course, such soils can easily be overwhelmed by sand from an eroding dune ridge, so buried soil layers in the form of dark bands are common in, for example, exposed sand cliffs at Formby Point.

The trend towards organic matter build-up and acidification is speeded up where pine trees have been planted. Here, needle litter on the soil surface produces organic acids which take out the calcium carbonate and also mobilise iron salts in the upper layers, leading to the appearance of rusty mottles as the iron is redeposited lower down in the soil. The pH can fall to

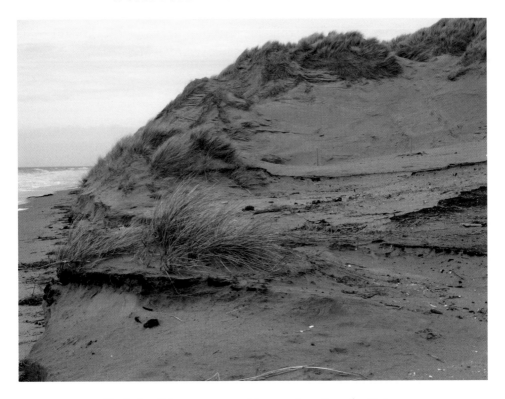

Buried soil layers exposed by erosion, Formby Point.

as low as 3.5 – 4.0 in less than a century, though, again, these changes are usually confined to the top 20cm or so.

The oldest soils on the coast lie on the eastern fringes of the dunes and support acid grassland or dune-heath. There has been enough time (over 300 years) for virtually all the lime to be washed out of the upper layers and pH ranges from between 3.4 and 4.5 at the surface to 4.0 to 4.5 at a depth of 10cm. However, various forms of disturbance, including Rabbit burrowing, can bring the lower, lime-rich layers back to the surface, effectively rejuvenating soil conditions and changing the vegetation locally.

Slack soils differ considerably from those of the dry dunes. The predominant factor is water-logging which leads to low oxygen levels in the soil and a reduced rate of decay of plant material. Thus, the oldest slacks often have a layer of peat, several centimetres thick, on the surface. Technically, these are known as gley soils. Although drainage from surrounding dune ridges brings some soluble plant nutrients into the slacks improving conditions for vegetation growth, slack soils are still relatively low in nutrients. More acid conditions are likely to prevail in older slack soils as peat layers develop. Thus, Blanchard (1952) showed that soil pH in the 50-year-old Massam's

Slack ranged from 6.9 to 7.5, while her "Second Back Slack", thought to be over 300 years old, had lower pH values between 5.0 and 7.0.

PLANT SUCCESSION

One of the fascinations of a large sand-dune system is that its plants and animals change over the course of time. Walking inland from the beach you are, in effect, going back in time to dunes that were formed decades or even centuries in the past. Sand-dunes are one of the few places where all the stages in the colonisation of a new, bare habitat can be observed actively taking place at the same time. This process is known as succession.

On dunes it begins typically with the strandline community, consisting of a few species of hardy annual plants with saltwater-tolerant seeds, such as Sea Rocket (*Cakile maritima*) and Prickly Saltwort (*Salsola kali*). Seeds washed or blown up onto the tide-line germinate in the late spring and the plants complete their growth during the summer. The low dunes they produce are often washed away in autumn but enough sand may accumulate to support

Birkdale strand-line with Sea Rocket.

tough perennial grasses like Sand Couch (*Elytrigia juncea*) and Lyme-grass (*Leymus arenarius*). These grow both sideways and upwards, raising the embryo dunes a metre or so high, representing the next recognisable stage in dune succession. Although both grasses are more-or-less dormant in winter, their dead shoots help to retain sand trapped during the summer. These plants are among very few able to withstand the harsh conditions of the embryo dunes, including sand-blasting and occasional immersion in seawater during high-tides. But they can only tolerate burial by about 30cm of sand a year. The zone of embryo-dunes is usually only about 5 – 10m wide. As already mentioned, embryo dunes formed around Common Saltmarsh-grass can be found at Birkdale Green Beach, but these are exceptional.

Once the dune gets high enough to be free of the risk of over-wash by saltwater, the main dune-building grass, Marram (*Ammophila arenaria*), joins and eventually replaces the other species. This plant cannot tolerate seawater but is drought resistant and has the unique ability to grow up through as much as 1m of sand a year by means of long underground stems or rhizomes. Its tall, spiky leaves are very effective at trapping sand and, as a result, dune ridges up to 15m high are formed in a zone as much as 100 – 200m wide. Because Marram grows in separate tufts, there is usually plenty of bare sand and these dunes are therefore susceptible to wind erosion, prompting their successional name – the mobile or yellow-dunes. On the Sefton Coast, the best series of mobile-dunes is found at Ainsdale Sandhills LNR.

New mobile-dune ridges eventually shelter and cut off sand-supply to the older ridges. This allows plants which cannot tolerate burial to move in. Also, by now there has been time for a primitive soil to develop, making conditions suitable for a greater range of plant species. This zone of semi-fixed-dunes is soon followed by the fixed-dunes proper, where the surface is largely consolidated by vegetation. These are also known as "grey-dunes" because they often have a greyish appearance, either due to the colour of the organically enriched soil or because there is often a carpet of mosses and lichens. Even here, the soil is low in plant nutrients. Paradoxically, this allows the fixed-dunes to support a particularly wide variety of flowering plants because the poor supply of nutrients prevents aggressive, fast-growing species taking over and crowding out the smaller plants.

Fixed-dunes are by far the most extensive of the dune habitats, extending inland to include large parts of the golf courses. They are often lower and less steep than the mobile-dunes because they have been subject to the erosive effects of wind and rainfall for a century or more, during which time little accretion of new sand has taken place.

Marram gradually disappears from the fixed dunes and is replaced by

Mobile dunes, Ravenmeols.

other grasses, particularly Red Fescue (*Festuca rubra*). This decline of Marram has been the subject of much research, especially in the Netherlands. It seems to be linked to micro-organisms, particularly nematode worms and fungi, which build up over time on the roots of the grass, damaging them and causing poor growth. On mobile-dunes, Marram constantly grows up into fresh sand and produces new roots, keeping one step ahead of its parasites. So, when blow-outs develop in the fixed-dunes, the moving sand rejuvenates the Marram, the plants grow tall again and begin to flower.

Sheltered sites in the fixed-dunes may eventually be colonised by woody plants to produce dune-scrub. Although widespread on the Sefton Coast, this successional stage is made up largely of species that have been introduced to the area, in particular Sea Buckthorn, Balsam Poplar (now known as Balm of Gilead) (*Populus* x *jackii*) and White Poplar (*Populus alba*). Some native species, such as Silver Birch (*Betula pendula*), Downy Birch (*B. pubescens*) and Hawthorn (*Crataegus monogyna*) accompany the foreigners. Scrub development enriches the soil with organic matter and extra nutrients, this being especially so with Sea Buckthorn, which has root nodules containing bacteria with the ability to fix nitrogen from the air. Introduced in about

Transition from mobile to fixed dunes, Ravenmeols.

1900, this spiny shrub has spread rapidly since the 1950s and can cover large areas with a grey, impenetrable thicket whose orange berries provide a splash of colour in winter.

Often associated with dune-scrub, but also with dry-slacks, wet-slack margins and old asparagus fields, is coarse grassland containing much False Oat-grass (*Arrhenatherum elatius*) and Cock's-foot (*Dactylis glomerata*). This is not a vegetation type normally associated with sand-dunes but it is becoming increasingly common on the Sefton Coast, partly because of the over-stable condition of the dunes. Research on the Dutch dunes suggests that tall-grass encroachment is linked to a higher than normal nutrient content in the soil. This may come about through addition of large amounts of leaf litter from, for example, dune-scrub, lack of grazing, or from atmospheric pollution. The latter is a particularly worrying trend. Recent measurements suggest that the rate of airborne nitrogen deposition on our sand-dunes is reaching a critical level (10-20kg per ha per year), beyond which major changes in vegetation can be expected.

The eastern fringe of the dune system consists of old fixed-dunes and level areas of "links" sand blown off the dunes in the past. There has been enough

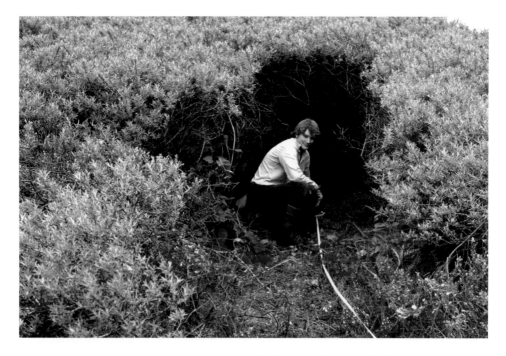

John Houston investigating Sea Buckthorn scrub at Birkdale in 1981.

time for the soils to become acidic in the way described earlier and this has allowed colonisation by lime- hating plants such as the rare Grey Hair-grass and Heather (*Calluna vulgaris*) to form dune-heath, one of the final stages in sand-dune succession.

Dune-heath is a relatively rare habitat here, Peter Gateley's 1994 survey mapping 154ha (7.3% of the present dune-system). Most of the heath occupies previous agricultural land, present-day golf courses and a former golf course which became part of Woodvale Aerodrome. Although pollen analysis shows that ericaceous plants (heathers and their relatives) were present here in the Neolithic period, several 19th century publications on local flora make no mention of heathland on the dunes. The earliest reference I have been able to trace is a 1923 article by Wheldon and Travis in which they state "*....very rarely is the dune pasture allowed to degenerate into dune-heath, but between Freshfield and Ainsdale, characteristic examples of the beginnings of such an association may be found.*" Presumably, before that time, heavy livestock and Rabbit grazing, together with arable cultivation, prevented the growth of Heather. Certainly, by the time Travis's Flora was published in 1963, dune-heath was firmly established, being described as "*...especially well-developed in the Woodvale area.*" However, over the past 30 years or so, in the almost complete absence of grazing, shrubs and trees,

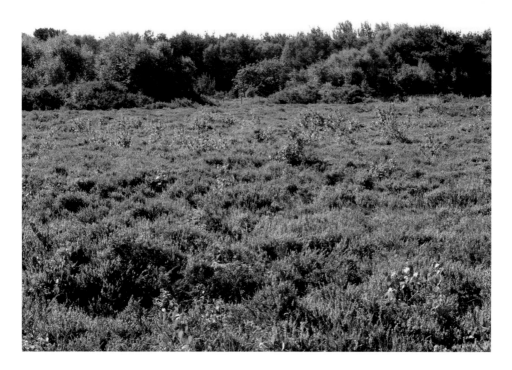

Freshfield Dune Heath showing tree invasion, 2007.

especially birch, oak (*Quercus*) and pine (*Pinus*), have invaded parts of the heath, shading out the Heather and other heathland plants.

Apart from patches of mature scrub, there is very little natural woodland on the Sefton Coast dunes to form the traditional final "climax" stage of succession. Both the pinewoods and areas of mature deciduous woodland, such as that south of Lifeboat Road, Formby, have been planted. Intensive livestock grazing and Rabbit warrening has no doubt greatly restricted woodland development on the dunes for centuries but, in prehistory, pollen analysis suggests there was natural woodland of, for example, birch, oak and Alder (*Alnus glutinosa*), in more stable parts of the system. The name "Birkdale", derived from the period of Norse settlement, implies the presence of birch woodland at that time.

Plant succession occurs in slacks as well as on the dry dunes. In her detailed 1952 study of Massam's Slack, Barbara Blanchard showed that the deeper, semi-aquatic slacks and pools are rapidly colonised by specialised calcareous algae called stoneworts and then by higher plants such as Shoreweed (*Littorella uniflora*) . Later, tall-growing emergent species like Sea Club-rush (*Bolboschoenus maritimus*) and Yellow Iris (*Iris pseudacorus*),

among many others, invade the margins and may eventually spread across the entire surface. These marsh plants tend to form a patchwork with little intermingling between species. Blanchard argued that this reflected the chance establishment of a seedling in the open community of the young slack, after which their vigorous growth prevented invasion by other less competitive plants. The height of the water-table also influences plant survival; thus, flooding for eight months of the year is sufficient to eliminate Creeping Willow (*Salix repens*).

A newly formed wet-slack first supports a microbial mat of bacteria and algae, after which early higher-plant colonists, such as Creeping Bent (*Agrostis stolonifera*) and Jointed Rush (*Juncus articulatus*), move in. After a few years, these are joined by a wide variety of low-growing wetland plants which cannot compete with taller vegetation. At this young stage in slack development, the soil is still low in organic matter and there is general agreement that the plant-life is at its most interesting from a conservation standpoint.

As time passes, a mossy layer develops, accompanied by taller-growing plants, often including several species of orchids. Creeping Willow is invariably present by this stage, if not earlier, and often becomes increasingly dominant, clothing the slack surface and spreading onto adjacent dune ridges.

In older slacks, there is a rapid build-up of organic matter, due to waterlogging and acidification which reduce the rate of decay of dead plant material. Acid-loving species, like Common Cotton-grass (*Eriophorum angustifolium*), may appear. Slacks also become dryer with age, as described earlier. They may then be colonised by coarse grassland. Scrub is also likely to invade, particularly willows (*Salix*) and Alder in the damper spots and Sea Buckthorn, Hawthorn and birch in dryer areas. Over a period of about 30 years, a large slack at Cabin Hill NNR was completely smothered by 4m-high Grey Willow (*Salix cinerea*). When cleared in 2005, despite having stems up to 60cm in diameter, counts of growth-rings showed that these bushes had an average age of only 24 years.

Sand-dune succession is a malleable process. It can be halted for a time by a variety of means. Perhaps the most important of these is grazing. Depending on the type of grazing animal, this can have many different effects. Thus some plants are more susceptible than others; grasses may be encouraged at the expense of woody plants; summer grazing can reduce flowering; dunging alters soil nutrients; livestock often help to disperse seeds; trampling creates bare patches giving opportunities for annual plants and invertebrates.

Traditional livestock husbandry virtually disappeared from the dunes in

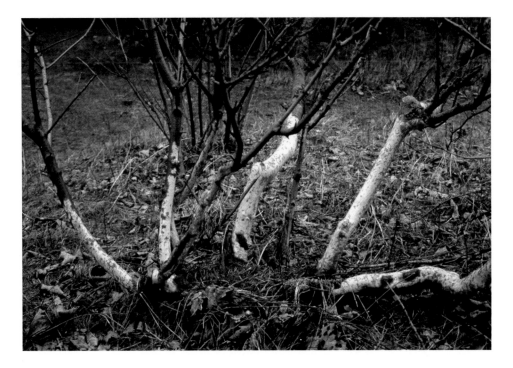

Bark-stripping by rabbits, Formby Point.

the 20th century, apart from a small area at Cabin Hill where cattle and horses were grazed up to the1980s, so the chief grazer became the Rabbit. Old photographs show that, before myxomatosis wiped out most of the population in the late 1950s, these creatures were abundant and maintained a short, grassy sward in the fixed-dunes with much bare sand on the ridges and around the edges of slacks. They also controlled dune-scrub by nibbling off seedlings and young shoots. Since their demise, tall grassland and scrub have flourished and the dune landscape has become much more stable with little bare sand.

Rabbits have increased again in recent years but their distribution is patchy. There are very few in some places, like Birkdale Sandhills east of the coastal road where coarse grassland and scrub have become dominant. In contrast, at Ravenmeols, numbers became so high in the 1990s that the sward appeared to be over-grazed to the detriment of some of the rarer flowers and insects. Even here, however, there was little evidence of increased sand mobility. Occasional outbreaks of myxomatosis seem to limit the higher-density Rabbit populations.

It is apparent that light to moderate Rabbit-grazing plays a vital conservation role on the dunes. By erecting small wire pens in 1974 to

exclude Rabbits, Sally Edmondson studied their effects on slack vegetation at Ainsdale NNR. Over a period of 15 years, vegetation, especially Creeping Willow, grew taller, the variety of plants declined and grasses increased. Only one notable plant, Round-leaved Wintergreen (*Pyrola rotundifolia*), did well in the pens.

Once it reaches a certain size, woody vegetation is considered to be little affected by Rabbits. However, shortages of winter food in areas with high populations have led to them stripping the bark from trees and shrubs, including rare willow hybrids. In extreme cases, this can kill the affected plants. Bark-stripping usually occurs just above ground level to as high as a Rabbit can reach. But, surprisingly, they will even climb up into bushes as high as 2m in their search for food. In past centuries, Rabbits were raised in warrens for food and pelts, so they must have had a significant effect on dune succession on the Sefton Coast over a long period.

Human activity has also played an important role in modifying vegetation development. Thus, in the 1960s to 1980s, recreational trampling destroyed plant cover over large areas at Formby Point and Ainsdale, leading to wind erosion of sand and a return to an earlier, more mobile stage in succession. This can be damaging to the coast protection function of the dunes but lighter levels of trampling can he helpful to wildlife, maintaining a low sward in fixed-dunes and slacks, together with bare sand-patches, both being essential to many of the special sand-dune plants and animals.

Similarly, sand-winning, mainly during the 1940s and 1950s, though at first highly destructive, had the long-term effect of rejuvenating areas of dune landscape, reversing for a time the trend towards a more stable and less diverse fauna and flora.

There is no doubt that the large-scale planting of pine-trees and shrub introductions in the late 19th and early 20th centuries have had a major impact on dune succession. The shelter produced by the maturing trees has encouraged rampant scrub development at the expense of more open dune habitats. This is particularly noticeable in the centre of Ainsdale NNR where birch woodland has replaced open dune habitats over the past 30 years. Increased evapotranspiration from the trees may also have accelerated the trend towards drier conditions in the slacks.

Clearly, an understanding of successional processes is crucial to the successful management of both the physical and biological resources of the dune system.

CHAPTER THREE

HISTORY OF THE DUNE COASTLINE AND ITS USE BY MAN

At the end of the last ice-age, there were few people in Britain. We have few signs of their presence in northwest England; some stone tools from the Mesolithic hunter-gatherers of about 10,000BP have been found in the Fylde and at Little Crosby. These people moved from place to place, hunting wild animals and collecting plant foods. The small family groups of that time probably had little, if any, effect on the natural, lightly forested landscape.

However, in the later Mesolithic (about 8800 – 6000 years BP), recent studies have shown that Sefton was one of the richest areas of lowland prehistoric settlement in northwest England. There is evidence from flint-tool finds of "base-camps" on the slightly higher ground near Little Crosby and on the edge of the River Alt floodplain, from which hunter-gatherers exploited the rich resources of the nearby freshwater wetlands and coastlands. It seems likely that, during this period, Sefton also laid within the territories of foraging hunters from Wirral and North Wales who could easily have walked across Liverpool Bay with its sand-bars and inshore shallows.

Intriguingly, at around 6900 – 6500BP, although the evidence is not strong, it seems that small clearings were made in the woodlands and cereal cultivation was practised locally. This is some time before the transition to the Neolithic at about 6000 – 5500BP, when there was a general move towards growing crops and herding domestic animals. Even so, there is not much sign of a major change in life-style in the area until the later Neolithic, when it is thought Sefton was a focus for mobile pastoralists who grazed the dunes and neighbouring wetlands, especially during the summer. Artefacts of Neolithic age are rare here but include two stone axes from near Hightown which may be connected with woodland clearance during a period of lower sea-level. The 1996 excavation of a wooden trackway eroding out of estuarine silts at Hightown, carbon[14] dated at about 4900BP, is further evidence of our ancestors' use of the area.

Through the late Mesolithic and Neolithic (6000 – 3500BP), the Sefton coast was one of low dunes and salt-marshes. Behind the sandhills stretched mile after mile of swampy fenland and peat bogs, with patches of trees on the

Top, a reconstruction of Mesolithic Sefton landscape. *Left*, Excavated Neolithic wooden trackway, Hightown shore, 1996.

slightly higher land. On the shore itself, layers of mud were being laid down in an intertidal lagoon and the sun hardened and preserved footprints of the animals roaming the area. Coincidentally, the sea-level today is about the same as it was then, and present-day erosion over a distance of about 4km at Formby Point is revealing these same silt layers before washing them away again. The footprints, first noticed in about 1970, provide startling evidence of that ancient fauna. Particularly dramatic are hoof-prints of the Wild Ox or Aurochs. This was a huge beast up to 2m (6 feet) high at the shoulder and 3.5m (11 feet) long with great curved horns. It has been extinct in Britain since the Bronze Age but French cave-paintings give us some idea what it looked like. Also present were Red Deer, Roe Deer, unshod horse and sheep or goat. There are tracks of dog or Wolf, Wild Boar and several wading birds, including the Oystercatcher, Heron and Common Crane, the latter being only rare visitors to Britain these days.

Most interesting, however, are the human footprints. National Trust and Sefton Coast & Countryside volunteer, Gordon Roberts, has recorded to date no less than 219 trails of men, women and children, mostly barefoot. Occasionally, the children seem to have been playing. Some individuals even show signs of chronic disease such as claw-foot, arthritis, bursitis and perhaps diabetes. Elizabeth Roberts has estimated the average height of the men as 1.66m and the women 1.45m. Adult male footprints are often associated with those of deer. These people were apparently going about their every-day life, tracking animals, gathering seafood on the beach or heading out to do some fishing. Perhaps their homes were at the Mesolithic "base camps" described earlier. It is an intensely moving experience to see these footprints which give a unique insight into aspects of their lives, so different from our own. Dating (by optical luminescence) of the upper, imprint-bearing strata gives ages of 6000 - 5000 years BP (Late Mesolithic to Middle Neolithic) but some footprints in deeper, undated, layers may be older. A set of Red Deer antlers from the uppermost sediments is of more recent origin at about 4400BP (late Neolithic), while a dog jawbone comes from a layer dated at around 3600BP (middle Bronze Age).

The Formby footprints have gained national recognition. Several radio and TV programmes have featured them and they have attracted scientists from as far away as South Korea. There is only one other comparable British site – east of Uskmouth on the Severn Estuary in South Wales, where the footprints are also Mesolithic in age.

From about 3000 years ago, in the late Bronze Age and Iron Age, the climate became cooler and wetter, leading to water-logging inland of the dunes and accelerated peat-bog formation. This must have made the area less

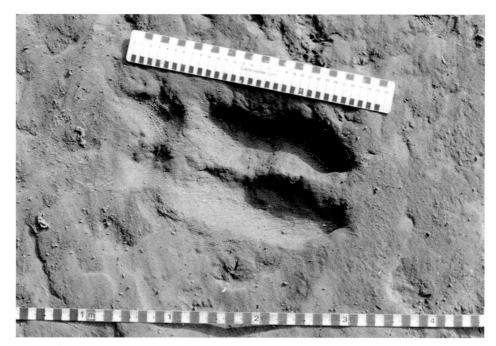

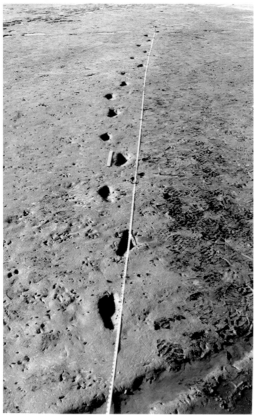

Top, Aurochs footprints Formby shore.
Left, Neolithic human footprints, Formby shore.

attractive to habitation. Evidence of human activity is hard to find but a few settlements are known on the Wirral Peninsula and Iron Age round-houses have recently been excavated at Lathom in West Lancashire. At Lifeboat Road, Formby, hoof-prints of domestic cattle in dune-edge peat, dated at about 2300-2500BP, suggest a nearby Iron Age farmstead.

Although the climate improved again around 2000 years BP, the Roman army largely ignored southwest Lancashire. Its ports were at Chester and Lancaster and the main road to the north ran through Wigan, well inland from the coast. Nevertheless, some people did occupy the area, as shown by a scatter of Roman pottery at sites around Lathom. A few artefacts have also been found at Altmouth and other places in north Merseyside. For example, Howard Smith has found Roman coins of Hadrian and Constantine by authorised metal-detecting on the National Trust foreshore. Also, there are ancient British place-names from this period, such as Alt and Ince (of Ince Blundell), the latter meaning an island, in this case in a marsh or bog.

After the Romans left Britain, Anglo Saxons moved into the area, reaching the coast of Lancashire by 650AD. The later period of Anglo Saxon settlement is associated with place-names such as Sefton and Marton. However, it is thought these people mostly lived on the higher, more easily farmed, land east of the mosses.

In the 9th and 10th centuries, the coastal lands were occupied by Scandinavians, descendents of Norsemen or Vikings, who had earlier settled in Scotland, Cumbria, the Isle of Man and Ireland. There are many place-names on the Sefton Coast dating from this time, including Birkdale, Ainsdale, Formby, Ravenmeols, Altcar, Crosby and Litherland. Formby was originally Fornbei, meaning either "Forni's town" or "old town", while Meols meant sandhills. It seems likely that the Norsemen were the first people to settle on the coast in any numbers. They presumably lived by fishing, bird-catching, livestock grazing and what agriculture was possible in what would have seemed to us a hostile environment but was actually quite rich in resources.

After the Norman Conquest, William I ordered the compilation of the Domesday Book (1086AD). Information about Lancashire is rather scanty. Sefton was surveyed as part of "Inter Ripam et Mersham" (between Ribble and Mersey), divided into six hundreds, this term referring originally to the land occupied by 100 families. Sefton was part of the hundred of West Derby, with Formby, Ainsdale and Ravenmeols being specifically listed as three of the 14 vills or townships identified in Sefton. Remarkably, these still form recognisable units within the present administrative system. The population was probably not more than a few dozen in each of the coastal vills, but it seems there was a well-developed farming system with arable and pasture,

though no doubt other resources such as wildfowl and fish would have been exploited as well.

STORMS AND SANDBLOW

During the Middle Ages, there were several settlements along the coast, including Aynesdale, Argameols, Ravenmeols and Morehouses (Hightown) but, in the 14th century, some were overwhelmed by the sea or blowing sand. Argameols at Birkdale was totally destroyed, while Ravenmeols and Little Crosby lost part of their arable lands. Aynesdale seems to have been inundated and permanently lost between 1311 and 1346. This kind of problem was commonplace on such an exposed coast and there are several accounts of terrible storms affecting the region in the early 18th century. Thus, in 1739, a violent storm blew enormous quantities of sand up to a mile inland from the coast at Ravenmeols and Formby, leaving a desolate landscape which one traveller, some years later, compared to the Sahara Desert. It is said that this storm blew down Formby church, buried the grave-yard, demolished several houses and filled in a freshwater lake called Kirklake. Another consequence was the relocation of St Peter's Church over a mile inland in 1746.

From the early 17th century, if not before, steps were being taken to try and prevent the sandhills blowing by planting Marram, locally known as "starr" or "bent", and prohibiting its removal. In the 1630s, four "Hawslookers" were appointed for Ainsdale and Birkdale by the manorial court. Their job was to keep an eye on the dunes and bring before the court anyone taking starr grass which, at the time, was much used for making mats, baskets and brooms and for repairing thatched roofs. In 1637, three local men were fined one shilling each for this offence but, by 1762, the fines had increased to 13 shillings and four pence, reflecting how seriously the crime was perceived. By 1711, the landowners began to include in their leases a clause compelling tenants of land near the shore to plant starr grass. Then, for 30 years from 1757, Starr Setters or Starr Lookers were appointed by the court to decide where Marram needed to be planted and to see this was done, charging the tenants at a rate "proportional to their estates".

The seriousness of the situation may be judged by the enactment in 1742 of an Act of Parliament "for the more effectual preventing of the cutting of starr or bent."

"Whereas it has been found by experience that the best way of preventing the said hills from being blown away, is to plant them with a certain rush or shrub called Starr or Bent... And whereas many idle and disorderly persons

residing near the said coasts do unlawfully and maliciously in the night time as well as in the day, cut, pull up, and carry away the Starr or Bent And instead of working in an honest manner for the maintenance and support of their families, do privately sell the said Starr or Bent for making of mats, brushes and brooms or besoms ... it shall be lawful for his Majesties justices of the peace, to issue warrants to apprehend the persons And being thereof convicted, they shall pay the sum of twenty shillings, one moiety to the informer; and the other to the lord or owner of such Starr or sandhills, or to commit the person to the house of correction for the space of three months, and for a second offence one year in jail, there to be whipt and kept to hard labour And if any Starr or Bent shall be found in the custody or possession of anyone within five miles of the sandhills they shall be convicted and pay twenty shillings."

Evidently, the problem of sand-blow continued and, in his book describing the "Battle of Land and Sea" on the northwest coasts, W. Ashton (1909) wrote with reference to Formby:

"It would be difficult to find a district where blowing sand has inflicted so much loss upon farmers and landowners, nor upon cultivated land only."

The instability of the dunes in earlier centuries may have been partly due to their use for Rabbit warrening and livestock which overgrazed the vegetation. Also, at times of lower sea-level and before the channel into the Mersey was altered, much more sand was blown up from the foreshore and swept inland by storms. In more modern times, the dunes have become much more stable, with rising sea-levels, reduced sand-supply, extensive tree-planting and an almost complete plant cover, meaning that damaging large-scale sand-blow is no longer possible.

FISH, RABBITS AND FARMING

Along the shore, fishing was a long-established activity, providing food and an income. Since at least the 16th century, the beaches were divided into "fishing-stalls" leased to tenants by the Lords of the Manor. These were strips of foreshore staked out from the dune frontage to the low tide-mark. By the early 18th century, the Birkdale shore was divided into four stalls, each about 1044 yards wide, while Ainsdale had much smaller stalls 360 yards wide. Within these areas tenants, who could share or sub-let the stalls, were allowed to fish or catch birds. Fishing was usually done by fixed stake-nets

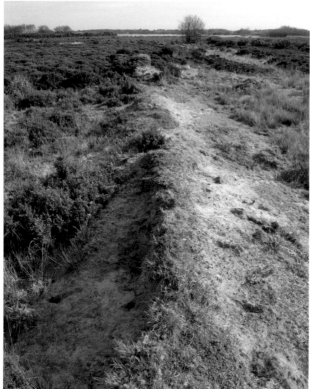

Top left, boundary marker between Formby and Weld Blundell estates, Formby point. *Bottom left*, Old field boundary or "cop" at Freshfield Dune Heath.

which trapped fish as the tide ebbed. By this means, Cod, Whiting, Plaice, Sole, Fluke (Flounder) and Ray were obtained, the tradition surviving until the early 20th century.

While there were Cockle-beds to the north and south of Ainsdale, there was none on Ainsdale beach. This may have been one reason that led Charles Weld-Blundell to try and develop oyster-beds off Ainsdale. He was inspired by the large beds he had seen in the tidal lagoons of Les Landes in south-west France and would also have been attracted by the profits made from oyster culture in south-east England. In 1904, the scheme was implemented, the oysters being brought from Arcachon, France. The *Southport Visiter* reported:

> "*Already close to two million bivalves have been placed upon the beach in the direction of Freshfield and it is understood that several million more will be laid.*"

Predictably, the strong currents and waves of this exposed coast washed the oysters away and the venture failed.

Another major recorded land-use on the coast during these early times was Rabbit warrening. Rabbits were not widespread in the countryside, as they are today, but were largely confined to managed warrens. In Sefton, warrening took place mainly on the sandhills which, like the foreshore, were valuable economic units. Farmed warrens were certainly in use from the time of Sir Cuthbert Halsall who died in 1632. In 1667, there is a record of the two Lords of the Manor, Henry Blundell and Robert Formby, establishing warrens at Formby and setting the boundary between them at Wicks Lane, where some of the iron boundary-posts still survive. Original documents are preserved for warrens at Ainsdale (1720s), Formby (1734) and Great Crosby (1736). In 1845, James Rimmer leased a warren covering 168 acres, the largest area held by any tenant at that time. He was probably a dealer in Rabbits.

Rabbits do best in areas with a light, sandy soil which is easy to dig and where burrows remain dry and warm, so fixed-dunes were ideal for managed warrens. They were protected from predators by ditches and fences or banks, often capped by gorse or thorn bushes. Some scrub was encouraged to provide cover and winter food. Each warren was under the control of a keeper or warrener who often had a watchtower to look out for poachers. A sustainable cropping rate was about 40% of the population per year. Using nets, dogs or ferrets, most Rabbits were caught in December or January when the fur was in its finest condition. Rabbit fur was reported to be one of

the warmest known, therefore the pelts were as valuable as the meat, which was also in great demand; being much cheaper than beef or mutton, it was affordable by the poor. Nothing was wasted, the remains of the carcasses being used as fertiliser.

There were also warrens on the farmed land at the back of the dunes, one of the largest being at what is now Bedford Road, Birkdale. Here, profitability could be increased by combining warrening with arable cultivation, taking a crop and reseeding the field to grass for the Rabbits.

John Holt wrote in 1795:

> *"It is a fact... that neither cows nor sheep will produce so great a profit as rabbits will afford on that land which is suitable to them. Their skins, which in season, are nearly as valuable as their carcases, and they are prolific to a proverb."*

Poaching was apparently always a major problem and, in 1753, an Ormskirk attorney drew up an agreement by *"lessees of commons, coney-warrens and waste grounds of Formby"* to prosecute Rabbit stealers. There are several documented cases of local men being taken to court for this offence in the 17th and 18th centuries. Indeed, an Act of Parliament of 1765 enabled any person convicted of poaching Rabbits to be whipped, fined, imprisoned or transported for seven years! Clearly, Rabbit farming was an important and lucrative part of estate management along the coast and it continued to be so until the late 19th century.

The flat lands just behind the sand-dunes proper were always farmed, their light, sandy soils being easy to work. The land was divided into small fields or "heys", divided by "cops" or banks of soil or sods up to five feet high. As well as providing field boundaries, cops helped to shelter the field from the erosive effects of strong winds. Hedges were sometimes planted on top of the cops to provide additional wind-breaks and lengths of chopped straw were incorporated into the soil surface to hold it together. Arable crops were predominantly cereals, inventories of the 1620s and 1630s mentioning rye, barley and corn (wheat). Oats are first listed in 1680 and potatoes in 1664. Tradition has it that an Irish vessel wrecked in 1565 at Churchtown contained the first potatoes ever imported into England, Lancashire being the first county where this crop was grown in quantity. Other traditional crops were turnips, carrots, peas, beans, celery and cabbages. There is little mention of fertiliser usage until the early 18th century when the local farmers used animal manures. After the Liverpool-Southport railway opened in 1848, night-soil from Liverpool became available in quantity and was brought

in via the new Freshfield Station, named after Thomas Fresh, Inspector of Nuisances for Liverpool, who pioneered this trade. The *Liverpool Mercury* observed:

"The railway has brought fertility to the fields in reach of the market."

Mixed farming seems to have been the norm, the livestock including sheep, horses, cattle and pigs. As early as 1377, William de Aughton and neighbouring land-owners drew up an agreement for joint grazing rights in *"Northmeles, Aynaltesdale, Byrkdale and Argarmeols"*. Some areas of land benefited from common rights and were grazed particularly by sheep. "Common Hills", presumably on the dunes, are mentioned in 1768 and there were also commons at Ainsdale and Birkdale.

Farms were generally very small, for example West End Farm, Ainsdale, consisted of only nine acres. Farms and fields were leased from the Lords of the Manor for an annual rent which also granted rights of pasture on the commons. In the late 18th and early 19th centuries, the leases began to include specific instructions on how the land should be used. Thus, in 1823, Cooper's Meadow Ainsdale, which had grown wheat the previous year, was to be sown with barley and clover, well manured. Crop rotation and use of manures had the effect of improving productivity, hence rents could be increased. By the 1820s, farms began to merge into larger units; in 1823-24 four units at Ainsdale were combined into one of 32 acres, the largest farm in Ainsdale up to that time.

Tithe Maps, drawn up in 1845, show the relative proportions of arable and pasture on these dune backlands. For example, Birkdale had 1200 acres of sandhills and warrens, 545 acres of arable and 315 acres of meadow and pasture. The land at Formby presently occupied by Woodvale Aerodrome and Freshfield Dune Heath was about 50% arable. Field names reflect the crops grown, for example: Carrot Hey, Vetch Hey, Rye Hey, Potato Croft and Bean Yort.

Wild birds were another traditional crop on the farmland and sandhills; these were trapped in "pantles" which were long lengths of cord set a few inches above the ground, with slip-nooses of horse-hair arranged at frequent intervals. In his 1892 *"Notes on the Bird Life of Formby"* John Wrigley describes Snipe Pantles set up around the muddy edges of water in flooded fields. Teal, plovers, Snipe and various small birds were the principal victims and as many as 60 or 70 in a night was not considered an unusual catch. Pantles were similarly used to catch Skylarks. *"Hundreds of dozens of these beautiful little songsters are snared every winter when snow is on the*

ground...." The method involved clearing snow from a strip of land about 200 yards long and a foot wide, setting the pantles and scattering a few handfuls of grain. The birds were sold at Liverpool market for 8d to 1s per dozen.

The earlier farmers of the Sefton Coast had great difficulties getting their produce to market by horse and cart on the unsurfaced tracks that led towards Liverpool. However, the arrival of the railway in 1848 was a great boon to the growers and became known as the "*Farmers' Line*".

ASPARAGUS

Both the major land-owning families on the coast were actively involved in asparagus farming on the dunes from the 18th century onwards, though the growing of this crop probably dates back to the 16th century. Cultivation of asparagus was centred on Formby with a few fields as far north as Woodvale, Segar's Farm on the landward side of the railway being Ainsdale's only asparagus grower. Field patterns were well established before large-scale tree-planting began in the late 19th century and some of the plantings may have been designed to protect asparagus fields. Certainly, this was a major land-use at the time with about 100ha (250 acres) involved. At its peak, Formby asparagus enjoyed a world-wide reputation and, benefiting from the good road and rail links then established, some of the crop was exported. It was even served on trans-Atlantic liners. However, the industry declined during the 20th century with 60ha cultivated in 1950, 16ha in 1966 and only 10ha by the early 1980s.

Fields were created by hand using wheelbarrows or horses and carts to shift sand and level the dunes. The top layer of turf was buried in trenches, a process known as "delving". The plant needs a free-draining soil with no stones, so dune sand is ideal. The crop was grown in rows, often with clumps of cut Marram inserted between the furrows to provide shelter.

Asparagus was a long-term investment as cropping could not take place until at least the third year after sowing the seed. It was also a highly seasonal crop, most cutting being restricted to a period from late April to mid-June, it being a tradition that none could be cut after the 21st June. Productivity ranged from about 0.5 to 1.0 tons per acre. After 10 to 15 years, despite manuring, the land would be exhausted and had to be left fallow. So, asparagus growing was a form of shifting cultivation, constantly requiring new fields to be opened up. Abandoned field are common-place on the Formby dunes, often recognisable by their surviving ridge-and-furrow pattern and sometimes by

Formby Asparagus

old boundary hedges. Many have been used for other purposes, such as car-parks, caravan-sites and new woodland plantations.

The decline in asparagus farming locally is attributable to several factors; the shortage of new land for fields, the labour-intensive nature of the industry and, since the 1960s, the loss of the small-freight facility on the railway. Also, the new supermarkets demanded an all-green stem, while the traditional Formby varieties had a purple tip and white base. This encouraged the importation of the crop from abroad, especially Spain, where it could also be grown cheaper. A further problem was the arrival of a serious pest – the prettily marked but damaging Asparagus Beetle (*Crioceris asparagi*).

A joint project between the National Trust, Formby Civic Society, Sefton Coast Partnership and other community groups is currently celebrating and promote the heritage of asparagus-growing in the area. The National Trust has already reintroduced a small area of asparagus cultivation on its Formby Point property as a demonstration project, while this crop has also been grown on farmland at Range Lane, Formby since 2006.

Star of Hope ship-wreck, Formby Point.

EARLY DEVELOPMENT

Early built development along the coast was often associated with shipping. It seems there were small ports or landing places with quays at Formby and Altcar in the 17th century. Thus, a 1626 return of shipping from the Lancashire coast lists nine ships, totalling 263 tons at Formby and three ships of 42 tons at Altcar. The goods carried were mainly, corn, cheese and other food stuffs. However, unlike Liverpool, these ports did not flourish, no doubt partly because of the shallowing of Formby Channel, which is recorded from 1765 onwards, and due to the exposed nature of the shore. In 1826, a guide to Southport described the coast off Formby and Southport as *"Probably as dangerous as any around the kingdom."* In the 1790s alone, there were 17 recorded wrecks on the North Meols shore. Even so, this did not stop the lucrative trade of smuggling which was rife for about 100 years from the mid-17th century, mainly from the then independent Isle of Man. To avoid heavy taxation, tobacco, wines and luxury goods were brought ashore in small boats, often at Fairclough's Lake, an inlet from the sea at North Meols (later renamed Southport). All levels of society were complicit; for example, it is recorded that Little Crosby's Lord of the Manor, Nicholas Blundell, received large quantities of claret and brandy in 1720.

Loss of life on the coast prompted the building of Britain's first lifeboat station in the dunes at Formby Point, probably in 1775; it was certainly in existence by 1776. This structure was rebuilt in 1809 and survived with slight modification until its final demolition in 1965. Its foundations can still be seen on the foreshore at the end of Lifeboat Road.

By the end of the 18th century, a trend had begun which was to make major inroads into the dune coast in years to come. The landlord of the Black Bull Inn at Churchtown, William Sutton (also known as "Old Duke"), began to accommodate visitors who wanted to participate in sea-bathing. The extensive sandy beach at South Hawes, on what is now the Southport/Birkdale boundary, was particularly suitable for this purpose so, in 1792, Sutton built a ramshackle bathing-house there out of wreck timber, which he called the "King's Arms". He erected a more permanent building in 1798, known as the South Port Hotel or "Duke's Folly". It was situated near to a small stream which entered the sea at this point and was given the rather grandiose name "The Nile", perhaps because of its sandy surroundings or, alternatively, to celebrate Nelson's 1798 victory over the French fleet at Aboukir Bay.

The cult of sea-bathing had developed steadily throughout the 18th century as medical men began to recommend it as a cure for various ailments,

preferable even to warm-water spas which had long been fashionable. By about 1794, Liverpool had "*a full mile of bathing machines*". But the needs of commerce soon replaced the old bathing beaches with docks and Southport took over. The latter was difficult to reach until the Leeds-Liverpool Canal opened in 1777. Then it was possible to take a boat to Scarisbrick Bridge and be transported by coach to Churchtown. The *Liverpool Mercury* of 18th August 1830 describes the extent of the trade at Southport:

> "*This favourite resort was very full of company, and the bathing ground is in uncommonly fine condition. No fewer than one hundred and seventy persons arrived at the village on one afternoon that week.*"

Not everyone approved; thus P. Whittle comments in 1831:

> "*At the height of the tide every machine is in motion, carrying, indiscriminately, occupants of either sex, at no unsociable distances from each other, not provided even with screens, which are common at all continental bathing places, but left to the uninterrupted gaze of the passing crowd.*"

The few fishermen's cottages at South Hawes in 1790 increased to 38 houses with 100 inhabitants in 1809. Whittle, again writing of Southport in 1831, states:

> "*It is surprising to learn how infinitely this place has increased of late years. Upwards of one hundred and thirty cottages have been built in a short space of time and we counted thirty that were building. Some of these near the sea are extremely picturesque, placed in an isolated situation among the sand hills and surrounded by a garden abounding with shrubs and flowers which creep around the doors and windows of the cottages There are several fancy shops, called repositories.*"

In the early 19th century, the site of Southport's famous Lord Street, named after the Lords of the Manor, was a chain of shallow pools (dune-slacks) which persisted until 1842. Houses had to be built well back from the slacks, this being the reason for the street's great width. The street was well demarcated by the 1820s and was named by 1831. At about that time, a ditch was dug to drain the slacks, access to houses on the south side being by little wooden bridges over the ditch.

During this period, boats carrying coal from Wigan could be sailed up the "Nile" at high-water and moored opposite the Prince of Wales Hotel.

Left, Formby Lifeboat House
foundations 2006.
Below, Formby Lifeboat House
c.1930.

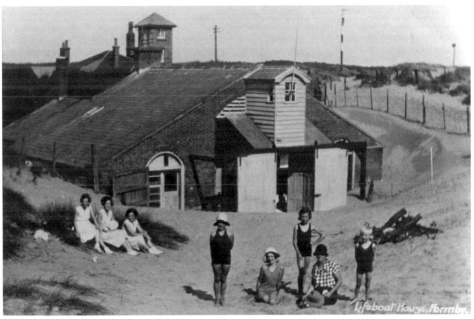

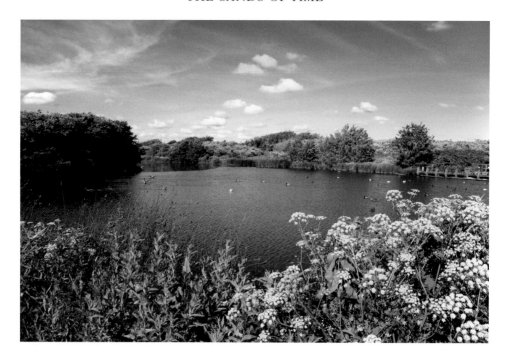

Sands Lake, Ainsdale: dug by hand in 1911.

THE FIRST HOUSE IN SOUTHPORT

Sutton's Hotel at North Meols.

There was even a boat-builders' yard on the corner of Duke Street and King Street. With the coming of the railway in 1848, Southport soon grew to be a fashionable resort, the pier being constructed only twelve years later.

Thomas Weld-Blundell was acutely aware of the importance of the new railways and promoted the building of the Liverpool, Crosby and Southport line through his estate. In 1847, he had put a private bill to parliament stating that he wished to improve 3470 acres (1400ha) of sandhills and Rabbit warrens in Birkdale, Ainsdale and Formby for "*agricultural and other purposes.*" The Weld-Blundell Estates Bill became law just after the railway opened, and land was offered for lease to construct "*Villas and Handsome Residences*" in the township of Birkdale.

The *Liverpool Mercury* foresaw the development potential.

"*.... There is scarcely anything on the west side but sandhills for the eye of the passengers to rest upon. These are inhabited by numberless rabbits, whose gambols and evident astonishment at hearing the snorting and hissing of the engine as it travelled at a rapid rate, attracted the notice of all. We hope ere long to see the land along the railway studded with beautiful villas ...*"

Weld-Blundell produced a plan of a proposed new development at "Birkdale Park Estate" in 1848, a start on building being made in 1850. Birkdale benefited from being adjacent to the already well-established facilities of Southport but the remoter parts of the coast were not so attractive to developers.

Charles Weld-Blundell took over his father's estate in 1887 and is said to have had the ambition to create a second Bournemouth. In 1890 he published plans which included a promenade six miles long from Birkdale to Freshfield, with Ainsdale at its centre, having a "*boulevard from the station to the shore*" and a tramway lined with trees. Large hotels, a pier and a boating lake were included in the plans. To give further impetus to the scheme, Weld-Blundell invoked an option to have a station built on the Southport and Cheshire Lines Extension Railway. "Seaside" station opened in 1901, a new "Lakeside" hotel (now Sands Club) being built next-door the following year. However, progress was slow and, by 1911, there were still only two houses to the west of the station and the short section of promenade built in 1903 had been overwhelmed by sand. In 1911, "Bulrush Slack" near the hotel was dug out by unemployed men to create a boating-lake, now known as Sands Lake. After 1906, Weld-Blundell proposed a more modest development plan "Seaside Garden Village", involving more affordable housing between the two railway lines. Again, this proceeded very slowly and, by 1921, there were

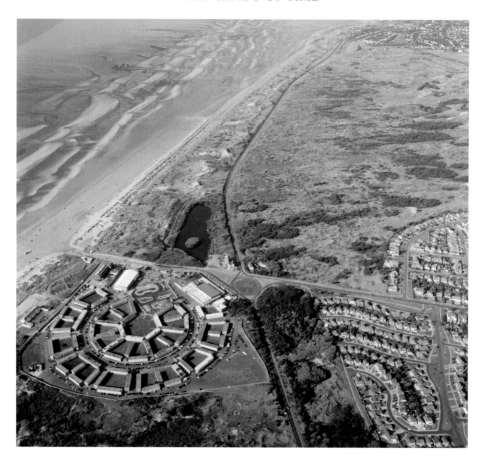

Pontins Holiday Village and Southbeach Park housing development on former sand-dunes at Ainsdale

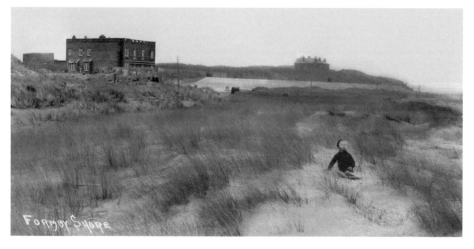

Formby Promenade early 1920s. The small boy is Philip Clulee, born 1916, who lived in one of the nearby houses.

only 37 houses.

Nevertheless, between the wars there were strong pressures for further coastal development, a 1930 planning report containing the following bleak prediction which, perhaps due to the Depression and World War II, did not materialise:

> *"It seems probable that, if modern tendencies continue, practically the whole of the Lancashire coast will, at some not very distant date, be fringed by a tremendous promenade some eighty or ninety miles in length, from Widnes to beyond Morecambe, generally built on a seawall in long straight stretches, broken only by the three rivers, the Ribble, the Wyre and the Lune, which themselves will be bridged It is disquieting to think that in the near future a resident of Lancashire may have to go outside his own county to se a piece of natural coast...."*

Political doubts over land tenure and ownership were persuading many landed families to dispose of their holdings at this time and, in 1928, the Ince-Blundell estate sold 3700 acres of land in Birkdale and Ainsdale to Southport Corporation for £10,000. The Planning Committee decided that 400 acres of duneland either side of Shore Road would be developed as a residential suburb but the next 30 years saw only modest growth, partly because the sewage system was inadequate. Opening the Ainsdale Sewage Treatment Works in 1960 enabled a spurt of development in the 1960s and 1970s, including Pontin's Holiday Village.

Development proposals also applied to dunes further south. The Formby Land and Building Company was established in 1875 with the aim of setting up a rival resort to Southport at Ravenmeols. About 100 acres (40ha) of land were purchased; two parallel tracks, Albert and Alexandra Roads, were driven through to the beach and their ends joined by a double-tiered promenade of brick and concrete 300 yards (290m) long. Other roads and several large villas were built but the Company failed and was wound up in 1902. All but two of the houses have since been demolished but the remains of the promenade, mostly covered in sand, can still be seen.

LANDCLAIM & TREE PLANTING

The nineteenth century saw more attempts to control and manage the dune environment than had been possible in the past, particularly through land reclamation and the planting of trees. One of the most ambitious reclamation

Photograph by R. K. Gresswell of newly planted pines at Woodvale, Ainsdale, c.1930.

schemes was at Balling's Wharf on the north side of the River Alt. In 1779, Commissioners were appointed to supervise the drainage of the Alt catchment area. To prevent large amounts of sand impeding the outfall of the river, they arranged for gorse faggots (bundles) to be placed in several rows at a distance of 50 to 100 yards from the river to trap sand and build up a protective embankment. This worked well and, the following year, more faggots were used to increase the size of the embankment which was later stabilised by planting starr (Marram). By 1855, an area of 150 acres of reclaimed land could be rented out for rough grazing. However, the land proved too wet for agriculture and, in 1860, became the Altcar Rifle Range estate.

Between 1845 and 1906, further land was won from the sea by the Formby and Weld-Blundell estates at Formby Point, using brush-wood fences to trap sand, coupled with the planting of starr. In the 1880s, Charles Weld-Blundell employed six men for this work which was generally carried out during the summer. By 1913, the estate was spending £330 per annum on planting starr grass. The area they reclaimed included the long ridge seaward of Massams Slack stated to be 300 feet (95m) wide, much of this later being lost to marine erosion.

The first record of tree-planting on the Sefton Coast dates back to the early 18th century when Nicholas Blundell planted "witherns" (willows) and other

An ancient Black Poplar on a field boundary at Ravenmeols

species to prevent sand blowing into ditches. In the 1790s, the Reverend Richard Formby planted Sycamore (*Acer pseudoplatanus*), Ash (*Fraxinus excelsior*), Alder and "Fir" (probably Scots Pine *Pinus sylvestris*) at what was later called Firwood, south of Lifeboat Road. This area now supports a mature mixed woodland.

After Charles Weld-Blundell saw pine plantations on the French sand-dunes at Arcachon and Boulogne in about 1887, tree planting experiments began in earnest. His interest was partly a response to the constant disruption to agriculture, tracks, buildings and even the railway line from blowing sand. He also envisaged a financial return from timber after about 40 years, and hoped that more "settlers" would lease the now sheltered land for growing asparagus, poultry farming and pig keeping. It would also obviate the expense of constant starr-planting and he foresaw an improved amenity for the district. Initially, he tried four pine species – Maritime (*Pinus pinaster*), Scots, Austrian (*Pinus nigra* ssp. *nigra*) and Weymouth (*Pinus strobus*), as well as Canadian (*Populus* x *canadensis*) and White Poplars, birch, Sycamore and Alder. The first large area, Jubilee Wood, between Blundell Avenue and Victoria Road, was planted in 1887, mostly with Scots Pine, but this species

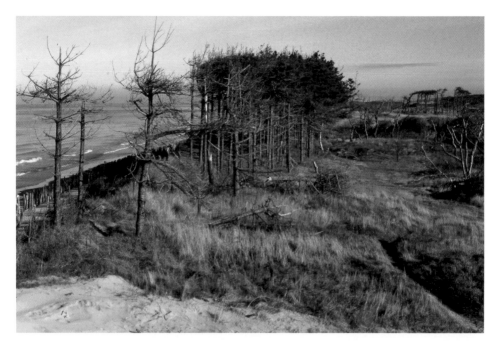

Gypsy Wood remnant, Freshfield 1986.

was found not to thrive. Similarly, a few Sitka Spruce (*Picea sitchensis*) trees were tried but proved useless on pure sand. However, in about 1893, Weld-Blundell discovered that Corsican Pine (*Pinus nigra* ssp. *laricio*) "*grew astonishingly well in the sandhills*" and thereafter this became the dominant species.

Corsican Pine seed was bought in, initially from Denmark, and grown in the estate nursery. The ground for forestry was prepared by reducing the slope of the dunes using hand-tools, planting Marram and draining the slacks by means of ditches and pipes. Three year-old trees were planted out at 4 ft. intervals and, once established, made a foot or more growth a year. Fast-growing Black Poplars (*Populus nigra*), known then as "Frenchmen", were sometimes used to protect the young conifers or planted on field boundaries. Many of these trees have survived to the present day, a survey in 2008 mapping about 500 of them at Formby Point.

Problems included rather frequent fires, due mainly to sparks from steam locomotives. To reduce the risk, Weld-Blundell planted strips alongside the railway line with Asparagus. The practice of "brashing", i.e. lopping and removing the lower branches, was also introduced. Nevertheless, about 30,000 trees were destroyed by fire in 1936 and another 40,000 by bombing during World War II. He also had concerns about "trespassers" lighting fires, and therefore encouraged the erection of fences along Victoria Road and

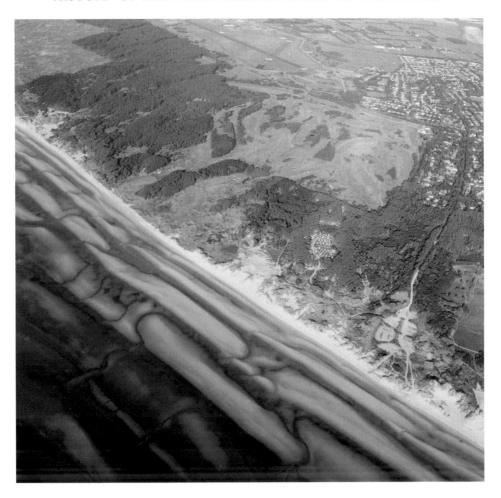

Aerial photograph of the National Trust and Natural England dunes showing the current extent of pine woodland and how close it is to the sea on an eroding coast.

Blundell Avenue, in addition to those alongside the railway tracks. In the 1930s he had Sea Buckthorn planted along the seaward edges of plantations and on the northern boundary of his holdings, again to deter trespass.

During the winters of the1920s, Rabbits began to attack the young trees. This was solved by giving permission for estate employees to trap the Rabbits, thereby greatly reducing their populations.

The main insect pests were Pine Shoot Beetle (*Myelophilus piniperda*) and Banded Pine Weevil (*Pissodes notatus*), which mostly attack young plantations. Weld-Blundell thought that birds helped to control insect pests and in 1905 urged a stop to the commercial killing of birds at Formby and Ainsdale. He is quoted as stating "*The salvation of my trees depends on this!*"

Both Charles Weld-Blundell and Jonathan Formby undertook extensive planting from Ravenmeols northwards to Ainsdale and, by 1925, most of the woodland we see today was in place. Up to the 1930s, there was an extra narrow coastal belt of pines from the north of Fisherman's Path to Formby Point but this was gradually washed away by the sea. The last remnant, known as Gypsy Wood, disappeared in the late 1980s.

Quite a lot of felling was done during World War II but shelter belts were left around felled areas to prevent sand-blow. Some restocking took place after the war but little forest management was undertaken until the Weld-Blundell estate was sold to the Nature Conservancy and the National Trust in 1965 and 1967 respectively.

GOLF

Among the chief users of sand-dunes throughout the country are golf-clubs, this being particularly true of the Sefton Coast, which has been described by Harry Foster as the "*Mecca of golf*". In 1873, the pioneer course, West Lancashire, was laid out on the dunes between Blundellsands and Hightown, inland of the railway line. It was moved to the dunes west of the railway in two stages in 1921 and 1961. West Lancs was followed by six more courses: Formby in 1884, Hesketh (1885), Royal Birkdale (1889), Formby Ladies (1896), Southport & Ainsdale (1907) and Hillside (1912; extended 1960-65). All seven are nationally renowned championship courses; Royal Birkdale has been the venue for the Open Championship on several occasions, most recently 2008, while both this course and Southport & Ainsdale have hosted the Ryder Cup.

There were two other courses in the past. To encourage housing development north of Shore Road, Ainsdale, Charles Weld-Blundell offered this area to the Liverpool Banking & Insurance Golf Club in 1906, including the use of Lakeside Hotel as a club-house. However, the golfers were daunted by the wild nature of the duneland and found an easier site, also on Weld-Blundell land, between Freshfield and Ainsdale, inland of the railway line. Constructed in 1908, this later became the Freshfield Golf Course and was described as "*a flat course with banks and ditches and some very big bunkers.*" The 18th hole was claimed to be the longest in the district. Its demise came in 1941 when it was requisitioned for Woodvale Aerodrome.

In 1911, the Blundell Club established a golf course on partly cultivated land owned by Weld-Blundell south of Ainsdale. This was closed in 1935 and built over.

West Lancashire Golf Course, first constructed in 1873 overlooking Liverpool Bay.

Hesketh Golf Club-house.

A proposal to establish another golf course on duneland owned by the Mountrule Land Company at Ravenmeols and Cabin Hill surfaced in 1974. After protracted study and negotiation, the plan went to public inquiry in 1994 and was turned down by the Secretary of State for the Environment. Part of the area was leased to the Nature Conservancy Council (now Natural England) as the Cabin Hill National Nature Reserve, the remainder being purchased by Sefton Council with the help of funds from English Nature, the Countryside Commission and the European Union's LIFE-Nature programme.

At present, golf courses cover about 500ha (25% of the dune system). However, a proportion of the land is not intensively managed as tees, fairways, greens and practice areas. According to a 1997 survey of four courses, the area of "roughs" ranges from 70% at Southport & Ainsdale to as high as 90% at Formby. The golf courses therefore support extensive areas of semi-natural dune habitat, particularly fixed-dune, dune-heath and dune-scrub, while much of the original topography has been retained. However, wet habitats have not fared so well. All the courses are artificially drained by ditches and most of the low-lying slacks have been converted into fairways. There is still a small amount of surviving slack habitat, for example on the unused part of Formby Golf Course and on Royal Birkdale, where scrub-clearance and annual mowing has restored three botanically rich wet-slacks with an abundance of marsh-orchids. Also, most of the courses have small water-features, many of which were originally irrigation reservoirs.

Coastal links golf courses, like those in Sefton, are characterised by their exposure to the elements but, over recent decades, the courses have become more sheltered, partly due to amenity tree-planting and partly to scrub colonisation. This is now increasingly recognised as a problem and several clubs have a programme of woodland and scrub management to restore links conditions.

While golf is one of the largest users of land on the Sefton Coast, it can be said to have played an important role in saving large areas of duneland from the march of bricks and concrete.

SAND EXTRACTION

Another activity which had a major impact on the dune landscape is sand-winning. This began, on a small-scale, before World War I and was well-established by the 1940s. Before World War II, and for some years after,

Sand was removed in 1972 to prevent it blowing onto the coastal road north of Ainsdale. The bare sand was stabilised with sewage sludge.

Southport Corporation sold sand from anywhere it was causing a nuisance. This seems to have led to the recognition of a commercial potential, the sand being much used in metal-casting and other industries. From 1952 to 1963, the Corporation contracted sand extraction from two areas of frontal dunes north and south of Shore Road, Ainsdale, over 800,000 tons being removed during that period. Sand-winning then switched to the foreshore north of Shore Road where, from 1966 to 1973, 570,000 tons were taken out, after which the industry was deemed to be in conflict with recreational uses of the beach and was transferred to the Horse Bank in the Ribble Estuary, where it continued until recently.

The threat of sand-blow onto the coastal road near the Ainsdale Sand Dunes NNR entrance led in 1974 to the removal of a large dune known as Little Balls Hill. At about this time, two other large schemes took sand from just west of the coastal road between Ainsdale and Birkdale, again due to the problem of sand-blow.

Large-scale sand-winning also centred on Formby Point. A detailed study in 2007, supported by the Aggregates Levy Sustainability Fund, shed further light on this. The sand was used for a variety of purposes, including glass-making and for foundry castings. In 1939, 150,000 tons of Formby sand was

Site of former sand quarry Range Lane, Formby.

taken to fill eight million sand-bags in Liverpool. However, the land-owner, Jonathan Formby, objected and submitted a claim for compensation the following year.

The large dunes seaward of St. Luke's Church, known originally as Shorrocks Hill and Beacon Hill were among the earliest victims. Their removal began when Mr Formby found he had death duties to pay in the late 1920s; so he funded these by selling the sand for six-pence a ton. There were huge sand-pits either side of Lifeboat Road, near where the caravan site and carpark are now situated. On the north side of Lifeboat Road, the steep west-facing slope in front of the pinewoods was once the face of a quarry. Similarly, the low-lying area at Ravenmeols, west of the caravan park, was created by sand-winning which broke through the main dune ridge to the beach at one point. The frontal dunes at Lifeboat road were also worked for sand, old aerial photographs showing a close correlation between the extraction site and the enormous area of bare, blown-sand thought to have been caused by recreational pressure in the 1960s and 1970s. It seems likely that the protective Marram was first destroyed by sand-winning rather than by visitors' feet.

This work was unregulated until planning controls came in during the late 1940s. In the early years, digging was done manually, using the "number 11 shovel" and a flat-bed truck. Mechanisation arrived during the 1950s by means of dragline excavators and ten-ton lorries.

In hindsight, it seems extraordinary that so much sand was permitted to be removed from a part of the dune system that had been subject to marine erosion since 1906 and was a crucial defence against the sea. Concerns about this were being expressed by the Formby Urban District Council as early as the 1930s but the land was privately owned and the minerals highly valued. Charles Rathbone of Sandhill Cottage wrote to the *Formby Times* in August 1951 to condemn the organised destruction of Formby's sandhills and pointing out the danger to children of "... *holes, open and unguarded as they are, filled up with a revolting mixture of cinders, cotton waste and decaying matter...*"

In November of that year, Formby councillors organised a visit to the sand quarries and began to insist on controls under the Town & Country Planning Act 1947. The scale of the operation may be judged by the fact that, in 1952, planning permission was given for the contractors Woodwards to take 200,000 tons over a six-year period from the Albert Road area. Also in 1952, it emerged that sand-winning was taking place without planning permission at Range Lane and that this had breached the dune belt. Restoration conditions were imposed by the Council.

Finally, in 1958, the Urban District Council enacted a Coast Protection Order, refusing all further planning applications for sand-winning to the seaward of a line half-a-mile into the dunes. Even so, a 1965 application to remove 150,000 tons of sand from the area between Atherton Cottage and Wicks Lane was allowed on appeal to the Ministry of Housing and Local Government, much to the dismay of the Council. This extraction was completed in 1970.

Further south, the landmark of Cabin Hill, the largest sand-dune on this part of the coast, was also entirely removed, in places down to the water-table. Sand was taken out on a light railway along Hogg's Hill track and was used for building in Liverpool and foundry castings in the midlands. The dune barrier was so weakened here that, following a report by the Hydraulics Research Station, the then Mersey & Weaver River Authority built a flood defence barrier bank 780m long in 1970/71 at a cost to the tax-payers of about £23,000. The borrow-pits, from which sand was excavated to make the bank, became one of the most important Natterjack Toad breeding sites on the coast, this being a prime reason for setting up a National Nature Reserve here.

MILITARY USES

The military services have been prime users of duneland on the Sefton Coast since 1860 when the Altcar Rifle Range estate was established on the reclaimed Ballings Wharf. This rapidly developed into one of the premier facilities in the country. Much of the estate has been modified to produce butts, targets, service roads and ancillary buildings, in addition to extensive areas of mown grassland. However, the peripheral dunes are in a more-or-less natural state, being perhaps the least disturbed on the coast. Indeed, their dense coverage of vegetation is not ideal from a conservation viewpoint. The northern part of the estate supports fixed-dunes, dune-grassland and small slacks which are used for Territorial Army training and were officially declared as free from explosives as recently as December 1983. Training also took place until 1979 on the then privately owned dunes at Cabin Hill by agreement with the land-owner. This included the digging of fox-holes and occasional use of heavy vehicles, such as tanks.

Another large-scale facility was the 18.3 acre Fort Crosby built on the dunes near Hightown in 1906. Six-inch naval guns were installed to protect the approaches to the Mersey in both Wold Wars but they were never fired. After the second war, the fort housed up to 1000 German prisoners of war, guarded by British and Polish soldiers. Fort Crosby became disused in 1957 and, together with 170ha of foreshore, was sold to the Borough of Crosby in 1963 for £2000. The remains of block-houses, concrete platforms and tall fence-supports persisted until 1983 when the area was restored with the help of derelict-land grants. Most of the material was broken up and buried in the sand.

During World War II, much of the Ainsdale sea-front, including the Lido, were requisitioned by the Admiralty for use as a naval base – H.M.S. Queen Charlotte. Several additional buildings were constructed, the base being finally closed in 1946.

There are also wartime relicts at Ravenmeols, ruins on the top of a high dune crest being the remains of a lookout post. A flat-roofed hotel, Stella Maris, built on the old promenade, was converted into a radar station in 1940 to protect the western approaches into Liverpool. It was later demolished.

A ruined block-house at the western end of Range Lane was part of a "Starfish" decoy, a lighting system designed to draw bombers away from the docks at Bootle and Seaforth. However, it was built after the main Liverpool blitz of May 1941 and it is not clear whether any damage was prevented.

Early in 1941, it was decided to develop a new all-weather airfield for the defence of Merseyside. The site chosen at Woodvale included land occupied

Right, Fort Crosby restoration in 1984
Below, wartime lookout post on high dune at Ravenmeols.

by Bronk and New Bronk Farms and the Freshfield Golf Club. It had the advantages of level topography, few trees or buildings and access to a main road and railway. Woodvale Aerodrome is still in use for training RAF pilots and, in 2004, surplus land on its southern fringes was sold to the Lancashire Wildlife Trust as the Freshfield Dune Heath Nature Reserve.

Harington Barracks was built at Formby during World War II between the village and the coast. The site was closed down in the 1960s and converted into a housing estate. The presence of the barracks led to proposals in 1945 by the War Office to use the whole of Formby Point for training. However, local opposition resulted in plans being withdrawn in 1947. Nevertheless, the foreshore from Crosby to Ainsdale was requisitioned and used by the military from 1944 onwards, concern being expressed in 1953 about the creation of breaches through the dunes to allow tracked vehicles to reach the shore, thereby creating a flood risk. Strong pressure from the local authority and land-owners led to the foreshore north of Albert Road being derequisitioned in 1951, the rest following in 1958.

These activities and uncertainties about the future probably contributed to the landowners' reluctance to invest in duneland management during this period. So the military presence on the coast probably had a greater impact than the more obvious direct effects.

TIPPING

After World War II, several abandoned asparagus fields and former sand-workings at Formby Point were used for tipping tobacco waste by the British Nicotine Company of Bootle. This was first done indiscriminately and then, from 1962 and 1964, under planning permissions. In 1966, it was estimated that 22,000 tons were being tipped annually.

The material was a by-product of the extraction of nicotine from waste tobacco leaves and resembled wet sawdust with a pungent odour. It was bulldozed into layers and composted rapidly to form a peat-like substance with a high water-holding capacity. The largest tipped area south of Victoria Road extended over about 7ha and was colonised by weeds, such as nettles and thistles. Depressions on the surface held shallow water and some of them were very successful breeding sites for Natterjack Toads in the 1970s and 1980s. I well remember finding toads that were so warm from the composting waste that they ran about like demented ants. Tipping ceased in 1974 when the Company closed down, Formby Council having strongly opposed a renewal of planning permission the previous year. Since then,

Tobacco waste tip, Formby Point, just before it closed in 1974.

marine erosion has exposed dark-brown bands of tobacco waste in sand cliffs above the beach.

The use of tipped material for reclamation purposes began on the coast as early as 1914 when rubbish was used to landfill an area behind the Marine Drive at Southport. This area was converted into Prince's Park in 1921.

Similarly, during the early 1980s, an area of reclaimed beach and dunes at Southport Esplanade was progressively infilled with rubble to create a "park-and-ride" carpark. Despite efforts to protect them, this led to the loss of two rare plants, Saltmarsh Flat-sedge (*Blysmus rufus*) and Buttonweed (*Cotula coronopifolia*), the latter being an introduction from South Africa. Both were rediscovered on the coast in 2005/06.

A large hollow in the Birkdale frontal dunes was used to dispose of beach-cleanings in the 1970s and early 1980s. It developed an exotic flora with many alien plants, including garden-escapes and was mentioned in Roy Lancaster's (1983) book *In Search of the Wild Asparagus*.

The only other large tipped area on the coast is between Blundellsands and Hightown where, from about 1942, brick rubble from Liverpool bomb-sites was used to form an embankment along the dune frontage in an attempt to slow down coastal erosion. This was extended northwards in 1947/48 and again in the late 1960s and early 1970s using material from the construction of the Mersey Tunnel.

RECREATION AND ITS IMPACTS

Informal recreational use of the dune coast no doubt goes back to the earliest human occupancy, but documentary evidence exists only from the late 18th century when William Sutton established sea-bathing at Southport.

By the early 19th century, visitors were also appreciating the delights of the sand-dunes. In particular, the ride to the "Isle of Wight" was a must for every visitor to Southport. The "Isle", next to the present-day Portland Hotel, was a giant sandhill surmounted by a flag-pole, giving wonderful views towards Cheshire, the Welsh hills and Liverpool. Getting to it involved a rural ride through lanes heavy with sand. This was so popular in the mid 19th century that one report describes 30-40 donkeys and 12-20 carts tethered in front of the adjacent public house the "Ash Tree". Also much used was the "Velvet Walk", described as *"a most delightful ramble"* southwards through the Birkdale sandhills along a valley between the hills, *"carpeted with the softest moss, green as emerald"*. There were green and brown lizards basking in the sun, the valleys were rich in flowers, especially the white, starry-flowered Grass-of-Parnassus (*Parnassia palustris*); and *"each little dell was the haunt of many species... of insects, and little butterflies gleamed azure in the sun."* The slacks formed between the dunes reflected the colours of land and sky. This walk apparently left a lasting impression on those who enjoyed its charms. Then, in winter when the slacks were swollen, forming a continuous stretch of water along the valley, a hard frost brought the prospect of excellent skating.

Entertainments on Southport beach during this period, as well as large numbers of donkeys, included: *"The Flying Dutchman, a schooner-rigged land boat, which carried about a dozen passengers at a great speed along the level sands, tacking and going about as if it were on the sea."* This was introduced in about 1842 and then banned following a collision with a bathing machine, before being reinstated in 1852.

By the 1890s, the modern era was being ushered in with sand-yacht and motor-car racing on the shore. Southport Motor Club, formed early in the 20th century, organised many notable events, including Sir Henry Segrave's land speed record of 160mph in 1926. Perhaps the greatest meeting was in 1929 when an estimated 100,000 spectators assembled to watch a 100 mile race on the shore. The beach was also ideal as a runway; during 1910/11, five out of 15 licensed aviators in the whole of Britain flew from Freshfield.

Meanwhile, the southern part of the coast was also attracting many visitors. Writing in 1831, P. Whittle describes Crosby in glowing terms:

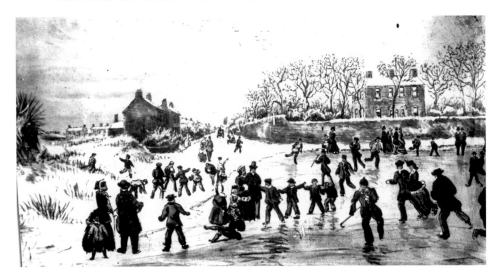

Ice-skating on slacks, Southport, mid-19th century

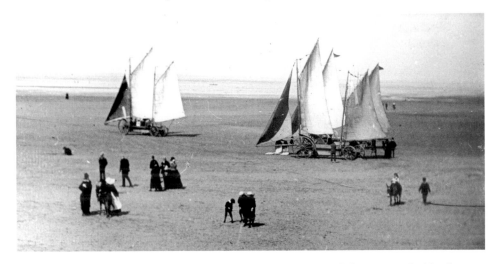

Sand-yachts on Southport beach, 19th century. One of these is probably the "Flying Dutchman".

"This elegant place may be justly entitled "Crosby Sea Bank". Tower's, the Royal Waterloo Hotel, is about five miles from Liverpool; the situation is universally acknowledged to possess every advantage of fine healthy air, and pure sea bathing; for which suitable machines are kept, and attended by experienced men.... The majestic mountains of Wales are in full view; and the continual passing of vessels, renders the marine scenery lively and interesting:- the shore is remarkably fine for walking, riding or driving; and possesses a hard bottom for many miles... it is surpassingly beautiful during the summer season"

Photograph by R. K. Gresswell of Ainsdale beach crowded with cars in the 1930s.

Much later, The Victoria County History for Lancashire (1907) states:

> *"When the tide is low a broad stretch of sands in uncovered and forms a favourite recreation ground of the inhabitants of Liverpool, since these sands are on the northside nearest the city, approached easily by the overhead electric railway."*

After 1928, when Southport Corporation bought the foreshore, Ainsdale-on-Sea grew in popularity as a venue for day-trippers. The bathing beach was superior to Southport's and in 1933 the Corporation built the "Ainsdale Bathing Centre" (also known as "The Lido") for £30,000. As the sand was firm, it was possible to park cars on the beach and these arrived in increasing numbers. During a July heat-wave in 1934, it was *"conservatively estimated that the number of people on Ainsdale beach was in the neighbourhood of 100,000. In certain places, it was impossible to find enough room for another motor-car."* Some of R. K. Gresswell's photographs illustrate the over-crowding. In the 1920s and 1930s, the Lakeside Hotel provided a campsite around the lake but "tenting" soon became regarded by local residents as a nuisance, being described as *"undesirable, indiscriminate and uncontrolled."*

Not surprisingly, considerable damage was done to the adjacent sandhills. By the late 1930s, for several hundred metres north of Shore Road, Ainsdale,

Off-road bike at Lifeboat Road, 1980.

the dunes had become so flattened that they had to be fenced off to allow recovery. Gresswell writes:

"They afford an excellent example of human beings as agents of denudation, for, of course, children and adults delight in running up and down the sandy slopes, and every time they do this a certain amount of sand is pushed downhill, and any incipient Marram that was attempting to cover the bare patch or path is hindered and prevented from further growth."

After World War II, recreation pressures extended beyond the traditional centres of Southport and Ainsdale, Formby Point becoming another popular venue, especially for visitors from Liverpool. A visitor-survey conducted by Lancashire County Council on 25th July 1965 revealed that about 10,000 people came to the area, 82% arriving by car. Based on this study, the Council proposed a Regional Park at Formby, including new roads, car-parks and restoration work but, in the event, these plans did not go ahead. Meanwhile, trampling damage to the dunes here and at Ainsdale was proceeding apace. The following description of the area around the boating lake at Ainsdale (formerly Bulrush Slack) from another mid-1960s report, graphically illustrates the problems associated with poor management:

Sand-winning and trampling destroyed the dune vegetation at Lifeboat Road,
Formby in the 1960s and 1970s.

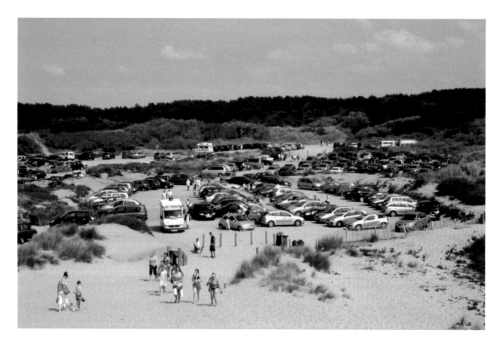

Crowded National Trust carpark, Victoria Road, Freshfield.

"Bulrush Slack is one of the most unpleasant blemishes on the whole system. The woods to seaward have been overridden completely by drifting sand, set in motion by concentrated recreational activity. The lake itself has been reduced by this drifting sand. Rotting hulks of pleasure boats punctuate the shallow water, and family groups picnicking sit around the lake in the filth of residual picnics from previous visitors. It is a blighted place."

Lack of management to take account of public pressure meant that parts of Formby Point were also under severe stress, including problems of litter, fires, vandalism and off-road motor-cycling. The latter activity proved particularly difficult to control and, over a period of about ten years in the 1970s and early 1980s, it damaged vegetation, disturbed wildlife, caused a noise nuisance and created considerable danger to other users. The most bizarre incident of many I encountered was on 10th August 1980 when a professional speedway rider from Halifax, complete with a team of mechanics, was practising on the beach at Ravenmeols. His activities that Sunday excluded all other visitors from a large section of foreshore and could be heard up to a mile away.

By the mid-1970s, the frontal dune ridges between the car-parks and the beach at Lifeboat Road and Victoria Road had been devastated. It was possible to see the sea while standing in the National Trust car-park, while at Lifeboat Road the shifting sand, perhaps first set in motion by sand-winning, was strewn with broken glass left behind on the surface as the lighter sand-grains blew away. The urgent need for dune restoration at Formby Point was the catalyst, in 1978, for the Sefton Coast Management Scheme (now the Partnership) which, over the past 30 years, has addressed the problems and has found effective solutions.

The popularity of the dune coast for informal recreation continued in the 1980s and 1990s at about the same level as the previous two decades. Thirty-five visitor surveys at Formby Point conducted on summer Sundays between 1977 and 1989 found that the average number of day visitors was 3700; only two of these surveys recorded higher figures (11,000 and 14,000) than the 10,000 of 1965. However, the National Trust did log a 10% annual increase in pedestrians from 70,000 in 1992/93 to 90,000 in 1994/95.

A major study (*The Quality of Coastal Towns*) in 2000 showed that key access points along the coast (excluding Southport) attracted over 1.4 million visitors that year, ranging from 55,000 at Ainsdale NNR to 340,000 at the National Trust's Victoria Road. Other major centres were Crosby Marine Park (300,000), Hall Road Blundellsands (270,000), Ainsdale Beach (240,000) and Lifeboat Road (145,000). Around 84% of these visitors lived in Sefton Borough.

Nowadays, we recognise that contact with a high-quality natural environment is important for our well-being. Places like the Sefton Coast

provide great opportunities for people from nearby urban environments to experience and enjoy beautiful landscapes and wildlife, from birds and butterflies to the visual delights of wild flowers.

It is likely that recreational demands on the Sefton Coast will continue to increase in the future. This will require a co-ordinated management approach to avoid the conflicts and damage that occurred in the past.

WILDLIFE AND ITS CONSERVATION

The outstanding wildlife interest of the Sefton coast duneland has been known and appreciated for over two centuries. Thus, George Alexander Cooke, writing as a "*Modern British Traveller*" in about 1805, states:

> "*To the lovers of botany and natural curiosities, the sand hills and shores will furnish and inexhaustible fund of amusement from the great quantities of flowers, plants and shells with which they abound.*"

In the 19th and early 20th centuries, the protection of this heritage was in the hands of the Lords of the Manor and came about largely through their control of the land and of land-uses, rather than any special interest in nature. Charles Weld-Blundell, in particular, banned public access to his duneland estate. The Victoria County History for Lancashire (1907) referring to the Birkdale dunes, states:

> "*The sandhills are so strictly preserved on account of 'game' that the naturalist has little chance of searching the hills for the many uncommon wild plants that grow there.*"

However, as we have seen, the construction of golf courses and leasing land for development were already making inroads into the dune system.

The first national recognition of the need to protect parts of the Sefton Coast came in 1915 when Ainsdale, Birkdale and Freshfield dunes appeared in a short-list of potential nature reserves drawn up by Charles Rothschild for the Society for the Promotion of Nature Reserves. When Rothschild knew it, Ainsdale was "*a wild, little visited place, the haunt of fishermen, grazing tenants and rabbit-catchers.*" Between 1915 and 1947, the dunes appeared on six lists of the most important nature conservation sites published by various bodies. Most notably, in 1944, the Nature Reserves Investigation Committee placed Ainsdale in its list of the top 22 wildlife sites in Britain. It was ranked

Guided walk for the Ainsdale NNR anniversary in 2005.

as *Category A, "outstanding merit"* and *"must be safeguarded"*.

A government wildlife conservation body, the Nature Conservancy (now Natural England), came into being in 1949 but, in the event, Ainsdale Sand Dunes could not be purchased as a National Nature Reserve until 1965, after 15 years of difficult negotiation with the Weld-Blundell estate. In 1955, the estate objected to the proposed nature reserve on the grounds that *"they have not fully grasped the fact that there might be the possibility of future development of the area for building purposes or for sand-winning."*

The present NNR covers 508ha of dunes, pinewoods and beach. It celebrated its 40th anniversary in August 2005, when over 600 visitors were attracted to a range of wildlife-related events. Ainsdale is also notified as a Geological Conservation Review site for its coastal geomorphology, in particular its dunes and foreshore sand-bars.

In 1967, the National Trust acquired another part of the same estate at Formby Point through public subscription as part of the Enterprise Neptune campaign to preserve unspoilt coastline. It had its 40th anniversary in October 2007.

Besides establishing reserves, as another string to its bow, the Nature Conservancy could designate Sites of Special Scientific Interest (SSSIs), ensuring consultation with the local planning authority should a proposal for development affect the site. A large part of the dune system and associated foreshore was so designated within six SSSIs between 1963 and 1988, covering a total area of 4122ha. Then, in 2000, most of these sites were

combined into an enlarged Sefton Coast SSSI, extending over 4600ha. The Hesketh Golf Course SSSI remains separate at the northern end of the dune system, while a new SSSI, the Mersey Narrows, has recently been declared at the southern end of the Borough.

In 1977, Derek Ratcliffe included Ainsdale-Formby dunes in his *A Nature Conservation Review*, a comprehensive survey and evaluation of all important wildlife sites in Britain. He provides a short, but largely accurate, description and ranks the dune area as Grade 1 (nationally important).

Before the 1981 Wildlife & Countryside Act, SSSI protection was weak and, following a 1967 public inquiry, a large area of open duneland at Ainsdale was lost to development for housing and Pontin's Holiday Village, including important habitat for the specially protected Natterjack Toad and Sand Lizard. The attitude to conservation in those days is epitomised by the Southport Council deputy leader's statement to the Liverpool Evening Post in 1971:

> "*I would rate the housing of people and their families as far more important than the fate of a few newts and toads. They are of academic interest to professors who live in a dream world. Unfortunately many of us have to live in a world which requires four walls and a roof.*"

It is worth remembering that, at the time, SSSIs occupied only about 6% of the British countryside.

In more recent times, one of the most significant acts influencing nature conservation on the Sefton Coast was local government reorganisation in 1974. This set up Merseyside County Council with a strategic regional approach to planning and also Sefton Metropolitan Borough Council, bringing the entire sand-dune coast under one local authority, whereas before it had been split between Southport, Formby and Crosby. Almost overnight, attitudes changed and conservation of natural resources became almost fashionable. Thus, Merseyside's Structure Plan (1980) included a policy to establish a Local Nature Reserve on Council-owned land at Ainsdale & Birkdale Sandhills. This was duly set up in the same year, being extended in 1983 to cover a total area of 298ha. Sefton Council, now the largest land-owner on the coast, also leased duneland from the Formby Land Company in 1978, declaring the Ravenmeols Local Nature Reserve in 1985.

In 1984, a second National Nature Reserve, covering 30ha of dunes was leased by the Nature Conservancy Council at Cabin Hill, south of Formby, and was formally declared in 1991. The reserve includes most of the flood barrier bank, erected in 1970, and its associated wetlands, as well as an outstanding area of fixed, mobile and embryo-dunes nearer the sea.

Conservation designation maps

Left, European Special Area of Conservation (horizontal hatch) and Special Protection Area (vertical hatch). *Right*, National Nature Reserves (green), Local Nature Reserves (red) and Sites of Special Scientific Interest (highlighted).

After the abolition of Merseyside County Council in 1985, Sefton's own Unitary Development Plan (1991) strengthened protective policies towards SSSIs and LNRs and extended the presumption against development to other sites which had a high nature conservation value and which met the criteria for inclusion in the Borough's Register of *Sites of Local Biological Interest* (SLBIs). A total of 24 SLBIs has been identified in the coastal zone, several of them lying outside SSSIs and other protected areas. Also, the whole of the undeveloped coast is protected by the Merseyside Green Belt.

Following the 1994 public inquiry into the proposed golf course at Ravenmeols, the 88ha privately-owned estate was offered for sale and was purchased by Sefton Council for £65,000. This area includes the existing Ravenmeols LNR and the Lifeboat Road recreational area, together with dunes and woodlands south to the Cabin Hill NNR boundary.

One of the sand-dune SLBIs, at the Southport Esplanade, was conserved in 1992 as the Queen's Jubilee Nature Trail. This project was a joint effort between Birkdale Civic Society and members of the Sefton Coast Management Scheme, supported by the Civic Trust, UK 2000 and British Telecom. It was awarded a silver medal by the Royal Anniversary Trust.

More recently, a voluntary nature conservation body, the Wildlife Trust for Lancashire, Manchester and North Merseyside, established the Freshfield Dune Heath Nature Reserve (35ha) in 2004. The land, part of which is designated SSSI, was purchased from the MoD with the help of public subscription and the Heritage Lottery Fund. It is being managed to restore the heathland habitat and provide public access to an area which was previously off-limits within the Woodvale Aerodrome boundary.

Finally, there are four international conservation designations that apply to the Sefton dune coast. In 1985, the foreshore and duneland were listed under the Ramsar Convention on the protection of wetlands especially as waterfowl habitat. Then, in 1995, the foreshore was given Special Protection Area (SPA) status under the EU Wild Birds Directive, while a large part of the dune system and associated foreshore were selected in 1996 as a candidate Special Area of Conservation (SAC) under the EU Habitats Directive. These sites are now part of the Natura 2000 network which aims to protect for the future all the most important European habitats and species. Because it includes land below the high water-mark, the SPA is also listed as a European Marine Site.

Recognition of the European significance of the area, but also continuing threats, led to the setting up of the Sefton Coast LIFE Project, co-financed by the European Commission through the LIFE-Nature programme. The project ran from September 1995 to June 1999. One major aim was to develop a nature conservation strategy for the SAC. Other tasks included undertaking emergency habitat restoration work, establishing a computerised Geographic Information System (GIS) and coastal resource centre, as well as writing management plans for many of the protected sites and the golf courses. Land purchase was also included in the LIFE Project, one of its first actions being the acquisition of the duneland at Ravenmeols mentioned previously.

In 2007, the Sefton Coast Partnership launched a new Nature Conservation Strategy and Biodiversity Delivery Plan. This adopts a coast-wide approach over a long time-scale and aims to involve local people in developing solutions to a wide range of conservation challenges. Also in 2007, the Sefton Coast was listed by Plantlife International as an *Important Plant Area* (IPA), one of only 155 such sites in the UK and part of a network of IPAs throughout Europe selected on the basis of their outstanding botanical richness.

To summarise, the history of nature conservation along the coast has been one of accelerating responses to threats and opportunities, so that most of the important areas have now been protected from the threat of development. Now the challenge is to maintain the biological diversity of these sites by high-quality management which depends, in large part, on appropriate allocations of manpower and financial resources.

CHAPTER FOUR

DUNE PLANTS

PLANTS AND THEIR HABITATS

The Sefton Coast supports a bewildering variety of plants. By late 2008, my Inventory of flowering plants, conifers and ferns (vascular plants) included 1280 species, sub-species and hybrids reliably identified within the Sefton Coast Partnership area and 1141 in the sand-dunes. These totals do not include hundreds of "lower" plants, such as mosses, liverworts and algae, nor the fungi which are not classed as plants nowadays.

The significance of the above figures may be judged by the fact that the Sefton Coast total is equivalent to over half the vascular plants recorded in the vice-county of South Lancashire (i.e. old Lancashire between the Mersey and the Ribble). The Inventory includes 188 nationally and regionally notable plants, representing 38% of all the rare plants found in northwest England (Cumbria, Lancashire, Merseyside, Greater Manchester and Cheshire). These are remarkable statistics and graphically illustrate the importance of the Sefton Coast's flora.

The Inventory also reveals that 52 vascular plants have become extinct here since the 19th century. Although an encouragingly low figure, this is actually less than the total a few years ago because 16 species thought lost were rediscovered between 1999 and 2007.

This outstanding diversity is a result of many factors, including the great variety of habitat types found on the coast, ranging from derelict land to dune-slacks and woodland. Also relevant is the position of the Sefton Coast half-way up the west coast of Britain. This means we have a mix of plants with both northern and southern distributions in the country as a whole. Typical northern plants include Saltmarsh Flat-sedge, Variegated Horsetail (*Equisetum variegatum*), Northern Marsh-orchid (*Dactylorhiza purpurella*), Grass-of-Parnassus, Isle of Man Cabbage and Baltic Rush. Those plants with a southern and eastern national distribution are characterised by Lesser Centaury (*Centaurium pulchellum*), Yellow Bartsia (*Parentucellia viscosa*), Southern Marsh-orchid (*Dactylorhiza praetermissa*), Strawberry Clover

Floral diversity at Altcar Rifle Range, June 2008.

(*Trifolium fragiferum*), Ploughman's Spikenard (*Inula conyza*) and Yellow Bird's-nest (*Monotropa hypopitys*).

Crucial to the success of our flora is the availability of the full range of habitats on which they depend. The vascular plant Inventory includes an analysis of the main habitat types in which the plants were found (Table 1).

Habitat	No. of occurrences	%
Disturbed ground	506	33.4
Slacks, scrapes & ditches	283	18.8
Fixed-dunes	214	14.2
Dune-scrub	138	9.1
Dune-grassland	122	8.1
Woodland	118	7.8
Salt-marsh	54	3.6
Dune-heath	44	2.9
Mobile & embryo dunes	17	1.1
Strand-line	17	1.1

Table 1. Main habitats occupied by vascular plants in the Inventory.

Interestingly, by far the largest number and proportion (33.4%) is associated with "disturbed ground". This can range from patches of soil exposed by Rabbit-burrowing to land disturbed by human activity, such as trampling, use of motor-vehicles, dereliction, tipping and agriculture. The next most important habitat is freshwater wetland, represented by dune-slacks, scrapes and ditches (18.8%). Many of the duneland specialists are dependent upon this habitat. The fixed-dunes are also important (14.2%), both this and the dune-slack habitat being priorities for protection within the European Community. Woodland (7.8%) is a relatively unimportant habitat for plantlife on the coast. However, the lowest numbers of species are supported by embryo-dunes and the strand-line (both 1.1%). This is because few plants have evolved the ability to thrive in such a hostile environment.

All plants live in associations or communities with other species. These can be recognised and recorded using the UK's National Vegetation Classification (NVC). Most of the dune system was surveyed by the NVC in 1988/89 by Sally Edmondson, Peter Gateley and Deborah Nissenbaum and again in 2003/04, by Peter Gateley, Pauline Michell and colleagues, maps being prepared to show the extent of the different communities.

Comparing the two surveys reveals some worrying trends. One of the most species-rich fixed-dune communities (code number SD8) has undergone a dramatic 90% reduction from about 100ha to 10ha. Equally striking has been the change in the open dune-annual community (SD19) from 150ha to less than 4ha (a 97% loss), though some of this change may be due to the way the maps were drawn, many small patches of SD19 being unrecorded. The 9% reduction in dune-slack communities (SD13 – 17) from 112ha to 102ha is also a matter for concern, the main losses being in younger slack types. Coupled with these changes has been a great increase in non-sand-dune neutral grassland communities in less disturbed areas from 11ha to 160ha.

The reasons for these trends, which have taken place in only 15 years, are probably complex and are not yet fully understood. However, one important factor seems to be the build-up of nutrients in the soil due to scrub invasion, lack of grazing and deposition of pollutants (mainly nitrogen) from the air.

SALT-MARSH AND DUNE TRANSITION

Salt-marsh is a relatively rare habitat along the dune coast, being largely restricted to two areas, the mouth of the River Alt at Hightown and the Birkdale Green Beach.

The small salt-marsh at Hightown seems to have been present since at least

Coastal form of Hedge Bindweed at Hightown.

the 1930s, though its southern end is now eroding away. It shows a classic succession over a short distance from pioneer communities of Common Cord-grass (*Spartina anglica*), glassworts (*Salicornia*) and Common Saltmarsh-grass to a more mature condition dominated by Red Fescue. Finally, there is a large bed of Common Reed (*Phragmites australis*) where freshwater seepage enters the marsh from the dunes.

At the back of the reed-marsh is one of few places on the coast where Grass-leaved Orache (*Atriplex littoralis*) can be found in any quantity, while there are also several patches of the attractive Common Meadow-rue (*Thalictrum flavum*). Most notable of all is a sizeable colony of the uncommon coastal form of the Hedge Bindweed (*Calystegia sepium* ssp. *roseata*), with pink-and-white striped flowers.

The areas of salt-marsh on the Birkdale Green Beach are even more species-rich with large patches of Hard-grass (*Parapholis strigosa*) accompanying the usual Common Saltmarsh-grass and Red Fescue. Muddy areas support three species of Glasswort, two kinds of Sea-spurrey (*Spergularia*) and the regionally rare Frog Rush (*Juncus ambiguus*). There is also a spectacular abundance of the pink-flowered Sea Milkwort (*Glaux maritima*), while Thrift (*Armeria maritima*) and Saltmarsh Flat-sedge have appeared recently. A single plant of the nationally rare Rock Sea-lavender (*Limonium binervosum*) was found by Pat Lockwood in June 2007 as a new plant for South Lancashire. Where the saline influence is modified by freshwater run-off, an interesting

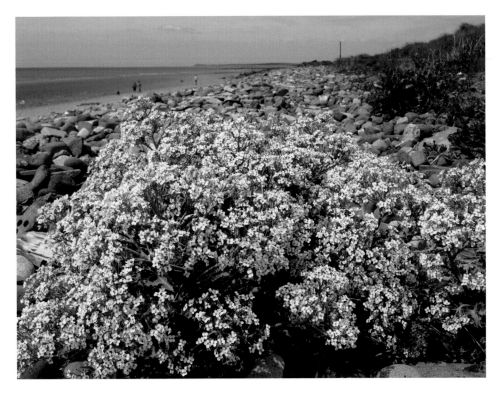

Sea-kale on the artificial shingle at Hall Road.

community of brackish-water species occurs, including Long-bracted Sedge (*Carex extensa*), Parsley Water-dropwort (*Oenanthe lachenalii*), Brookweed (*Samolus valerandi*), Wild Celery (*Apium graveolens*) and Lesser Water-parsnip (*Berula erecta*), all of these being of frequent occurrence here but hard to find elsewhere along the coast.

SHINGLE

The only "shingle" beach in Sefton is between Hightown and Hall Road where erosion of a tipped embankment has produced a zone of water-worn house bricks and other rubble. Despite its artificial origin, this supports a typical community of plants adapted to the harsh shingle environment. They have to be tough to withstand the movement of stones during storms and the saline conditions. Studies over 30 years have shown that the shingle vegetation has gradually increased, covering a total area of 0.39ha (1 acre) by 2007, when as many as 75 different vascular plants were present.

Most attractive of the shingle species is the Yellow Horned Poppy with

Shingle habitat Hightown.

its large, bright-yellow flowers in June, grey foliage and strikingly long seed-pods. It first appeared around 1975 and there is now a large colony at Hightown. Also characteristic is Sea-kale (*Crambe maritima*), its large fleshy blue-green leaves being familiar to some gardeners. A third notable plant is Rock Samphire (*Crithmum maritimum*), usually found on sea-cliffs. First seen in 1993, it is rapidly increasing at Hightown.

Vegetated shingle is a rare habitat in north-west England and is recognised as having great conservation importance both in Britain (a UK Key Habitat in the Habitats Action Plan) and in Europe (Annex I of the Habitats Directive).

STRANDLINE

Strandline communities are sporadic on the Sefton Coast, well developed in some areas in some years and virtually absent at other times. Probably the most reliable place to see this community is Birkdale Green Beach, especially the southernmost section. Here, typical plants include the

mauve-flowered Sea Rocket, which attracts many butterflies in late summer, and the very spiny Prickly Saltwort. Often, Spear-leaved Orache (*Atriplex prostrata*) is the commonest strandline species, while the related Grass-leaved Orache and Frosted Orache (*Atriplex laciniata*) are harder to find. Also worth looking out for is the regionally rare Ray's Knotgrass (*Polygonum oxyspermum* ssp. *raii*).

EMBRYO-DUNES / FORE-DUNES

Because of the shortage of freshwater, low nutrient levels, sand-blasting and occasional inundation by seawater, few species of plants can grow in the embryo dunes. Sand Couch and Lyme-grass are uniquely adapted to these harsh conditions and generally dominate the community. A few strandline plants may also make an appearance, particularly the ubiquitous Sea Rocket and Prickly Saltwort. At Hightown, Sea Sandwort (*Honckenya peploides*) is found on the embryo dunes south of the Sailing Club.

MOBILE-DUNES

The capacity of Marram to survive burial and grow up through thick layers of blown sand makes this the dominant plant of the mobile-dunes. It is also highly drought-resistant, its leaves having a thick, waxy cuticle and the ability to roll up into a tube to reduce water-loss. The importance of this plant to coastal dune development has been recognised for centuries. For example, P. Whittle writes in 1831:

> "*The sand hills, blown together in most irregular shapes, are held in these positions by the matted roots of the arundo arenaria – star, sea reed, marrum, or sea matweed. This is a useful and common plant on many of our sandy seashores. Its cultivation has, at various times been much encouraged, and even acts of parliament have been passed for its preservation, in consequence of its spreading roots giving stability to the loose, blowing sand, and thus raising a bulwark against the encroachment of the waves.*"

In gaps between the Marram tussocks and where sand-deposition is lower, a few other plants can gain a foothold, particularly "weed" species such as Groundsel (*Senecio vulgaris*), Common Ragwort (*Senecio jacobaea*) and Creeping Thistle (*Cirsium arvense*). Other typical plants of this community

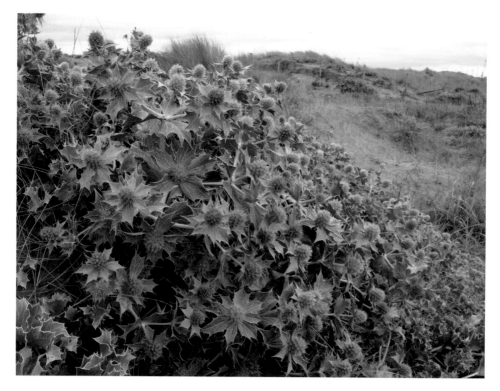

Sea Holly, Crosby dunes.

are the succulent Sea Spurge (*Euphorbia paralias*), and Sea Holly (*Eryngium maritimum*) whose blue flowers are extremely attractive to butterflies. A rare but characteristic plant of the mobile dunes is the beautiful Sea Bindweed (*Calystegia soldanella*). There are only five known patches on the Sefton Coast. Sprawling plants of Sea Radish (*Raphanus raphanistrum* ssp. *maritimus*) can also be found in this habitat, particularly at Birkdale and Southport.

On the older mobile dunes, especially the back-slopes, there is often a broad zone of vegetation intermediate between mobile and fixed-dunes. Marram is still abundant here but the reduced rain of blown-sand allows a much greater range of species to move in. Among the grasses, Red Fescue and Spreading Meadow-grass (*Poa humilis*) can often be common, while tall herbs, such as Rosebay Willowherb (*Chamerion angustifolium*) and Umbellate Hawkweed (*Hieracium umbellatum*), lend a splash of colour. Ground-hugging species, also with attractive flowers, include Common Restharrow (*Ononis repens*), Heath Dog-violet (*Viola canina*) and, less often, Wild Pansy (*Viola tricolor* ssp. *curtisii*). Potentially confusing yellow-flowered dandelion look-alikes also put in an appearance, the commonest being the large Cat's-ear (*Hypochaeris radicata*) and the smaller Smooth Hawk's-beard (*Crepis capillaris*).

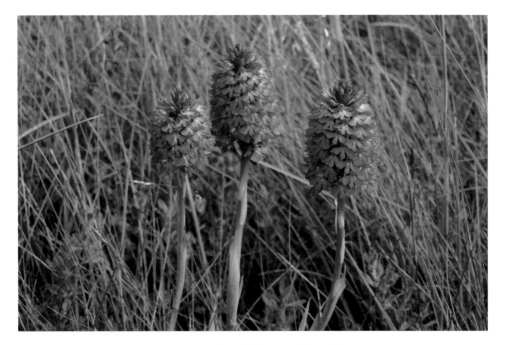

Pyramidal Orchid at Cabin Hill.

FIXED-DUNES

This is the most extensive habitat on the Sefton Coast, but rare in Europe, and one of the richest for plants with as many as 25 species per square metre in places. Although the ground surface is mostly well vegetated, this is still an inherently unstable substrate and localised erosion provides a seed-bed for lots of additional plants, especially annuals. As all gardeners know, more species can grow in calcareous soils than in acid ones, so the high lime content in the soil of the younger fixed-dunes creates favourable conditions for a wide variety of plants, including those known as calcicoles (lime-lovers). Typical examples are Common Centaury (*Centaurium erythraea*), Yellow-wort (*Blackstonia perfoliata*), Carline Thistle (*Carlina vulgaris*) and Lady's Bedstraw (*Galium verum*). This group also includes members of the pea family, such as Kidney Vetch (*Anthyllis vulneraria*), which puts on a particularly fine display at Hightown, Bird's-foot-trefoil (*Lotus corniculatus*), Hop Trefoil (*Trifolium campestre*) and Hare's-foot Clover (*Trifolium arvense*).

Several orchids also favour limy soils; they include the pink Pyramidal Orchid (*Anacamptis pyramidalis*), which is quite widely distributed in the fixed-dunes and is now much more abundant than it was 30 years ago. There are two really large populations at Cabin Hill NNR and Ainsdale Sandhills LNR; in 2008 the former contained about 5000 flower-spikes. The

Bee Orchid near Sands Lake, Ainsdale.

Dewberry.

spectacular Bee Orchid (*Ophrys apifera*) is also easy to see in most years and, like the Pyramidal Orchid, seems to be increasing. Another scarce calcicole is Viper's-bugloss (*Echium vulgare*), whose dramatic purple-blue spikes are especially prevalent on Hightown dunes. Burnet Rose is also a Hightown speciality, otherwise occurring only at the Blundellsands Key Park and an old asparagus field at Formby Point.

One of the most familiar fixed-dune plants is Dewberry (*Rubus caesius*), a sand-dune bramble. E. D. McNicholl (1883) knew this species well:

> "*In late summer they are loaded with the handsome fruit, at once distinguished from blackberries by the great size and the fewness of the component drupeolae, which are covered, moreover, with a delicate glaucous bloom instead of being jetty and shining.*"

An interesting feature of the fixed-dunes is the effect of which direction the sand-dunes slope. The cooler and damper north-facing slopes have a more luxuriant sward characterised by lots of Polypody fern (*Polypodium vulgare*) and Wood Sage (*Teucrium scorodonia*), together with Wild Strawberry (*Fragaria vesca*) and Sweet Vernal-grass (*Anthoxanthum odoratum*). South-facing slopes have sparser vegetation, often dominated by mosses and lichens.

Where the dune surface is damaged, for example by Rabbit burrowing, trampling or wind-erosion, colonisers of bare ground are found. Examples include Common Stork's-bill (*Erodium cicutarium*), the Nationally Scarce and paler-flowered Sticky Stork's-bill (*Erodium lebelii*) and the hybrid between them (*Erodium* x *anaristatum*) which can be recognised by its intermediate flowers, vigour and lack of seed pods. Although frequent on the Sefton Coast, this hybrid is uncommon nationally, being confined to dunes in Wales and South Lancashire. Portland Spurge (*Euphorbia portlandica*), Bugloss (*Anchusa arvensis*) and Hound's-tongue (*Cynoglossum officinale*) are other members of this plant community.

Among the most fascinating plants of the bare patches are the dune-annuals. These tiny species from several unrelated families have all evolved the same strategy for overcoming the problem of summer drought (Table 2). Their seeds germinate during the autumn rains and the small plants survive the winter, ready to grow rapidly and flower as temperatures rise in the spring. By the time the soil begins to dry out in May, they have shed their seeds and then die down completely. A particularly fine selection of these annuals can be seen on the grasslands around the Lifeboat Road carpark, Formby.

Wild Thyme, Lifeboat Road, Formby.

Grey Hair-grass, Southport & Ainsdale Golf Course.

English name	Scientific name	Plant family
Hairy Bitter-cress	*Cardamine hirsuta*	Cabbage
Common Whitlowgrass	*Erophila verna*	Cabbage
Thyme-leaved Sandwort	*Arenaria serpyllifolia*	Pink
Sea Mouse-ear	*Cerastium diffusum*	Pink
Little Mouse-ear	*Cerastium semidecandrum*	Pink
Rue-leaved Saxifrage	*Saxifraga tridactylites*	Saxifrage
Early Forget-me-not	*Myosotis ramosissima*	Borage
Common Cornsalad	*Valerianella locusta*	Valerian
Spring Vetch	*Vicia lathyroides*	Pea
Early Hair-grass	*Aira praecox*	Grass
Sand Cat's-tail	*Phleum arenarium*	Grass
Dune Fescue	*Vulpia fasciculata*	Grass

Table 2. Common dune-annuals on the Sefton Coast dunes.

A rare fixed-dune plant, Glabrous Rupturewort (*Herniaria glabra*), was discovered by Audrey Franks in 1980 on a sandy roadside verge at Kenilworth Road, Ainsdale. In 1998, Dan Wrench found it growing in similar conditions at Westcliffe Road, Southport. As a native species, Glabrous Rupturewort is largely confined to eastern England but its origin in Sefton was probably as a garden-escape. Due to its low-growing stature, it survives mowing very well and seems to be spreading.

The oldest fixed-dunes have had most of their lime washed out by rainfall, with the result that the soil has become more acid. This is reflected in the plant community, grasses such as Common Bent (*Agrostis capillaris*) and Sheep's Fescue (*Festuca ovina*) becoming more frequent. Particularly colourful constituents of these older dunes are the delicate Harebell (*Campanula rotundifolia*) and fragrant Wild Thyme (*Thymus polytrichus*), the latter occurring sparingly along the coast.

Southport & Ainsdale Golf Course has some of the oldest remaining dunes and here the Grey Hair-grass occurs in the roughs. Nationally Rare and one of our most beautiful grasses, it is mostly found in East Anglia. As this species was first seen on the Sefton Coast in 1919, it seems unlikely to have been introduced and is accepted as native here in the *New Atlas of the British & Irish Flora*. A survey of the golf course in 2007 showed that Grey Hair-grass has increased over the last decade with an estimated 10,000 plants, which may now represent the largest colony in Britain outside North Norfolk and the Channel Isles.

Also found mostly on the more acid sands, the rare Smooth Cat's-ear

Smooth Cat's-ear, Ainsdale NNR.

(*Hypochaeris glabra*) is a diminutive member of the Dandelion family with tiny yellow flowers which only open in full sun during the morning and early afternoon. It is therefore easily overlooked; in fact, there had only been two sightings on the dunes in 50 years until 2007. In that summer, the plant turned up in spectacular abundance – I counted over 5200 individuals at 28 localities, covering 2.4ha. This is a species which is rapidly declining nationally and is officially listed in the Red Data Book as "Vulnerable" which means it is facing a high risk of extinction in the wild.

DUNE GRASSLAND

Tall grassland communities occur extensively on the Sefton Coast, having noticeably increased in recent decades around slacks, scrub patches and on former agricultural land, as well as in some areas of fixed-dune. In addition to the common grasses, such species as Quaking-grass (*Briza media*) and the very striking Golden Oat-grass (*Trisetum flavescens*) appear occasionally, while stands of Downy Oat-grass (*Helictotrichon pubescens*) are a feature of Royal Birkdale Golf Course and Hightown dunes. An even rarer species, Wood Small-reed (*Calamagrostis epigejos*), was found by Peter Gateley in 1997 on West Lancashire Golf Course and at Birkdale. There is a sizeable

Cowslips, Altcar Rifle Range.

patch of this striking grass west of Sands Lake, Ainsdale. It is very invasive on the Dutch dunes but, fortunately, not here as yet. Large herbs are also a feature of these grasslands. They include the tall members of the carrot-family (umbellifers), Wild Parsnip (*Pastinaca sativa*) and Wild Carrot (*Daucus carota*), these being the original parents of the garden vegetables, and also Burnet Saxifrage (*Pimpinella saxifraga*) which is particularly common on the National Trust's Larkhill Meadow.

The most interesting area of damp grassland is on Altcar Rifle Range where carefully timed mowing maintains a short turf rich in orchids and, in a small area, many Cowslips (*Primula veris*). The ranges now support the largest population of Green-winged Orchids in the northwest of England. From its first discovery in 1984, Steve Cross estimates there are now between 15,000 and 25,000 flower-spikes annually. There are even more marsh-orchids here, comprising mainly Southern, Early (*Dactylorhiza incarnata*) and Northern Marsh-orchids and many hybrids, some of which have still to be identified. Adding to the vistas of red and purple are great stands of Ragged Robin (*Lychnis flos-cuculi*), providing one of the great botanical spectacles on the coast. Other orchids on the range estate include Bee, Pyramidal, Dune Helleborine (*Epipactis dunensis*), Green-flowered Helleborine (*E. phyllanthes*), Marsh Helleborine (*E. palustris*), Common Spotted (*Dactylorhiza fuchsii*) and Common Twayblade (*Listera ovata*).

Also interesting are the Hightown Meadows, an area of damp, former

Green-winged Orchids, Altcar.

agricultural land between the dunes and the railway line. A wide range of grassland plants here includes a long-established but now sadly declining population of Northern Marsh-orchids. A similar meadow just east of the railway is more acidic and here the uncommon Narrow Buckler-fern (*Dryopteris carthusiana*) and the spectacular Royal Fern (*Osmunda regalis*) can be found, together with Heath Milkwort (*Polygala serpyllifolia*).

DUNE-SCRUB

Dune-scrub is a natural stage in sand-dune succession, occurring mainly in older parts of the fixed-dunes where increasing shelter and improving soil conditions allow woody plants to become established. On the Sefton Coast, dune-scrub is surprisingly rich in species, the Inventory listing 138 vascular plants primarily associated with this habitat (12% of the dune flora). The downside is that a high proportion of these shrubby species is non-native, including many garden-escapes. Since the 1950s, dune-scrub has increased enormously in extent. The reasons for this, the problems it poses and the management solutions are discussed in Chapter 6.

One of the main components of the dune-scrub, especially in the damper areas, is willows. Our dunes are one of the richest parts of the country for these plants, 29 different ones having been recorded. This compares with 24 lowland willows in the whole of Cumbria. An area of about 200 x 200m at Lifeboat Road, Formby supports no less than 15 kinds. Fourteen of our

Green-beach Alder.

willows are hybrids and several are nationally rare (see section below on "Hybrids"). However, their origin was not always natural, several having been planted in the past for basket-making and other domestic purposes.

Freshwater seepage along the inner edge of the Green Beach has encouraged the recent development of Alder scrub from seeds germinating along old strand-lines. Richard Thomas counted over 3000 of these bushes in 2005, estimating that they were up to seven years old in the north and around two years in the southern sector. Despite the stunting effects of salt-laden winds, the older stands now exceed 3m in height and form an important "wet woodland" habitat, extremely rich in invertebrates. Inger Kristiansen found that the Alder covered an area of 1.85ha (4.5 acres) in 2008. This tree is not known to have any tolerance to salt-water, yet the woodland is flooded by high spring-tides several times a year.

DUNE-HEATH

On the eastern edge of the dune system and on areas of links sand blown off the dunes in past centuries, dune-heath prevails, much of it developed fairly recently on golf courses or former agricultural land. This is a rare habitat nationally and a priority for protection in the European Habitats Directive.

Peter Gateley's 1993/94 survey mapped 154ha of what he broadly defined as dune-heath, compared with only about 200ha in total on all English dune systems. The largest block is now within the Freshfield Dune Heath

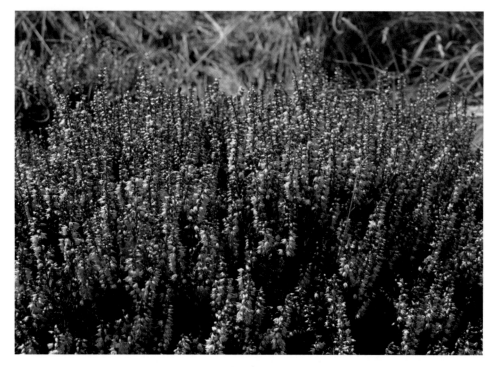

Heather.

Bird's-foot at Freshfield Dune Heath.

Nature Reserve on the southern boundary of Woodvale Aerodrome. Other representative examples, also accessible to the public, are on the Montagu Road triangle, Freshfield and on National Trust property at Larkhill Lane. These areas contain large stands of Heather (*Calluna vulgaris*), which puts on a wonderful show when flowering in late summer, and also much Gorse (*Ulex europaeus*), seen at its best in spring. The most frequent associates are Common Bent, Sand Sedge (*Carex arenaria*), Wavy Hair-grass (*Deschampsia flexuosa*), Sheep's-fescue, Cat's-ear, Wood-rush (*Luzula* spp.) and Sheep's Sorrel (*Rumex acetosella*). With a little more effort, the acid-tolerant Heath-grass (*Danthonia decumbens*) and Mat-grass (*Nardus stricta*) can be found, while in damper hollows, the equally characteristic Heath Rush (*Juncus squarrosus*) occurs. One of the few uncommon plants on the dune-heath is a diminutive member of the pea family, Bird's-foot (*Ornithopus perpusillus*), while a patch of Crowberry (*Empetrum nigrum*), a new plant for the dunes, was found at Woodvale during Peter Gateley's survey. He has since discovered two more patches on Formby Ladies Golf Course.

DUNE-SLACKS

Slacks are arguably our most precious habitat for dune plants; certainly, a significant proportion of the rarities occur in wet sites and diversity is also high. For example, I recorded 213 vascular plants during my 2003 survey of 26 small slacks in the Birkdale frontal dunes. The number of plants had increased by 43% compared with a similar survey twenty years earlier. Several factors seemed to be responsible for these changes. First most of the slacks had undergone succession, as described in Chapter 2, from an open vegetation type, typical of young slacks, to a more mature, heavily vegetated condition. This resulted in colonisation by new species. Secondly, the habitat in eight slacks had been diversified by the excavation of scrapes for Natterjack Toads, providing ideal conditions for a variety of aquatic plants which were not present before. Finally, control of Sea Buckthorn, from the mid-1990s onwards, had reversed the trend towards the domination of the slacks by scrub, allowing more opportunities for low-growing plants. These include several rarities, including Flat-sedge (*Blysmus compressus*), which is reckoned to be one of the most rapidly declining plants in Britain. Happily, this is not the case on the Sefton Coast where my 2008 survey shows a marked increase in the number of colonies over the past 20 years.

Although many slack plants are typical of freshwater-marsh communities, there are also some maritime species more usually associated with salt-marshes.

Examples in the Birkdale slacks include Sea Club-rush (*Bolboschoenus maritimus*), Sea Milkwort, Saltmarsh Rush (*Juncus gerardii*) and Sea Arrowgrass (*Triglochin maritimum*). Several of these have declined since 1983 and four maritime plants, Sea Aster (*Aster tripolium*), Sea Plantain (*Plantago maritima*), Common Saltmarsh-grass and Common Cord-grass, have disappeared. This, again, is attributable to maturation of the slack vegetation.

Looking more generally at slack plants, one of the most abundant is Creeping Willow, occurring here mostly as the very variable coastal variety *argentea* which usually grows close to the ground but can sometimes reach 3m in height. E. D. McNicholl (1883) describes it thus:

> "*The little grey salix the foliage of which often shines with silvery lustre.... Very pretty in the early summer, are the innumerable catkins; and a few weeks later, when the ripe cottony seed is discharged, most curious is the spectacle, the quantity being so vast as often to be gathered up by the eddying wind in what, but for the season, might be taken for snow drifts.*"

The plant usually appears within about 10 years of a slack being formed and may eventually become dominant, little other than mosses growing under its dense canopy in the oldest wet-slacks. Creeping Willow can also spread onto the lower parts of fixed-dunes. Rabbits browse the stems and seem to be able to control it to some extent, at least in younger slacks.

Some slack plants seem to be closely associated with Creeping Willow. One such is Yellow Bird's-nest, a strange looking, biscuit-coloured plant with scale-like leaves, lacking green pigment (chlorophyll). It obtains its food from the breakdown of soil organic matter, via the activity of a fungus in its roots. Another is one of our specialities, Round-leaved Wintergreen (*Pyrola rotundifolia* ssp. *maritima*), which occurs mainly on west-coast dunes from Cumbria to Devon. Its beautiful, waxy, white, saucer-shaped flowers and dark-green, glossy leaves, the latter persisting through the winter, can be found in suitable habitat throughout the dune system.

A slack plant that has attracted attention since the early 19th century is Grass-of-Parnassus. Not a grass at all, but related to the saxifrages, its starry, white flowers decorate the slacks in late summer. It often occurs in masses around the dryer fringes of wet-slacks, looking from a distance like a tidemark. Writing in 1883, E. D. McNicholl observes:

> "*There are localities among the sandhills beyond Birkdale where, in favourable seasons, so vast is the quantity of the Parnassia that the whiteness of the ground may be compared to that given by daisies to the sward.*"

Top, Flat-sedge. *Middle*, Creeping Willow with cottony seed. *Bottom*, Round-leaved Wintergreen.

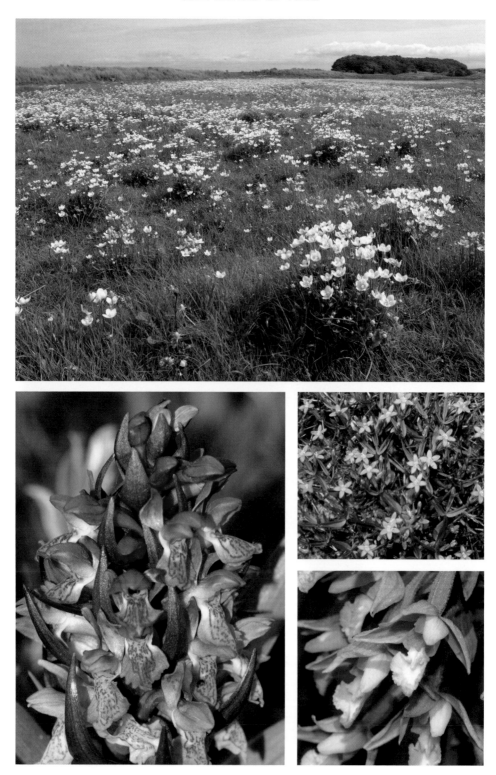

An even earlier description comes from P. Whittle (1831):

> *"But we have another floral beauty to mention – it is the exquisite grass of Parnassus, with its innocent, modest and unassuming petal argent, beautifully pencilled with lutea (yellow); this pretty flower grows luxuriantly here."*

Grass-of-Parnassus is declining nationally and has recently been listed as "endangered" in Lancashire. However, the plant remains abundant in many Sefton Coast dune slacks, its flowering at Cabin Hill NNR resembling a summer snow-fall. It has also colonised Birkdale Green Beach since 2004.

The marsh/spotted-orchid group is particularly associated with slacks. Four species occur here, together with hybrids. By far the commonest is the Early Marsh-orchid, most plants being of the brick-red, coastal sub-species *coccinea*, which is endemic to Britain and Nationally Scarce. Described as looking like "*a fat little hyacinth*", this plant can appear in colonies numbering thousands. Much less frequent, but apparently increasing on the coast, are the magenta spikes of the Southern Marsh-orchid, sometimes reaching heights of 50cm. Its close relative, the Northern Marsh-orchid, is shorter and darker and has a more restricted distribution in the dunes. Its largest populations, currently, occur in a Royal Birkdale Golf Course slack and on Altcar Rifle Range. Belying its national status, the least numerous member of this group on the Sefton Coast is the Common Spotted-orchid.

Another orchid of the slacks is the Marsh Helleborine, which is widespread and is often seen in spectacular numbers. Unlike most helleborines, it has very attractive flowers, but even lovelier is its rare pallid variety *ochroleuca*. The last orchid to mention here is the Fragrant (*Gymnadenia conopsea*) which I have only seen in two places, on Ainsdale NNR and Formby Golf Course, but not since 1988. It may yet be rediscovered

Younger slacks are favoured by lower-growing species like the Bog Pimpernel whose tiny pink flowers can form extensive carpets. Of a similar stature is Knotted Pearlwort (*Sagina procumbens*), with small star-shaped, white flowers. This puts on a great show at the Birkdale Green Beach. These two plants are often accompanied by yellowish-green tufts of Small-fruited Yellow-sedge (*Carex viridula* ssp. *viridula*) and the Seaside Centaury (*Centaurium littorale*), here near its northern limit on the west coast and rated Nationally Scarce. The closely related Lesser Centaury also likes recently-formed slacks and, until a few years ago, was hard to find in the dune system. However, there are now

Opposite page: Clockwise from top, Grass-of-Parnassus at Cabin Hill. Lesser Centaury. Pale form of Marsh Helleborine. Coastal form of Early Marsh-orchid.

Japanese Rose.

great drifts of this regionally notable plant on the Green Beach together with another species of conservation importance, the Strawberry Clover, so-called because its (inedible) seed-heads resemble pale-pink strawberries.

The distinctive Yellow Bartsia has a restricted distribution on the coast, being pretty well confined to the Cabin Hill and Ainsdale NNRs. It seems to respond well to winter grazing and, in 2004, about 20,000 flower-spikes were counted in the dune restoration area at Ainsdale.

The most restricted of our slack plants is the Black Bog-rush (*Schoenus nigricans*). This occurs as a single plant at Birkdale Sandhills. When the late Neil Robinson and I found it in 1977 as a new vice-county record, it formed a clump 30cm across. By 2005, it was over 1m in diameter. As its nearest locality is in North Wales, there has been speculation that this plant may have been introduced, though by whom, why and when is a mystery.

ALIENS

The Inventory of Vascular Plants shows that 404 non-native or introduced native plants have been recorded in the sand-dunes, just over 35% of the total number. Some of these introductions have had a major impact on the ecology of the dunes; fortunately, however, most have been relatively benign. The problems associated with the planting of conifers, Sea Buckthorn and White and Balsam

Intermediate Evening-primrose.

Poplars have already been referred to. These were, of course, deliberate introductions, whereas most exotics have appeared as accidental releases from cultivation, as garden-escapes or through trading links with other countries.

Other invasive species which may pose problems include Japanese Knotweed (*Fallopia japonica*) and an even larger relative, Conolly's Knotweed (*Fallopia x bohemica*). These are quite widespread along the coast, especially on roadsides. Another familiar garden-escape is the rampant Russian Vine or "mile-a-minute plant" (*Fallopia baldschuanica*), fortunately only found in a few places as yet. Similarly, the viciously spiny Japanese Rose (*Rosa rugosa*), with either pink or white flowers, is not a significant problem at present. However, it is said to be very invasive on the dunes of the Frisian Islands in Germany, where it was planted to assist sand stabilisation, and can reach 100% ground-cover. It is certainly spreading here and is one to keep an eye on.

Smaller garden-escapes include Snow-in-summer (*Cerastium tomentosum*) and White Stonecrop (*Sedum album*), both of which infest the dunes at Kenilworth Road, Ainsdale and turn up in lesser quantity elsewhere. The dreaded New Zealand Pigmy-weed (*Crassula helmsii*), an aquarists' introduction, has invaded ponds and other wetlands all over the country. Fortunately, it has been found only on about five occasions on the Sefton Coast and has been rigorously controlled with herbicides or, as in one case, by filling in the pond!

To the general public, the most familiar member of the alien flora is the Evening-primrose, sometimes known as the Dusk-beacon because the flowers

Hybrid Bluebell.

open in the evening and are pollinated by moths. Their gaudy yellow flower-spikes, a metre or more high, adorn the older mobile and fixed-dunes from July to the first frosts. There are four main types on the coast, though most plants are probably hybrids.

Evening-primroses mostly come from the Americas and were first grown in Britain as ornamental plants in 1629. Their roots were sometimes eaten but cultivation for the familiar medicinal oil came much later. One suggestion is that the Sefton Coast plants were introduced in ballast from ships importing cotton to Liverpool in the 19th century, the first record for the dunes being in 1801. Despite their abundance, Evening-primroses do not constitute a threat to the dune flora.

One group of introductions that does particularly well on the sand-dunes

is the spring bulbs. This is because the well-drained soils and summer drought suit their lifestyles. From February to May, you can find an amazing diversity of well-known garden bulbs. Most striking are the Daffodil cultivars (*Narcissus*), which seem to occur in greater variety in the dunes than can be found in nearby gardens and are often more floriferous. Also quite numerous are Glory-of-the-snow (*Chionodoxa forbesii* and *C. sardensis*), Siberian Squill (*Scilla siberica*) and the Garden Grape Hyacinth (*Muscari armeniacum*). In addition, there are a few less well-known species like the delicate Spring Star-flower (*Tristagma uniflorum*), found for the first time in 2004 in six different places in the dunes. The early-flowering bulbs are soon replaced by Garden Tulips (*Tulipa gesneriana*) and then by white clumps of Star-of-Bethlehem (*Ornithogalum angustifolium*). In more shady places, Lily-of-the-valley (*Convallaria majalis*) can be abundant. Bluebells also put on a fine display and, although the native species *Hyacinthoides non-scripta* does occur on the coast, most are Spanish Bluebells (*Hyacinthoides hispanica*) or hybrids (*Hyacinthoides* x *massartiana*), which have various colour-forms.

Summer drought also favours succulent plants, such as the spurges, the most widespread in the dunes being the Cypress Spurge (*Euphorbia cyparissias*), while a large colony of Twiggy Spurge (*Euphorbia* x *pseudovirgata*) has been known at Hightown for over 30 years. Another long-established alien is the Tuberous Pea (*Lathyrus tuberosus*), whose main population on the coast, at Ravenmeols, was first recorded in the 1920s. This species may have escaped from cultivation because it has edible tubers and was sold in Dutch markets in the early 19th century.

That familiar, berry-bearing, garden shrub, the Cotoneaster, spreads into the dunes through birds eating the berries. Sixteen different kinds have been identified here, often a long way from the nearest gardens.

Not surprisingly, there is a close relationship between the frequency of introduced plants and a site's proximity to housing. Table 3 shows the percentage of alien vascular plants on six sand-dune sites that I have intensively studied in recent years. The lowest proportion of non-natives (13%) is found at Birkdale Green Beach, which is the furthest site from residential development, followed by 17% on the dunes to the west side of Southport Marine Lake. Queen's Jubilee Nature Trail (20%) and Crosby Sand-dunes (22%) are separated from houses by Victoria Park and Crosby Marine Park respectively. Falklands Way dunes come next with 36% aliens, this site being bounded by the Southbeach Park estate. Finally, Kenilworth Road dunes, which are surrounded on three sides by housing, support the largest proportion of introduced plants (42%).

Garden refuse, Ainsdale dunes.

Site name	Area (ha)	Total vascular plants	No. of introductions	% introduced
Birkdale Green Beach	62	267	33	13
Southport Marine Lake dunes	6	176	30	17
Queen's Jubilee Nature Trail	9	229	45	20
Crosby Sand-dunes	8.5	141	31	22
Falklands Way	21	344	125	36
Kenilworth Road dunes	6	243	103	42

Table 3. Number and proportion of introduced vascular plants on five sand-dune sites.

It is not hard to find a reason for these trends. The deliberate dumping of garden refuse is common all along the coast. Thus, Sally Edmondson's recent survey of the National Trust's boundary with housing at Formby revealed over 60 tips of garden waste on National Trust land! She writes: "*Gardeners who take a pride in producing beautiful surroundings to their houses can pose a very real threat to the quality of semi-natural habitats on the other side of their garden fence.*"

The same is true almost everywhere. Not only does this fly-tipping lead to alien introductions, but it also adds nutrients to dune soils, resulting in the loss of typical sand-dune plants and their replacement by nutrient-

Rare hybrid willow *Salix* x *doniana*

demanding species, such as Common Nettle (*Urtica dioica*). It goes without saying that dumping garden-waste is illegal. Controlling it, however, is another matter and requires education and an increased respect for the natural environment.

HYBRIDS

A greater interest in hybrid plants in recent years led to no less than 111 being recorded for the sand-dune system by 2008. Many groups produce hybrids quite readily, some being very rare and of conservation interest. For example, three of the 14 hybrid willows on the Sefton Coast are nationally rare. These are *Salix* x *friesiana* (Creeping Willow x Osier *S. viminalis*), which occurs quite widely in the dunes, the endemic triple hybrid *Salix* x *angusensis* (Creeping Willow x Osier x Grey Willow), only a few bushes of which have so far been identified, and *Salix* x *doniana* (Creeping Willow x Purple Willow *S. purpurea*), represented by about 20 individuals. Its particularly striking red-tinged catkins in spring, bright red stems and small, bluish leaves would make it an attractive garden plant.

Two other very rare hybrids both involve the Baltic Rush as one of the parents, the others being Soft Rush (*Juncus effusus*) and Hard Rush (*Juncus inflexus*). Baltic x Hard Rush is endemic to Britain and has been recorded

Mike Wilcox studying the hybrid Baltic Rush at Hightown.

twice on the Sefton Coast, its only other locality being Lytham St. Annes LNR, Lancashire. The much smaller Baltic x Soft Rush hybrid (*Juncus* x *obotritorum*) is known in Britain only from the Sefton Coast, where it has been found three times, and Orkney. Both these hybrids have been cultivated and transplanted to wetlands along the coast to save them from extinction.

BRAMBLES

Depending on your point of view, brambles or blackberries (*Rubus*) are either a source of succulent fruit or the cause of tripping and nasty scratches. Surprisingly, around 35 different kinds have been identified on the dune coast by local expert Dave Earl. Common species include the heavily-armoured *R. tuberculatus*, while *R. nemoralis* is one of the best for flavour. Apart from the familiar Dewberry (*R. caesius*) and *R. tuberculatus*, most species are associated with woodland, dune-scrub or heathland rather than the open dunes and several are of conservation interest. Thus, *R. bartonii*, a bramble usually associated with North Wales, is abundant at Formby. Also here is *R. subtercanens*, a species whose British distribution is mainly centred on the lowlands north of Liverpool. Occurring locally in the pinewoods, *R. echinatus* is most frequent in central and southern England. In contrast, *R. latifolius* is a northern bramble which reaches its southern limit in Britain on Hesketh Golf Course.

The rare moss *Bryum warneum* at Birkdale Green Beach.

Freshfield Dune Heath is particularly important for brambles, with thickets of *R. bertramii, R. errabundus, R. wirralensis and R. warrenii,* the latter named after a Cheshire botanist. Near the Formby Bypass, *R. sprengelii* occurs together with Wheldon's Bramble at the southern limit of this presently undescribed Lancashire speciality.

MOSSES AND LIVERWORTS

The Sefton Coast is claimed to be the most important dune system in Britain for mosses and liverworts, collectively known as Bryophytes. Two of our mosses are included in the UK Biodiversity Action Plan, while a liverwort, Petalwort (*Petalophyllum ralfsii*), is listed under the Bern Convention and the EU Habitats Directive and is specially protected under the Wildlife & Countryside Act 1981. Petalwort resembles a tiny lettuce and is so small that, when I was shown some, I found I needed reading glasses to see it at all! detailed survey work since the mid-1990s has found 47 populations in dune-slacks in the Ainsdale/Birkdale area, where it requires damp sand and few competing plants.

Our two endangered mosses are Long-leaved Thread-moss (*Bryum neodamense*) and Warne's Thread-moss (*Bryum warneum*), both inhabiting

similar places to Petalwort. Several colonies of Long-leaved Thread-moss have been found at Ainsdale but the real highlight was the discovery in 2001, by David Holyoak, of spectacular populations of Warne's Thread-moss at Birkdale Green Beach. He writes *"The total amount here thus exceeds the combined total population known from all other localities in England and Wales by several orders of magnitude."*

While looking for *Bryum warneum*, Dr Holyoak found another rare moss, *Bryum dyffrynense*, in similar habitat on the Green Beach. This was described as a new species to science in 2003, being named after sand-dunes in central Wales where it was first discovered.

STONEWORTS

Among the most severely threatened group of plants in the UK, Stoneworts (Charophytes) are complex algae that resemble higher plants in appearance. They are supported by an external skeleton of lime (calcium carbonate) which is often branched making them look rather like under-water horsetails. These plants are exceptional indicators of water quality, being unable to tolerate pollution from phosphorus or nitrogen.

The Sefton Coast is of European importance for Stoneworts; 12 species have been found in the area and three of these are notable, though only five have been seen in recent years. The Lesser Bearded Stonewort (*Chara curta*) is the rarest, being listed as Nationally Scarce and confined to only 30-35 British sites. Opposite Stonewort (*Chara contraria*) and Clustered Stonewort (*Tolypella glomerata*) are also Nationally Scarce.

They all live in calcareous dune pools and slacks, mainly scrapes dug for conservation purposes in the 1970s and 1980s. Several of the older scrapes are now densely colonised by tall-growing plants which may be out-competing the stoneworts.

SOME SPECIAL PLANTS

ISLE OF MAN CABBAGE

The distinctive Isle of Man Cabbage, with its bright-yellow, four-petalled flowers and grey-green deeply divided leaves, can reach up to 2m across. It is Nationally Scarce, being mainly found near the sea on open sand-dunes in north-west England, south-west Scotland and South Wales. One of few

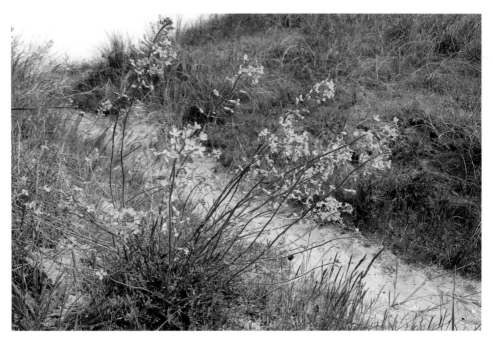

Isle of Man Cabbage at Blundellsands.

British endemics, this plant is the subject of a Species Action Plan in the North Merseyside BAP.

On the Sefton Coast, the Isle of Man Cabbage has been found growing wild in only three places: Blundellsands, Birkdale frontal dunes and the dunes west of Southport Marine Lake. The first of these colonies was long-established but its habitat was progressively destroyed by housing development until, by 1989, the plant was confined to a sandy footpath at Park Drive. The Birkdale site, which I discovered in 1983, was an eroded hollow recently planted up with Lyme-grass. The cabbage population here increased from 55 individuals in 1983 to 168 in 1986, but then declined to extinction by 1993, probably due to maturation of the vegetation. In 1989, Richard Hall and Deborah Nissenbaum found the Marine Lake colony, consisting of 347 plants. By 1997, this population had increased to 874, but another count in 2004 revealed only 281 individuals.

The original Blundellsands colony was lost in 1992 when the footpath was top-soiled and turfed over. However, a rescue operation organised by the Lancashire Wildlife Trust and Sefton Ranger Service (now Coast & Countryside Service) moved about 385 small plants to two ostensibly suitable sand-dune sites nearby, at Hall Road and Crosby Marine Park. Since then, I have monitored the transplants at one or two-year intervals. After two years, in 1994, only 29 survivors were found, a mortality of 92.5%. However, most

Baltic Rush, Birkdale Sandhills.

years since then have seen an increase in both the size of the populations and the areas of habitat colonised. By 2007, there were 1323 plants, while the total area occupied by Isle of Man Cabbage plants had increased fourteen-fold; quite a success story!

This species seems to require rather thinly vegetated dunes with plenty of bare sand. At both transplant sites and at Southport Marine Lake these conditions are maintained by moderately heavy pedestrian trampling and Rabbit grazing; there appears to be plenty of suitable habitat for future spread.

BALTIC RUSH

This medium-sized, patch-forming rush is surprisingly easy to recognise in the field due to its stiff, glossy, dark-green shoots and chocolate-brown flower-heads. In Britain, Baltic Rush is a Nationally Scarce plant of sand-dune slacks and other damp areas in sand, mud or peat near the sea. It is largely confined to the north and north-east coasts of Scotland and the Hebrides, the only English location being a small area of the Birkdale Sandhills where it was discovered by R.S. Adamson in 1913. The rush had disappeared from Adamson's site by 1944 but, fortunately, had already spread to new ones. In 1969/70, Clive Stace found it in three Birkdale slacks but predicted its extinction *"in the fairly near future"*.

Luckily, this did not happen and the rush actually prospered in the 1970s.

When I surveyed it in 1981/82, the plant had spread to 10 slacks at the northern end of Birkdale Sandhills. The Baltic Rush continued to do well at Birkdale during the 1980s and early 1990s but, by 1997, it was clearly in decline at its northernmost sites, due to invasion by Sea Buckthorn and heavy Rabbit-grazing of its shoots.

I conducted another thorough survey in the summer of 2004. This revealed that the plant had indeed disappeared from six slacks at the northern end of the Birkdale frontal dunes, and from one site on the Royal Birkdale Golf Course, but had colonised three new slacks and the Birkdale Green Beach to the south of its previous range. Despite the losses, the area occupied by the rush had increased 34% since 1982. Particularly encouraging was the discovery of 12 small patches on the Green Beach, all of which are of recent origin. This supports a conclusion of the first study that the Baltic Rush is a good coloniser of young, sparsely vegetated wet-slacks and may then persist for some years, before declining as the habitat becomes dryer and more heavily vegetated. The availability of so much potentially suitable habitat on the Green Beach (five more patches were found there in 2006-08) should ensure the future of this Sefton Coast speciality for years to come.

SHARP CLUB-RUSH

Sharp Club-rush (*Schoenoplectus pungens*) is a Nationally Rare UK Species of Conservation Concern which has only been recorded from two British localities; in Jersey, where it has not been seen since the early 1970s, and the Sefton Coast sand-dunes. Here, it was originally collected in 1909 by W.G. Travis at Massams Slack in what is now Ainsdale NNR. Travis concluded that the colony was native but this has been debated ever since and it is possible that the plant was introduced, as botanists of that period were inclined to do this sort of thing without telling anyone. The 2002 *New Atlas of the British & Irish Flora* describes its origin at Ainsdale as "*obscure*" and maps the plant as an alien here.

The colony at Massams Slack was extinct by 1978 but had already been taken into cultivation and transplanted to a pond near the reserve office, where it survived to the early 1990s. In 1990, using cultivated stock, Dave Simpson transplanted it again to four sites in the Birkdale frontal dunes where it flourished. Then, in 1999, Dan Wrench came across a patch of Sharp Club-rush on Birkdale Green Beach where it had obviously spread naturally from one of the transplant sites. In June 2004, I conducted a detailed monitoring exercise at Birkdale, finding five discrete colonies of the plant with a total area of about 173 m^2, the largest patch being that on the Green Beach (90m^2).

Top left, Sharp Club-rush, Birkdale Sandhills.
Bottom left, Dune Helleborine, Ainsdale NNR.
Bottom right, Early Sand-grass, Southport dunes.

DUNE HELLEBORINE

A rather unattractive-looking but fascinating orchid, the Dune Helleborine has recently been reclassified as a full species instead of as a variety of the Narrow-lipped Helleborine (*Epipactis leptochila*). It is Nationally Rare and endemic to Britain, being restricted to dunelands in Anglesey, Merseyside, Lancashire and Cumbria.

On the Sefton Coast, the Dune Helleborine often grows with the superficially similar Green-flowered Helleborine (*Epipactis phyllanthes*), the latter having drooping flowers that hardly open. Peter Gateley surveyed both species in 1988 and 1992, recording an increase of Dune Helleborine from 870 to 1911 flower-spikes and of Green-flowered Helleborine from 263 to 624. He noted that the Dune Helleborine was particularly associated with Creeping Willow; it was also found under deciduous trees and shrubs, in pine plantations, on open fixed-dunes and in such disturbed areas as along fence-lines and the edges of footpaths.

Threats to the future of the Dune Helleborine are considered to be the over-stabilisation of dunes, including the development of tall-grass swards, scrub encroachment and soil enrichment. Although there is no evidence of a decline in recent years, another detailed survey of this special plant was long overdue and funding was at last obtained to organise one in summer 2008. Around 30 volunteers led by Pauline Michell covered most of the dune area in July and August. Overall, 5487 Dune and 1343 Green-flowered Helleborines were found, a big increase on previous surveys, though this may be due in part to better coverage. The largest populations were found on Ainsdale Sand Dunes NNR and the National Trust estate. The wet summers of 2007 and 2008 seem to have suited the helleborines, especially in the drought-prone pine plantations where remarkable numbers were counted.

EARLY SAND-GRASS

By far the rarest of our dune annuals and officially listed as Nationally Rare, the Early Sand-grass was discovered here at Southport Marine Lake as recently as 1996 by Dave Earl and Joyce Buckley-Earl. Being only about an inch (2cm) tall, it is said to be the smallest grass in the world; this fact, together with its early flowering season in February and March, may be why it has not been found before on the Sefton Coast.

I mapped its distribution on the Marine Lake dunes in 1999; five years on, in March 2004, the colony had increased in area by 47%. Most of the population is associated with a low dune ridge which forms a "bulge"

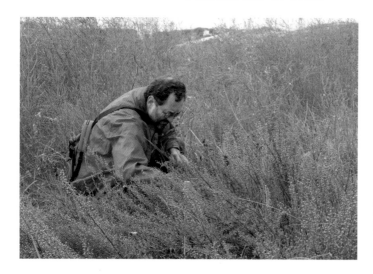

Prof. Joan Valles studying Dune Wormwood at Crosby dunes.

jutting out into the Marine Lake on its western side. The plant appears to like a very open, sparsely vegetated surface, often on the edges of sandy, informal footpaths. At Southport, the habitat is maintained by a slow rain of blown sand from the adjacent foreshore together with locally intense human trampling and moderate Rabbit-grazing. Since there is plenty more apparently suitable habitat nearby, it may continue to spread.

DUNE WORMWOOD

Another great rarity, Dune Wormwood (*Artemisia campestris* ssp. *maritima*) was discovered by Mike Wilcox and me at Crosby Sand-dunes in 2004. It was thought to be a new plant for Britain. This is a different sub-species from the Nationally Rare native Field Wormwood (*Artemisia campestris* ssp. *campestris*) which occurs mainly in Breckland. Our plant could possibly have been introduced in a seed mixture used to stabilise the area around a nearby pumping station. However, the eminent botanist, Eric Clement, did not agree, proposing that sub-species *maritima*, which inhabits coastal sand-dunes from southern Spain to Belgium, should be considered native in Britain. He also recommended the new English name "Dune Wormwood" which has now been adopted by the Botanical Society of the British Isles. The fact that this plant has been also been found growing on a dune system in South Wales lends further support to it being native. By September 2007, the single specimen at Crosby had been joined by three younger individuals. Joan Valles, the Professor of Botany at Barcelona University, made a special visit to see this small population in September 2008.

CHAPTER FIVE

DUNE ANIMALS

MAMMALS

Although about 21 land mammals have been recorded on the Sefton Coast in recent decades, as most are nocturnal, a casual visitor to the dunes will not see much more than the ubiquitous Rabbit. However, a look out to sea at high-tide may be rewarded by a sighting of the Grey Seal (*Halichoerus grypus*), easily recognised by its "Roman" nose. More rarely, a Harbour Porpoise (*Phocoena phocoena*) may break the surface, these small whales being occasionally washed up dead on the beaches. Other recorded cetacean strandings on the Sefton Coast are listed in Table 4, the most recent being an adult Minke Whale which attracted lots of sightseers to Ravenmeols beach in early September 2008.

Species	Locality	Date
Fin Whale (*Balaenoptera physalis*)	Seaforth	16th July 1985
Minke Whale (*Balaenoptera acutirostrata*)	Crosby	26th May 1948
	Ainsdale	4th July 1954
	Ravenmeols	30th August 2008
Bottle-nose Dolphin (*Tursiops truncatus*)	Birkdale	23rd September 1942
	Seaforth	15th June 1954
	Ainsdale	12th September 1961
	Ainsdale	9th August 1963
	Southport	10th October 1963
	Ainsdale	8th September 1964
	Formby	26th October 1967
Bottle-nose Whale (*Hyperoodon ampullatus*)	Ainsdale	23rd October 1942

Table 4. Recorded strandings of identified cetaceans, apart from Harbour Porpoise, on the Sefton Coast. (Sources: Hayhow, S. J. 2004. Lancashire & Cheshire Fauna Society General Report pp. 4-13; personal observations.)

Minke Whale washed up at Ravenmeols, September 2008.

Large terrestrial mammals used to occur on the coast, as evidenced by the footprints described in Chapter 3 and the tooth-marks of European Beaver (*Castor fiber*) found on a timber in the Hightown Neolithic trackway. Apart from a few rare sightings of Red Deer (*Cervus elephus*), these are long gone, though a Roe Deer (*Capreolus capreolus*) was reported near Ainsdale in 2008. I have encountered the Red Fox (*Vulpes vulpes*) and its earths quite often on the dunes. Other important predators of Rabbits are the Stoat (*Mustela erminea*) and Weasel (*Mustela nivalis*). On 7th July 2008, I watched a Stoat playing in a pond at Cabin Hill, jumping in and out of the water – an extraordinary sight! Smaller mammals include the Mole (*Talpa europaea*), Hedgehog (*Erinaceus europaeus*), together with the usual mice, voles and shrews. There is a 1966 record of Water Shrew (*Neomys fodiens*) in Massams Slack, while the current status of Water Vole (*Arvicola terrestris*) is uncertain. The only known colony is a small one at Whams Dyke, Freshfield Dune Heath, but there is also a recent record from Birkdale. The Dune Heath population seems to be spreading to ponds dug there in 2006/07.

Four species of bats have been recorded in the dune area. While surveying Natterjacks on spring evenings at Cabin Hill in the 1970s, I often watched Pipistrelles (*Pipistrellus pipistrellus*) and Noctules (*Nyctalus noctula*) hunting

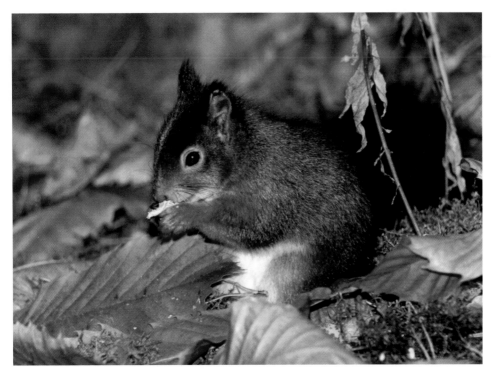

Red Squirrel.

overhead. I also once went to see a Brown Long-eared Bat (*Plecotus auritus*) roost at Ainsdale NNR. In 2003/04, Stan Irwin recorded echo-locations of Nathusius Pipistrelle (*Pipistrellus nathusii*) at Ainsdale NNR, the first record for Merseyside of this recently discovered species in Britain. He also found that the three common species, which forage widely throughout the dunes, often have their roosts in nearby residential areas.

By far the most charismatic mammal on the Sefton Coast is the Red Squirrel, a UK Biodiversity Action Plan priority species, which primarily lives in the pinewoods. As these plantations date back only to the late 19th century, the squirrel must be a fairly recent colonist; indeed, it is thought that part of the population, at least, originated from local releases of continental Red Squirrels in the 1940s. This could account for the general absence in our individuals of the summer bleaching of tail and ear tufts which is a characteristic of the British race *leucourus*.

Until recently, the best place to see these entertaining creatures was at the National Trust estate on Victoria Road, Freshfield, where they were tame enough to be fed from the hand and represented one of the Sefton Coast's foremost attractions. These pine woodlands supported an unusually high density of Red Squirrels, estimated at 3.5 to 3.8 animals per hectare, as

opposed to the usual average on the coast of about 1.5 per ha. This may have been, in part, due to supplemental feeding by the public, though natural foods, such as pine-seeds are thought to be better for them.

Population surveys indicated that, before recent disease outbreaks, there were about 650-900 breeding adults in the pinewoods, 300 or more in adjacent urban areas, such as Formby, Southport, Crosby and Blundellsands, and perhaps 50-100 in nearby woods away from the coast. This gave a healthy spring total for Sefton of 1000-1300 breeding Red Squirrels.

As is well known, despite legal protection since 1981, Red Squirrels are rapidly declining throughout England, mainly due to interactions with the Grey Squirrel (*Sciurus carolinensis*), introduced from North America in 1876. The main problem seems to be a squirrel-pox virus carried by the Greys, to which they are largely immune, but which is lethal to Reds. Until quite recently, the Sefton Red Squirrels were isolated by the nature of the agricultural, mainly treeless, hinterland which made it difficult for the Grey Squirrels to invade. However, Greys are increasingly finding their way here, with as many as 160 sightings in the area during 2004. A small population of Red Squirrels at Little Crosby caught squirrel-pox in 2003 and was wiped out, though they subsequently re-colonised this woodland area. In 2006, six diseased Reds were found in the Ainsdale area, while over a dozen infected animals were reported at Formby Point in 2007. Major outbreaks at the National Trust estate and at Lifeboat Road in 2008 led to 80-90% declines in the populations there. These are worrying times for our Red Squirrels.

It is clearly vital that the Grey Squirrel does not become established along the coast. Therefore, in September 2005, the Sefton Coast woodlands were designated a National Red Squirrel Refuge with a 5km-wide inland buffer zone. This is one of 16 such refuges in the north of England to be managed for Red Squirrels. The aim is to maintain or improve conditions for Reds within the refuge area and to control Greys rigorously in the surrounding buffer zone.

The success of this operation depends on voluntary cooperation between land-owners, managers, statutory agencies and conservation bodies, with the active support of the general public. It will build upon the work of existing local groups set up under "Red Alert North West" in 1993 and the North Merseyside Biodiversity Action Plan. Volunteers monitor the populations of both squirrel species and help organise the control of Greys. Meanwhile, important studies into the squirrel-pox are being carried out by the University of Liverpool at Leahurst. In the longer-term it may be possible to develop a vaccine against the disease.

In April 2006, a £1.1 million project, part-funded by the Heritage Lottery

Fund, was initiated to carry out conservation work on Red Squirrels for a period of three years across the north of England. This ties into the Refuge scheme and pays for a "People and Wildlife" officer to promote Red Squirrel conservation in Merseyside and Lancashire. The project also includes a viewing hide and all-ability footpath through the Lifeboat Road woodlands at Formby.

BIRDS

Systematic information on the bird-life of the Sefton Coast dates back to the late 19th century, when E.D. McNicholl (1883) and John Wrigley (1892) published lists for the districts of Southport and Formby respectively. In the days before birdwatching became a popular hobby, it is perhaps not surprising that McNicholl recorded only 130 species and Wrigley 150, several of these being mossland birds.

T.S. Williams (1943) describes Wrigley's observations as:

"A Shooter's Note Book. It comes to us from the days of shot-gun, pantles, gin and snare, when quantities of birds, both large and small, were killed every year and marketed in the towns." Such were the adverse effects that McNicholl was constrained to write: "*No policy is more short-sighted than the persistent destruction of birds. It is the opprobrium of the present day, and if not changed, will induce results that, when too late, will be deplored.*"

Changing lifestyles, the introduction of bird-protection legislation and positive conservation measures made an enormous difference to the fortunes of birds during the 20th century. Thus, T.S. Williams' list of birds in the Formby district reached 200 by 1939, while Chris Felton's 1966 check list for the Sefton dunes and shore included no less than 224 species. Most recently, Steve White worked out that 296 bird species had been seen on the Sefton Coast up to 2008. Despite the increasing popularity of bird-watching, it has proved hard to find rare species on the dunes, perhaps because of the amount of cover in the form of woodland and dense scrub. There have been exceptions, however, most notably a male Black-eared Wheatear (*Oenanthe hispanica*) at Ainsdale in April 1943, Britain's first Eleonora's Falcon (*Falco eleonorae*) at Cabin Hill in August 1977, a Sardinian Warbler (*Sylvia melanocephala*) at Freshfield in May 1992, a Fea's Petrel (*Pterodroma feae*) at sea off Formby Point in September 1995 and a Pallas's Warbler (*Phylloscopus proregulus*) at Hightown dunes in December 2006.

Top, Pallas's Warbler, Hightown Dunes December 2006. *Left*, Wheatear.
Right, Stonechat.

To bird enthusiasts, such finds are a once in a lifetime event, but regular visitors to the dunes can expect to see a good variety of commoner species, particularly in spring and autumn when birds are actively migrating. John Wrigley remarked as long ago as 1892: "*Formby is by no means the desert to the ornithologist which many people would think.*" Nevertheless, the dunes are rather quiet in the winter, a notable exception being the increasing

numbers of wintering Blackcaps (*Sylvia atricapilla*) in dune-scrub at Birkdale. Ringing studies have shown that these birds come mainly from continental Europe, especially Germany. Also significant are up to 200 Tufted Ducks (*Aythya fuligula*) which winter on Sands Lake, Ainsdale, and good numbers of Snipe (*Gallinago gallinago*) and Jack Snipe (*Lymnocryptes minimus*) on some of the larger slacks and at Birkdale Green Beach.

The breeding bird community of the sand-dunes has changed quite a lot since the 19th century, several species having disappeared. For example, there used to be colonies of Black-headed Gulls (*Larus ridibundus*) and Common Terns (*Sterna hirundo*) nesting in dune-slacks between Ainsdale and Freshfield. The gulls arrived in about 1873, increased to about 200 pairs in 1933 but declined rapidly after 1934 and, according to Formby naturalist, Roger Smith, last bred in 1943 or 1944. Surprisingly, Black-headed Gulls attempted to breed again at Ainsdale NNR in the mid-1990s; three nests with eggs were found but none hatched.

Common Terns peaked at over 900 pairs early in the 20th century despite the depredations of "sportsmen" from Wigan and Manchester detailed by Wrigley. Although protected after the First World War, the tern colony declined to extinction by the mid-1940s for reasons which have never been fully explained. T. S. Williams suggests that severe disturbance by military operations during World War II may have been to blame. A few Arctic Terns (*Sterna paradisea*) occurred with the Commons until the 1940s; they also bred sparingly on the higher beaches, the last nest being recorded in 1959. Very small numbers of Sandwich Terns (*Sterna sandvicensis*) and Little Terns (*Sterna albifrons*) bred until 1916 and 1948 respectively.

The Nightjar (*Caprimulgus europaeus*) was a regular nester in the coastal pinewoods from Cabin Hill to Woodvale until the late 1960s. In 1957, Roger Smith counted 8 – 12 pairs between Fisherman's Path and Woodvale but, by 1961, the young pines had grown so much that many territories were unsuitable. Birds were still present in 1968, Andrew Lassey noting three churring males at Formby Point, but few have been recorded since.

Another pinewood nester was the Long-eared Owl (*Asio otus*), with an estimate of 7 – 10 pairs by Roger Smith in 1957. This species seems to have declined at about the same time as the Nightjar but one pair has lingered on at Birkdale. A further sad and unexplained loss from the dunes is the Whinchat (*Saxicola rubetra*). They used to nest mostly between Crosby and Formby, up to 22 pairs being present in the 1970s. Although they are still recorded annually on spring passage, none has stayed to nest since 1980. The virtual disappearance of Cuckoo (*Cuculus canorus*), Spotted Flycatcher (*Muscicapa striata*) and Willow Tit (*Parus montanus*) in recent years follows national

trends. Another nester lost from the sand-dunes is the Wheatear (*Oenanthe oenanthe*), which used to breed abundantly in sandy areas associated with the farmed Rabbit warrens. The reduction of Rabbits and subsequent growth of vegetation on the dunes may account for its demise, though it still occurs in large numbers on migration.

On the plus side, in recent decades we have gained the Collared Dove (*Streptopelia decaocto*), Green Woodpecker (*Picus viridis*), Reed Warbler (*Acrocephalus scirpaceus*), Siskin (*Carduelis spinus*) and Buzzard (*Buteo buteo*).

Overall, the number of duneland breeding birds has remained much the same for forty years or more. Chris Felton recorded 72 species up to 1966, while the Atlas of the Breeding Birds of Lancashire and North Merseyside shows that around 71 nested in the dune area between 1997 and 2000. One of the most characteristic of these is the Stonechat (*Saxicola torquata*). During the 1970s and 1980s, this attractive little bird was well scattered in small numbers through the open dunes, but is now mostly found in the Blundellsands-Hightown area, where perhaps five pairs nest annually. Although extensive, the pinewoods have limited value for birds. Apart from the occasional breeding Crossbill (*Loxia curvirostra*) and regular Siskin, they hold relatively small numbers of common species. This contrasts with the dune-scrub habitat which, as several studies have shown, holds the highest densities of nesting birds on the coast though most are common and widespread species.

Several of our breeding birds are of high conservation concern (i.e. Red listed) in the UK. They include Grey Partridge (*Perdix perdix*), Skylark (*Alauda arvensis*), Song Thrush (*Turdus philomelos*), Grasshopper Warbler (*Locustella naevia*), Starling (*Sturnus vulgaris*), Linnet (*Carduelis cannabina*), Bullfinch (*Pyrrhula pyrrhula*), Yellowhammer (*Emberiza citrinella*) and Reed Bunting (*Emberiza schoeniclus*). In particular, the dunes are important for the nationally declining Skylark with a minimum of 95 pairs estimated during the Atlas survey. Similarly, there were 34 pairs of Reed Buntings and 15 of Yellowhammers, though the latter species may now be extinct as a duneland breeder.

Although this account has been primarily about the birds of the sand-dunes, it should be stressed here that the real ornithological importance of the Sefton Coast is as a wintering and passage haunt of shore-birds; the waders, gulls and other waterfowl that occur in tens of thousands. Resembling distant smoke, their high-tide gatherings attract bird-watchers from far and wide. Steve White has shown that this coast is the most important site in Britain for two species of wader and in the top five for another three. These flocks are internationally important and have resulted in most of the foreshore being designated a European Special Protection Area.

REPTILES AND AMPHIBIANS

The dunes are home to two species of lizard, three newts, two toads and one frog. The area is currently outside the range of our native snake species. Although Nicholas Blundell's diaries mention "adders" in 1712, 1721 and 1725, as Malcolm Greenhalgh explains, the lengths quoted for these snakes means they must have been Grass Snakes (*Natrix natrix*). One really exotic reptile was the Leatherback Turtle (*Dermochelys coriacea*) washed up dead on Birkdale beach in August 1994.

The Common Lizard (*Zootoca vivipara*) occurs quite widely in the dunes and is locally frequent; thus it was estimated in 2007 that Freshfield Dune Heath Nature Reserve has up to 200 individuals, while a tentative figure for the whole coast is 2-3000. Recently listed as a species of conservation concern, the Common Lizard is often mistaken for the much rarer Sand Lizard. The latter was given legal protection in this country in 1975 and is also scheduled under the EU Habitats Directive as a species of European significance. The endangered Sand Lizard is one of our rarest and most elusive dune creatures; not many present-day naturalists have even seen one. This was not always the case and in the 19th century they were so common as to be familiar to the general public.

E. R. Beattie, recollecting the area in the 1860s, states:

> "*The agriculturally barren sand-dunes had a charm of their own. On their sandy slopes in the hot summer days basked green lizards, shining like jewels in the sun; there was also another kind, the brown lizard, not so beautiful. We boys used to hunt for the green lizards, which, when caught, we took to Mr. Garside, seedsman and druggist; he gave us threepence apiece for them; what he wanted them for I could never find out, but he would not buy the brown ones.*"

The "brown ones" may have been either female Sand Lizards or Common Lizards. The two species are potentially confusable unless well seen, but the Sand Lizard is larger, about 20-24cm long when adult. There is usually a pair of grey "tramlines" down the back and the sides have black markings with white centres. The flanks of breeding males are a vivid lime-green colour, even brighter than those from the south of England, leading some authorities to suggest that the Sefton Sand Lizard has evolved into a distinct sub-species during its long isolation. Common Lizards are usually brown, rarely show green colouration, are smaller headed, shorter-tailed and lack the white-centred spots.

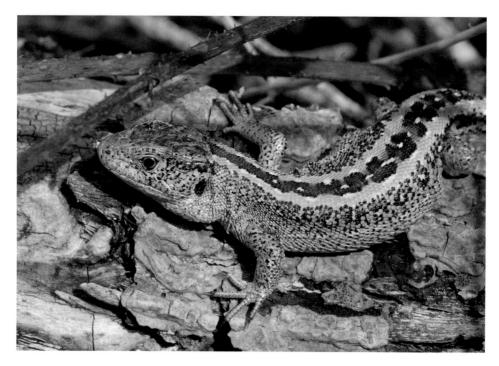

Male Sand Lizard, Ainsdale.

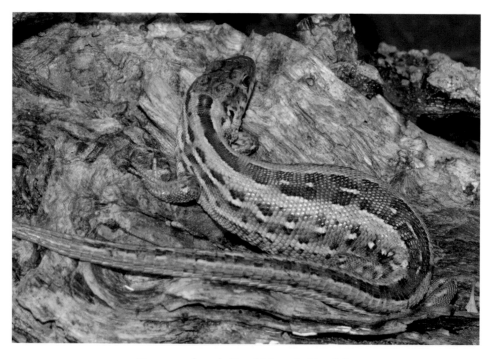

Pregnant female Sand Lizard, Ainsdale.

Unlike the Common Lizard which produces live young, female Sand Lizards lay eggs which are buried in sandy patches to be incubated by the heat of the sun. They hatch in late summer. Both young and adults feed on a variety of small invertebrates. The winter is spent underground in hibernation, animals emerging from their tunnels in spring to bask in the sun, especially in the morning and again in the late afternoon. Finding a basking site gives the best chance of seeing wild Sand Lizards.

Arnold Cooke defined the optimum habitat for Sand Lizards in Sefton as dune-slopes facing south-east to south, at an angle of 30-49° and with bare sand ranging from 5 to 34% of the area. Varying heights of vegetation should be present, from 5cm to over 100cm. Knowing this helps to narrow down areas where lizards might be found or where reintroductions are more likely to succeed.

On the Sefton Coast, Sand Lizards greatly declined in numbers from estimates of 8 – 10,000 in the 1920s-1940s to under 500 in 1991. They occur in small colonies scattered between Altcar and Southport. Suggested reasons for their problems include habitat loss due to building development, afforestation and scrub development, a reduction in May sunshine between 1964 and 1973 and even predation by domestic cats!

During the 1990s, the Sefton Coast LIFE-Nature programme organised survey work which located some additional colonies along the railway corridor between Ainsdale and Birkdale. The species is also the subject of a national Species Recovery Programme, initiated by English Nature and supported by other agencies, including the Herpetological Conservation Trust which, together with its North Merseyside group, organises regular surveys and practical conservation work. A captive breeding programme for Sefton Sand Lizards at Chester Zoo has led to releases of youngsters in the sand-dunes to augment the existing colonies and establish new ones. About 25 to 30 per year have been introduced to the Ainsdale NNR dune restoration area since 2000 and they appear to be doing well. Others were released on Ravenmeols dunes during the 1980s and I found a juvenile there in October 2007. There are plans to introduce this species to Hightown dunes and Freshfield Dune Heath. These steps, together with sympathetic dune management, and a series of warmer summers, have halted the decline, the result being a five-fold increase in sightings during recent surveys compared with the 1970s. Thus, studies by Dave Hardaker and Mike Brown of the North Merseyside Amphibian & Reptile Group have helped to boost the current estimate of the coastwide population to 1200-1500 adults. The outlook for this isolated population of Sand Lizards, over 300km north of its other British localities, is now much more promising.

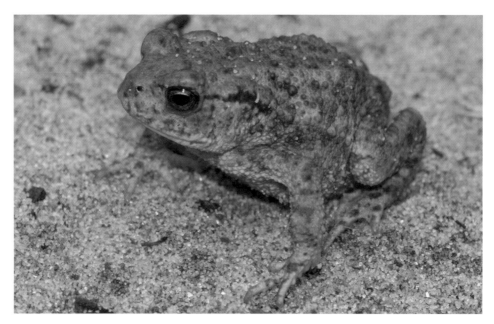

Common Toad.

All three native species of newts have been found in the dunes. The Smooth Newt (*Triturus vulgaris*) is by far the commonest, breeding in most of the deeper slacks, scrapes and ponds. A remarkable total of 196 Smooth Newts was counted by Alice Kimpton in April 2005 at a small Cabin Hill pond. The only record of Palmate Newt (*Triturus helveticus*) was one at Hightown in 1972, but this species may have been overlooked as it is rather similar in appearance to the Smooth Newt.

The Great Crested Newt (*Triturus cristatus*) is rare in Britain and is specially protected under the Wildlife & Countryside Act 1981 and the EU Habitats Directive. The Sefton Coast population seems to date back to the early 1970s when it was introduced to ponds dug in the Ainsdale NNR for conservation purposes. About 12cm long, the Great Crested is our largest newt. It is mainly dark-grey with black spots but underneath it is bright yellow to orange. Males have a tall, shaggy crest in the breeding season.

Breeding ponds should be unpolluted and, ideally, free of fish with few waterfowl present. They should not be too large and have a variety of aquatic vegetation. Infrequent drying out of the pond is tolerated. The terrestrial habitat, where the newts spend most of the year, is also important. It needs to include a range of relatively undisturbed vegetation types, including scrub and woodland, and fairly long grassland. The Ainsdale NNR seems to provide ideal conditions for this species, as it has markedly increased here over the past 30 years, both in numbers and distribution. As early as 1975,

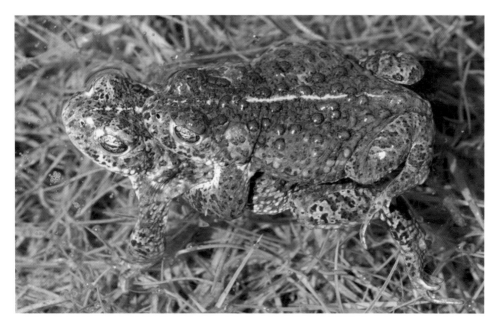

Natterjack pair, Birkdale Green Beach April 2009.

96 were counted in one small scrape in the central part of the reserve. More recently, it has spread onto the adjacent Ainsdale Sandhills LNR and the National Trust property at Formby Point. Night-time counts of adults show that many hundreds are present, breeding in any slack or scrape holding sufficient water.

The Common Toad (*Bufo bufo*) and the Common Frog (*Rana temporaria*) are numerous throughout the older parts of the dune system, breeding in many of the excavated ponds and scrapes. Populations have increased in recent decades and Common Toads, in particular, now assemble in thousands during the breeding season at such sites as Cabin Hill NNR, Altcar Rifle Range and Birkdale Sandhills, much to the detriment of the rarer Natterjack Toad (see below). Male Common Toads compete physically for mates and can often be seen in struggling balls around the larger female, sometimes leading to the death of the latter.

The Natterjack Toad is about as pretty as a toad can get. Its sandy ground-colour has darker markings of brown, green and orange and, most characteristic, a yellow stripe down the back, occasionally broken or missing. The eyes are a beautiful greenish-gold. Very rarely, all-dark, melanistic Natterjacks have turned up. With its short back legs, this species is unable to hop but, instead, walks or runs and is a powerful digger in sand.

After their winter hibernation in tunnels, Natterjacks breed later in spring than the related Common Toad. From early April onwards, on mild, damp

Male Natterjack calling at night.

evenings, the males attract their mates by inflating a throat sac the size of a golf-ball and producing a rattling croak that can be heard up to a mile away. This led to the 19th century vernacular names of "Southport Nightingales" and "Bootle Organs". Females generally choose the largest males with the deepest croak and there is hardly ever any fighting. Most spawning takes place in April and early May but, exceptionally, breeding activity starts up again during rainy periods later in the summer. Thus, many spawn-strings were laid during the unusually wet June/July of 2007.

Spawn-strings are deposited in shallow, poorly vegetated slacks, the tadpoles having a race against time to complete their development before the water dries up. They invariably cluster in the shallowest, warmest water around the edges of pools, thereby speeding their growth. Due to drought, in only about one year in five will there be much breeding success but, in a wet season, thousands of yellow-striped youngsters are produced, this being enough to maintain the population.

Why the adults do not choose to breed in deeper, longer lasting pools is explained by the fact that their tadpoles suffer badly in competition with those of the Common Toad and Common Frog which breed earlier and usually use deeper water bodies. If the water already contains other tadpoles, the growth rate of those of the Natterjack is greatly reduced and they often fail to metamorphose into toadlets. Also, Natterjack tadpoles can suffer catastrophic mortality from predators such as fish, water-beetles and dragonfly larvae, which are commoner in deep ponds and are less likely to occur in pools that dry up in the summer.

Natterjacks are good colonisers of newly-formed slacks because the males

wander and can call up others from a distance with their loud voices. On the other hand, Common Toads usually return to their natal pond and are slower to discover new sites. Therefore, Natterjacks tend to keep one step ahead of the other amphibians and tadpole predators.

The condition of the terrestrial habitat is important for the adults. Natterjacks need open conditions with sparse vegetation in which to forage successfully for their invertebrate food. They burrow in sandy banks or hide under pieces of debris to avoid drying out during the day. Taller vegetation and scrub favour the Common Toad and Common Frog which require moister conditions, lacking the ability to burrow deeply. Therefore, the spread of dense, grassy swards and scrub on the Sefton Coast sand-dunes in recent decades has gradually restricted Natterjacks to a narrow zone of mobile-dunes near the sea.

Vegetation charge, habitat destruction and other factors have resulted in a national decline of the Natterjack, there being only about 50 colonies left, many small, and mostly in the northwest of England and southwest Scotland. The Sefton Coast is now thought to hold about 40% of the British population.

Although it must have been here for thousands of years, the earliest (indirect) written reference to the Natterjack on this coast seems to be that of Sir George Head, who published his impressions of Southport in 1835. He writes:

> "It is with extreme pleasure that one then explores recesses where nothing but the sky is to be seen, and which seem as wild and solitary as an Arabian desert. Rabbits burrow here abundantly with little or nothing apparently to feed upon; and small green lizards, of a colour beautifully vivid, are plentiful. A species of toad, not common, is also met with."

It seems reasonable to deduce that the last remark refers to the Natterjack and this is confirmed in *The Naturalist* journal of 1838, which states that the Natterjack Toad is "...*found in great abundance in the Bootle area.*"

The open dunes of this period, unaffected by drainage and heavily grazed by livestock and Rabbits, must have been a perfect habitat for the Natterjack. Unfortunately, no-one counted them and the literature only gives vague indications of abundance; L. Greening mentions "*hundreds of thousands*" in 1889 and H. O. Forbes "*thousands*" in 1896. However, by 1906, declines are being hinted at due to drainage of slacks for forestry. In 1924, Wheldon describes the toads as "*excessively numerous*" at Ainsdale. Presumably, then as now, the Natterjacks had good and bad years. Also, during this period, there was some collecting pressure. In 1927 and 1928, F. W. Holder was

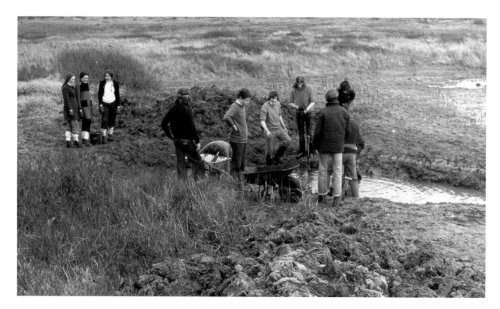

Hand-digging Natterjack scrape, Ainsdale Sandhills, March 1973.

bombarded with requests to send Natterjacks to a Mr Masefield ("*a cousin of the poet*") at Cheadle, Staffs. He writes in his diary: "*Evidently, he thinks I've nothing else to do but hunt the hills for* toads" and "*I told Burrow that Masefield will soon have the Natterjack population at Cheadle.*"

By 1936, R. Wagstaffe and J. Clegg were reporting decreases near Southport, this time due to housing development. Also in the 1930s, it is clear that not all of the dunes were being used by Natterjacks, Eric Hardy (1939) finding them mostly in "*the more barren slacks on the bare pans of sand at Ainsdale.*" But they were still numerous; he writes "*The evening chorus is almost deafening, like thousands of Nightjars at a distance.*"

J. H. Mathias found good numbers of Natterjacks in Ainsdale NNR from 1968 to 1970. Although his estimates were not particularly accurate, it is possible that up to 2400 toads used the reserve for breeding during that period.

Breeding failure due to lack of water in the slacks was reported in 1956 and 1957 and this problem hit the headlines again in the early 1970s, when several drought years led some observers to predict the Natterjack's imminent extinction on the Sefton Coast. Attempts were made to create more breeding sites by digging down to the lowered water-table. The earliest pools were dug by sweating volunteers using hand-tools. Later, funds were raised to employ machinery. The new scrapes and ponds were remarkably successful for a few years, attracting large numbers of Natterjacks to breed. Populations boomed in some areas, notably Cabin Hill where, in late summer 1978, I counted

Reprofiling scrape at Ainsdale NNR.

of over 1500 Natterjacks across the whole of the Ainsdale dunes (including the LNR). The dune restoration project, involving removal of part of the frontal woodlands with follow-up grazing by sheep, has also been helpful to Natterjacks on the NNR. Previously unusable slacks have re-flooded and, from 1998 onwards, these supported about 100 spawn strings per year, while grazing improved the terrestrial habitat.

Another important new site is the Birkdale Green Beach, where shallow slacks fed by surface-water drains provide near perfect conditions for Natterjack breeding. Since 2001, numbers have risen steadily to 275 spawn strings counted in 2008. This is now one of the largest Natterjack breeding colonies in Britain.

Attempts have been made to identify "key" Natterjack breeding sites throughout the dune system and keep these free of Common Toads. This is a major and ongoing task with 2000-3000 Common Toads removed from key sites in some years and transported to ponds further inland. Lined ponds have been constructed to extend the range of Natterjacks along the coast to areas where wet-slack habitat is absent or rare, as at West Lancashire, Royal Birkdale and Hesketh Golf Courses and the National Trust estate. These can be filled with a tanker at the start of the breeding season and then emptied in autumn to eliminate predators. It is also hoped to establish a new population at the RSPB Marshside Nature Reserve where shallow scrapes have recently been provided.

Rangers, wardens and volunteers monitor up to 100 breeding sites annually,

the well-being of the population being assessed by counts of adults, spawn strings and toadlets. Every few years, the body lengths of samples of adults are measured to get an idea of the proportions of young and old (larger) individuals, and therefore the age-structure of the breeding groups. When spawn or tadpoles are threatened by desiccation, they can be translocated to deeper water to improve breeding success. While breeding activity and success varies greatly from year to year, largely due to water-table changes, overall toad numbers seem to be holding up well.

Each year since 1987, records from all contributors have been brought together in an Annual Natterjack Report for the Sefton Coast. This gives a long-term insight into the success or otherwise of conservation measures and the degree to which targets for each site along the coast are being met.

INVERTEBRATES

The dune system has long been renowned for invertebrates. Species diversity is high and there are many coastal specialists. Indeed, Steve Judd of World Museum Liverpool has recently calculated that 3,333 species have been recorded, of which 264 are nationally notable and 33 listed in Red Data Books.

One of the richest habitats is dune-heath. The Sefton Coast LIFE-Nature programme commissioned a survey of dune-heath invertebrates from Liverpool Museum in 1997/98. A remarkable total of 702 species was identified, as many as 30% being new records for the Sefton Coast. Included were three Red Data Book and 22 nationally scarce species. A further 155 species were described as "local" in their British distribution. Butterflies and moths (Lepidoptera) were poorly covered by this study, so Steve Palmer and colleagues of the Lancashire Moth Group later investigated this group, finding 273 species (six nationally scarce), making a grand total of 975 invertebrates for the dune-heath habitat.

The strandline supports a nationally scarce white woodlouse, *Armadillidium album*, found at Altcar Rifle Range, Cabin Hill and Ainsdale. Also characteristic of tidal debris is the large black ground-beetle *Broscus cephalotes*, which often shares burrows with the Natterjack Toad.

A special insect of the embryo-dunes is the Sandhill Rustic moth (*Luperina nickerlii* ssp. *gueneei*) whose caterpillars feed on Sand Couch. Officially listed as "vulnerable", this is a sub-species that is endemic to Sefton, Wirral and North Wales. This moth is usually hard to find and its status obscure. It was only known from a small area of embryo-dunes at Altcar until 2007 when 16 were recorded on Birkdale Green Beach. The following year, an amazing

Northern Dune Tiger Beetle, Devil's Hole.

total of 315 was counted by Richard Burkmar and Graham Jones who also recorded another 69 moth species on the Green Beach, one being new to Lancashire and another not seen in the region since the 1950s.

A flag-ship species of the mobile-dunes is the purplish-brown Northern Dune Tiger-beetle (*Cicindela hybrida*). This fierce predator operates best at a body temperature of about 36°C and therefore inhabits bare sand patches that warm up in the sun, especially on south-facing slopes. Being confined in Britain to the Sefton Coast and Drigg (Cumbria), it is Red Data listed and has been the subject of a detailed survey by Steve Judd. About 95% of its British population is thought to be on the Sefton dunes, where it occurs along a 15km stretch between Birkdale and Hall Road. It has recently colonised the young dunes at the south end of Birkdale Green Beach.

Moving into the fixed dunes, one encounters a myriad of invertebrates, many of which are dependent on small bare patches for burrowing. This applies to the many solitary wasps and bees which are a particular speciality of the coast here. One such is the Nationally Rare Vernal Bee (*Colletes cunicularius* ssp. *celticus*), this sub-species being named from specimens taken at Hightown and confined to coasts of northwest England and Wales.

Vernal Bee on Creeping Willow catkins.

Sizeable colonies of this small, brown bee can be found in the spring, tunnelling into south-facing slopes and busily collecting pollen, especially from Creeping Willow. A comprehensive survey of Ainsdale NNR in 2004 by Susan Taylor located 76 colonies and over 8000 nest holes.

Another important species of the fixed dunes is the nationally notable Grass Eggar moth (*Lasiocampa trifolii*), one of several moths that have large hairy caterpillars. Patches of willow and poplar provide food-plants for many other caterpillars, spectacular examples including the Eyed Hawk-moth (*Smerinthus ocellata*), Puss Moth (*Cerura vinula*) and White Satin Moth (*Leucoma salicis*). The latter should not be handled as they can cause a skin-rash.

One of the most characteristic insect groups on the dunes is the grasshoppers and crickets (Orthoptera). There are three common grasshoppers, the Field (*Chorthippus brunneus*), Mottled (*Myrmeleotettix maculatus*) and Common Green (*Omocestus viridulus*), their chirping being a feature of warm summer days. The tiny, well-camouflaged Common Ground-hopper (*Tetrix undulata*) also occurs but seems to be rather scarce here or perhaps overlooked. Not recorded for over 20 years, the House Cricket (*Acheta domestica*) used to sing on the Formby Point nicotine waste tip.

Short-winged conehead, Birkdale Green Beach 2006.

Our most recently discovered orthopteran, and certainly the most unexpected, is a small green-and-brown bush-cricket, the Short-winged Conehead (*Conocephalus dorsalis*), photographed by Peter Gateley at Marshside in 2002. During an intensive survey in 2005, I found it well-established both at Marshside and on the Birkdale Green Beach, mainly in dense beds of Sea Club-rush. This is a southern species in Britain, its nearest locality being on Anglesey. As it is generally flightless and its habitat on the Sefton Coast is of fairly recent origin, how it got here is a mystery. One suggestion is that eggs, which are resistant to saltwater, could have been transported in floating salt-marsh detritus. This species has since turned up on the north shore of the Ribble Estuary and around Morecambe Bay to the Duddon Estuary, so it is certainly on the move.

Among the most dramatic and popular invertebrates are the dragonflies and damselflies (Odonata), known as "the bird-watchers insect" because they can be identified and studied using binoculars. Once called "devil's darning-needles" and "horse-stingers", dragonflies were thought to sting people but are now known to be completely harmless, except to other insects which they catch and eat on the wing.

Ruddy Darter pair. at Birkdale Sandhills

Red-veined Darter, Crosby Marine Park 2006.

Thanks, in part, to the large number of ponds and scrapes excavated for conservation purposes since the 1970s, the Sefton Coast has become nationally important for these insects which have an aquatic immature stage. Twenty species have been recorded on the dune coast, of which 12 have bred (Table 5). Several of them are recent arrivals from the south and east, reflecting the ability of these fast-flying insects to respond quickly to the effects of climatic change.

The first new colonist was the Ruddy Darter (*Sympetrum sanguineum*), photographed by Bob Letche at Ainsdale NNR in 1989. By 1994, this attractive and nationally notable insect was well-established on the dunes, though it has remained rather localised as it likes well-sheltered ponds. Our largest dragonfly, the Emperor (*Anax imperator*) was first recorded here in 1976, after which it bred for several years before becoming extinct. Returning to breed again in 1995, another exceptionally warm summer, it can now be seen patrolling many of the dune ponds in June and July. The 1995 summer also saw a national invasion of a continental species, the Yellow-winged Darter (*Sympetrum flaveolum*); with an increasing sense of disbelief, I encountered 12 at Birkdale on 3rd August. Smaller influxes took place in 1999 and 2006. The latter year provided further excitement when, in July, up to eight Red-veined Darters (*Sympetrum sanguineum*) were found at the boating lake at Crosby Marine Park and a Lesser Emperor (*Anax parthenope*) turned up on Sands Lake, Ainsdale. Both are from southern Europe.

The autumn-flying Migrant Hawker (*Aeshna mixta*) was unknown in our region until 1996, since when it has become the commonest large dragonfly in the dunes, while another southern species, the Broad-bodied Chaser (*Libellula depressa*), became established here at about the same time.

A peatland specialist, the Black Darter (*Sympetrum danae*), disperses from its inland haunts in late summer and appears regularly along the coast, with large influxes in 2004 and 2008. Another recent addition is the Black-tailed Skimmer (*Orthetrum cancellatum*) which has been rapidly colonising the northwest since 1997 and was first seen in the dunes in 2004. Finally, in July 2006, a male Banded Demoiselle (*Calopteryx splendens*) stayed at Sands Lake for a couple of days. As it breeds not far away on Downholland Brook, near Formby this was a not unexpected addition to our coastal list.

Name	Status	Breeding
Banded Demoiselle *Calopteryx splendens*	Rare; one sighting, 2006	No
Emerald Damselfly *Lestes sponsa*	Common	Yes
Large Red Damselfly *Pyrrhosoma nymphula*	Rare; 3 sightings, none since 1984.	No
Blue-tailed Damselfly *Ischnura elegans*	Common	Yes
Common Blue Damselfly *Enallagma cyathigerum*	Common	Yes
Azure Damselfly *Coenagrion puella*	Fairly common	Yes
Common Hawker *Aeshna juncea*	Rare; 4 recent records include females egg-laying in 2005 and 2008	?
Brown Hawker *Aeshna grandis*	Fairly common	Yes
Southern Hawker *Aeshna cyanea*	Uncommon; recently increasing. Has bred at Ainsdale NNR	Yes
Migrant Hawker *Aeshna mixta*	Increasingly common	Yes
Emperor Dragonfly *Anax imperator*	Fairly common	Yes
Lesser Emperor *Anax parthenope*	Rare vagrant in 2006	No
Broad-bodied Chaser *Libellula depressa*	Occasional but increasing; egg-laying seen	?
Four-spotted Chaser *Libellula quadrimaculata*	Fairly common	Yes
Black-tailed Skimmer *Orthetrum cancellatum*	Scarce but increasing; egg-laying seen in 2008	?
Common Darter *Sympetrum striolatum*	Common	Yes
Ruddy Darter *Sympetrum sanguineum*	Occasional; frequent in 2006 and 2008	Yes
Black Darter *Sympetrum danae*	Occasional late-summer visitor, mainly males	No
Yellow-winged Darter *Sympetrum flaveolum*	Rare vagrant in 1995, 1999 and 2006	No
Red-veined Darter *Sympetrum fonscolombii*	Rare vagrant in 2006	No

Table 5. Dragonflies and damselflies of the sand-dunes.

Comma, Freshfield Dune Heath.

One of the great delights of the dune coast is the abundance of butterflies and day-flying moths. I have often walked the dunes in high summer marvelling at the clouds of these insects spring up before me, bringing to mind descriptions of an English countryside before the advent of modern farming methods. Such sights are now largely confined to rare remnant patches of landscape relatively unaffected by intensive agriculture.

Some 23 species of butterflies have been identified on the dunes and at least 17 of these have bred (Table 6). Our knowledge of their occurrence and status owes much to the efforts of Mike Bird who recorded a weekly spring-summer transect through Ainsdale NNR from 1982 to the end of the century.

Rather as in the case of the dragonflies, there have been major changes in the status of several butterflies over the last 20 years. Although it was recorded at Formby in 1949 and 1951, the Speckled Wood (*Pararge aegeria*) was almost unknown north of the Mersey until 1982 when I was delighted to find it at Ravenmeols. It was soon breeding throughout the dune woodland and scrub areas, males characteristically defending their territories in sunny patches from April to September.

Another fairly recent colonist is the Orange Tip (*Anthocharis cardamines*), seen annually since about 1983. During the 1990s, the Comma (*Polygonia*

Top left, Dark Green Fritillary. *Top right*, Cinnabar moth caterpillars on Ragwort. Above, Six-spot Burnets.

c-album) established itself sparingly on the coast and is now seen increasingly in late summer. Two of its colourful relatives, the Red Admiral (*Vanessa atalanta*) and the Peacock (*Inachis io*), have also increased markedly over the past 15 years or so. Most spectacular of all, however, was the sudden appearance of the Small Skipper (*Thymelicus sylvestris*) whose northern limit on the west side of the country used to be the River Mersey. It was first recorded on the Sefton Coast at Seaforth in 1994. By the summer of 1997, Small Skippers could be seen throughout the dune system in any suitable rough-grassland habitat – a really dramatic expansion in such a short period.

One of the most charismatic of our duneland butterflies is the Common Blue (*Polyommatus icarus*), described by E. R. Beattie (1845-1917) as the *"little butterfly gleaming azure in the sun."* Its caterpillar feeds on Common Bird's-foot-trefoil, the blue males and mainly brown females being abundant in most years.

Also among the most numerous of our dune species are members of the "brown" family (Satyridae), whose caterpillars eat grasses. Most frequent is the Meadow Brown (*Maniola jurtina*), associated with taller grasslands. The Gatekeeper (*Pyronia tithonus*) is also abundant and likes scrubby, more sheltered places where the adults can often be seen nectaring on brambles or Common Ragwort. Two other relatives, the Small Heath (*Coenonympha pamphilus*) and Wall (*Lasiommata megera*), are associated with shorter and more open grass swards and both have declined in recent years.

Some butterflies are mainly migrants, only common in particular years. For example, there were Clouded Yellow (*Colias croceus*) "years" in 1983 and 1992, while the Painted Lady (*Cynthia cardui*) appears in small numbers in most summers but was spectacularly abundant in 1996.

In a national context, our most important butterflies are the Dark Green Fritillary (*Argynnis aglaja*) and the Grayling (*Hipparchia semele*), both of which feature in the North Merseyside Biodiversity Action Plan. Breeding on violets, the fast-flying Dark Green Fritillary is commonest at Ainsdale NNR where it is attracted particularly to the nectar of thistles. Graylings are characteristic of coastal and heathland sites and are found along the length of the dune system, especially in the mobile-dunes. The caterpillars feed on grasses, while adults favour flowers of Sea Holly. I once counted about 50 on one clump of this plant at Hightown.

Several colourful day-flying moths may be mistaken for butterflies by visitors. They include the red-and-black Cinnabar Moth (*Tyria jacobaea*) which flies in early summer. Its colour is a warning to potential predators, such as birds, that the moth is distasteful. Even more familiar are its black-

and-orange banded caterpillars found abundantly on Common Ragwort. They store the protective poisons manufactured by this plant and pass them on to the adults.

Two species of burnet moth are abundant in summer. Also warningly-coloured in red-and-black, their identity is confirmed by counting the number of spots on one forewing. The Narrow-bordered Five-spot Burnet (*Zygaena lonicerae*) emerges a few weeks earlier than the Six-spot (*Zygaena filipendulae*), the caterpillars feeding on Common Bird's-foot-trefoil, from which they absorb cyanides. One of my earliest memories is collecting "red flies" in a jam-jar at Ainsdale when I was about three years old. These were burnet moths which were as common then as now.

Species	Status	Breeding
Small Skipper *Thymelicus sylvestris*	Common	Yes
Large Skipper *Ochlodes venata*	Occasional	Yes
Clouded Yellow *Colias croceus*	Uncommon migrant	
Pale Clouded Yellow *Colias hyale*	Rare vagrant	
Large White *Pieris brassicae*	Fairly common	?
Small White *Pieris rapae*	Common	?
Green-veined White *Pieris napi*	Very common	Yes
Orange Tip *Anthocharis cardamines*	Occasional	Yes
Small Copper *Lycaena phlaeas*	Fairly Common	Yes
Common Blue *Polyommatus icarus*	Abundant	Yes
Holly Blue *Celastrina argiolus*	Occasional	?
Red Admiral *Vanessa atalanta*	Common	Yes
Painted Lady *Cynthia cardui*	Fairly common migrant	Yes
Small Tortoiseshell *Aglais urticae*	Common but declining	Yes
Peacock *Inachis io*	Common	Yes
Comma *Polygonia c-album*	Occasional	?
Dark Green Fritillary *Argynnis aglaja*	Locally fairly common	Yes
Speckled Wood *Pararge aegeria*	Very common	Yes
Wall Brown *Lasiommata megera*	Occasional, declining	Yes
Grayling *Hipparchia semele*	Locally common	Yes
Gatekeeper *Pyronia tithonus*	Abundant	Yes
Meadow Brown *Maniola jurtina*	Abundant	Yes
Small Heath *Coenonympha pamphilus*	Fairly common, declining	Yes

Table 6. Butterflies recorded on the Sefton Coast sand-dunes

CHAPTER SIX

DUNE MANAGEMENT

INTRODUCTION

Sand-dunes are one of Britain's more natural habitats. It might be supposed, therefore, that nature could be left to look after itself, little human interference being needed other than protection from development. Indeed, in some remote dune systems the different habitats can, in theory, be maintained by natural processes, such as dune-formation, wind-erosion and vegetation development. However, as we have seen, the Sefton Coast dunes have been so changed by past human activities that these processes no longer operate in an unrestricted way. The duneland is much smaller than it used to be; even the surviving areas have been altered and fragmented by agriculture, forestry, military training, recreation, development and coastal erosion. Also, for many decades, there has been a low rate of new sand-dune formation and older parts of the system have become over-mature and scrubbed-up, resulting in an under-representation of early successional stages and some of the typical open-dune species. Similar trends are commonly reported throughout Western Europe.

Evidently, active management is needed so that the characteristic sand-dune animals and plants can thrive and prosper. However, there is a balance to be struck. Keeping the full range of biodiversity means later stages in succession must be maintained as well, while other major values, such as recreation and landscape conservation need to be accommodated.

When I came back to the area in 1968, the dune system was split between three local authorities and only the Ainsdale Sand Dunes NNR and the National Trust estate at Formby Point had formal management structures, both in their early years. Recreational pressures were increasing and largely uncontrolled, the result being wind erosion, rubbish dumping and general vandalism.

A major breakthrough came about in 1974 with local government reorganisation. This meant that the whole dune coast came under the control of a single local authority, Sefton Metropolitan Borough Council, within the

new County of Merseyside. Now there was an opportunity for voluntary and statutory bodies to work together with land-owners and the new Councils for a unified approach to the management of the coastline. The result was the establishment in 1978 of the Sefton Coast Management Scheme. At first, the Scheme had to tackle problems of weakened coastal defences and sand-drift in recreational hot-spots like Ainsdale-on-Sea and Formby Point. By the 1990s, these were largely resolved and attention shifted towards restoring a dynamic landscape by encouraging new dune and slack formation, controlling scrub development and maintaining dune-grassland, for example, by grazing with livestock.

THE SEFTON COAST PARTNERSHIP

The original Sefton Coast Management Scheme operated through Sefton Council with representatives from other groups given the status of "observers". In 2001, it was decided that this was not ideal for the new Millennium and that a true partnership should be set up as an informal association of land-managers, land-owners, community groups and other agencies with an interest in the integrated management of the coast. The Sefton Coast Partnership is steered by a Board representing the various interest groups, the Board being supported by a number of Task Groups with expert members. An annual public Forum allows issues to be discussed with a wider audience. The attractive twice-yearly magazine "*Coastlines*" and a web-site (www. seftoncoast.org.uk) also provide lots of useful information about the coast for the general public.

The Partnership prepares and regularly reviews the Sefton Coast Management Plan which seeks to promote "best practice" in coastal management, with an emphasis on cross-ownership and cross-boundary working for the benefit of landscape, wildlife, amenity, heritage and economic activity.

HABITAT MANAGEMENT

Habitat management is addressed in various current working documents, including Site Management Plans, the Sefton Coast Management Plan and the North Merseyside Biodiversity Action Plan (BAP).

There are two main approaches to habitat management – continuity and restoration. Many dune habitats have a long history of human intervention and depend for their special interest on continuity of management; for

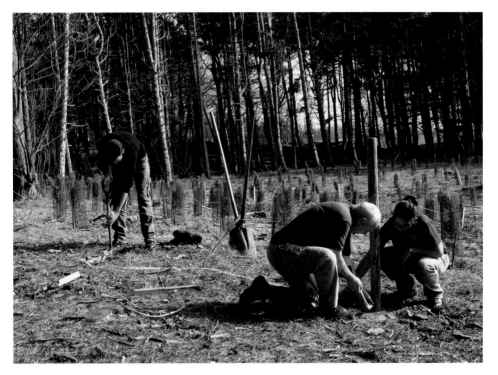

Replanting of woodland "coup" Ravenmeols, March 2009.

example grazing on grassland and heathland. Restoration involves a change from one state to another and may be relatively small-scale, such as the excavation of a Natterjack breeding pool, or large-scale, as in tree-planting or the removal of scrub and woodland to restore open dune habitats.

Woodland

Most of the woodland on the coast is conifer plantation, dating back to the late 19th and early 20th centuries, and which now covers about 263ha. In the past, management of the plantations was often neglected but this has improved in recent decades with thinning taking place and a significant amount of new planting. However, it became clear that woodland management needed to be addressed on a coast-wide basis. The response was the Sefton Coast Woodland Forest Plan, finally approved in January 2003 after a long period of public consultation. The Plan covers a 20-year period up to 2023 and seeks to involve all land-owners on the coast working together to improve the condition of their woods.

The main objectives of the Forest Plan are to maintain historically important

landscapes and the habitats for rare species, to provide for quiet enjoyment of the countryside and to support business opportunities in the area. These will be achieved by, for example, selective thinning of trees, felling and replanting small areas ("coups") of over-mature trees, encouraging natural regeneration where appropriate and planting up new areas. Overall, this should ensure that the total area and character of the woodland will remain much as it at present, "priority" species, such as the Red Squirrel, will continue to have the right kind of habitat and some income will be obtained from the timber produced. The latter is a particular challenge because timber prices have been falling in recent years and there are few outlets which avoid expensive transport costs. Local production of fence posts, signs, board-walks, benches, seating, path edges and the like is one possible solution. Fortunately, the considerable costs of management can be offset by Forestry Commission and other grants and the use of volunteers where appropriate.

At the time of writing (early 2009), the Plan seems to be progressing well. By the end of 2006, about 66ha of woodland had been thinned, 17ha of coups created and over 22ha planted up. About 90% of targets had been achieved. A total of 290ha has been certified as being sustainably managed under the UK Woodland Assurance Scheme.

The Ainsdale dune restoration project

Ainsdale Sand Dunes NNR has the largest extent of pinewood on the coast (130ha), mostly planted between 1920 and 1934. In 1990, about 40ha of mainly Corsican Pine near the sea, known as the frontal woodlands, were programmed for removal to restore the former landscape of dune ridges and slacks with their special wildlife which the reserve was established to protect. This frontal woodland, which is in poor condition, is vulnerable to future coastal erosion and acts as a shelter-belt for about 50ha of fixed-dunes and slacks to the east where scrub invasion, especially of birch, has become a major problem. The conifers also seed into the open dunes, acidify the soil and draw down the water-table in the slacks. By 1996, two phases (20.5ha) out of four had been completed, clear-felling being followed up by winter sheep-grazing. At first, tree-stumps were left in place for the benefit of mosses, lichens, ants and wood-boring beetles. However, being considered visually intrusive, they were later removed and used to create "habitat piles" in the rear woodlands.

Sand-dune plants quickly re-colonised the ground and the slack flora, in particular, has responded well with specialities like the nationally declining Field Gentian (*Gentianella campestris*), Yellow Bartsia and marsh-orchids

Ainsdale dune restoration area: Marsh-orchids colonising after tree removal.

appearing in spectacular numbers. On the dryer ridges, the rare Smooth Cat's-ear was discovered in 2000 and was particularly abundant in 2007. A further bonus is that Skylarks, Linnets, Reed Buntings, Grey Partridges and even the Ringed Plover have retuned to nest, the latter making its first breeding attempt for many decades. Sand Lizards and Natterjack Toads have colonised the opened-up areas, the toads spawning again in the wet-slacks for the first time in over 50 years (see Chapter 5). A few small blow-outs have begun to develop, benefiting the rare Northern Dune Tiger Beetle and other specialised sand-dune insects.

The dune restoration project also included management of the landward plantations on the NNR, including especially works to improve the habitat of the Red Squirrel. However, following the completion of Phase 2, adverse public reaction to the tree felling led to a moratorium on management works, including the removal of conifers in Phases 3 and 4, until further assessment had taken place. A detailed 150-page Environmental Assessment by the consultants WS Atkins was published in 2004. This recommended either of two felling options taking due account of landscape concerns. In February 2008, Natural England proposed a modified programme for the remaining frontal woodland, avoiding large-scale clear-felling and phasing restoration work over about 20 years in line with new Sefton Coast Nature Conservation Strategy.

Scrub invasion at Birkdale Sandhills, 2008.

Scrub

One of the most dramatic changes I observed on the coast during the 1970s and 1980s was the rapid increase of the mainly introduced species of shrub, especially Sea Buckthorn, Balsam Poplar and White Poplar. This gave rise to a good deal of concern and a number of studies to investigate the problem and its possible solutions. As early as 1971, Dr Barbara Knowles (neé Blanchard) drew attention to the changes she saw in the areas around Massam's Slack, Ainsdale that she had studied 20 years earlier. She writes:

> "There was a general increase in the "shrubbiness" of the vegetation, and there was evidence of the growth of many new trees and bushes. One can only hope that this trend towards scrub and woodland does not increase to such an extent as to eliminate many of the interesting (and occasionally, very rare) plants of the slacks – which are such a special feature of this particular reserve."

My own students contributed usefully in the 1980s, using air photographs to plot the rate of spread of the scrub habitat in three representative areas. Between 1945 and 1985, total scrub cover in the study areas rose from 7.7

Volunteers clearing scrub at Ainsdale NNR.

to 45.3ha, a six-fold increase. This rise coincided with the demise of the Rabbit in the late 1950s/early 1960s and the droughts of the 1970s which allowed scrub to colonise the dryer wet-slacks. It was also shown that the presence of scrub has important affects over time on soil conditions, adding organic material and nutrients which can be deleterious to dune flora and fauna. On the plus side however, dune-scrub is a natural component of the sand-dune ecosystem, providing a habitat for breeding and wintering birds, food-plants for many invertebrates and shelter for warmth-loving insects such as butterflies and dragonflies.

Nevertheless, it became apparent that, on balance, the scrub habitat was becoming too extensive and needed managing for the benefit of open dune habitats and species that it was replacing. Scrub control began in a small way on Ainsdale NNR in the late 1960s when Sea Buckthorn thickets were removed using hand-tools. Three large slacks in the Ainsdale Sandhills LNR were cleared by hand from 1980 onwards. This work was extended to Birkdale in 1984 and 1985, when about 3ha of mainly young Sea Buckthorn clumps were taken out of slack margins. Hand-cutting was insufficient for this job and a tracked bulldozer was used to uproot the bushes and pile them up for burning. This method proved particularly effective as root-stocks were removed, making regrowth from stumps and

Cabin Hill NNR willow patch before clearance, 2005.

Recovery of slack vegetation after willow removal, Cabin Hill 2007.

suckers less likely. Then, from 1991 to 1993, funding was obtained through the Natterjack Toad Species Recovery Programme to tackle a huge scrub problem on 40ha of the Ainsdale LNR, again using machinery. The most recent major project took place from 1996 when, over several years, the chain of important slacks in the Birkdale frontal dunes was cleared, mainly of Sea Buckthorn. As elsewhere, this had a dramatic effect on the botanical richness of these slacks (see Chapter 4).

Following scrub clearance, two problems are likely to arise. The first is regrowth. This can be reduced by treating cut stumps with an approved herbicide but follow-up spraying of seedlings and suckers is often required for several years, this being a labour-intensive and expensive operation. Where present, Rabbits or domestic stock can help by browsing the regrowth and preventing new seedlings becoming established. Secondly, soil enrichment by organic matter and nitrogen often results in "weed" (ruderal) species, such as thistles (*Cirsium*), sow-thistles (*Sonchus*), evening-primroses, Rosebay Willowherb and Common Ragwort becoming abundant on dryer areas for the first few years after scrub removal.

Similar changes occur in cleared slacks, though the species are different. For example, a 1ha slack cleared of dense willow scrub in November 2005 at Cabin Hill NNR supported an interesting 50-50 mixture of wet-slack and ruderal plants by the following summer, including such exotic rarities as Cape-gooseberry (*Physalis peruviana*), Green Nightshade (*Solanum physalifolium*) Garden Orache (*Atriplex hortensis*), Angels'-trumpets (*Datura ferox*) and Thorn-apple (*Datura stramonium*). Such changes are usually temporary, the normal dune flora slowly returning as organic material breaks down and rainfall washes away the excess nutrients. Indeed, a follow-up study of this slack in 2007 showed that almost all the ruderals had disappeared, being replaced by a rich mix of typical slack and fixed-dune plants. Overall, the slack was colonised by 139 different plants, 28 of which were new to the reserve; a real biodiversity bonus.

Future scrub management is likely to turn increasingly to the identification of areas to be retained for their wildlife and educational value. Some of the older patches at, for example, Birkdale Sandhills and Falklands Way are becoming more like deciduous woodland, which is otherwise scarce on the dune coast. However, these incipient woodlands have a far from natural tree composition, containing mainly non-native species. There is also concern that they may encourage the invasion of Grey Squirrels.

Scrape 8 Birkdale Sandhills dug in 1976, showing vegetation changes from 1977 (*top*) to 2000 (*middle*) and 2006 (*bottom*).

Turf-stripping

The removal of vegetation and upper soil layers to rejuvenate especially slacks may be said to replicate the once widespread, ancient practice of turf-cutting for fuel and building materials. On the Sefton Coast, turf-stripping was much used in the 1970s and early 1980s to improve breeding conditions for Natterjack Toads. About 50 gently shelving excavations were made in slacks by removing surface plant-life and organic matter layers down to bare sand, representing the original slack surface when it was formed. Re-colonisation by pioneer plants was rapid and, within a few years, several of the special slack plants could be found, including Shoreweed (*Littorella uniflora*), Brookweed and Lesser Water-plantain. The deeper sites have also proved important for dragonflies and other invertebrates, as well as for uncommon aquatic plants, such as stoneworts. However, many of the older scrapes have now become overgrown with tall swamp plants and need active management to bring back some open water.

Before turf-stripping, it is essential to check that no important communities or species will be destroyed. Even the smallest scrape produces a surprising quantity of spoil which is difficult and expensive to remove, though it may be possible to profile it into existing dune ridges at the edges of slacks. Spoil heaps re-vegetate rapidly and will be dominated for a time by weeds, such as thistles. These, however, have their uses as nectar sources for insects, such as the Dark Green Fritillary. Turf-stripping has also been used on a small scale to produce bare sandy patches for basking Sand Lizards. Recently, this technique has been used to create two large scrapes on the Royal Birkdale Golf Course in areas previously dominated by scrub. It will be interesting to follow their development

Mowing

At Ainsdale NNR and in the Birkdale frontals, mowing has been used to reduce the height and dominance of Creeping Willow in several slacks. Following Dutch experience, the slacks are now mown in the spring, when water-levels permit, rather than the autumn. The cut material is collected and removed to prevent a build-up of soil nutrients. This method has successfully reduced the height and cover of Creeping Willow, has prevented further scrub-invasion and seems to have increased plant diversity. Similarly, at Altcar Rifle Range and Royal Birkdale Golf Course, slacks are being mown annually by the site managers to improve habitat for Natterjacks and plants. Three previously

overgrown slacks at Royal Birkdale now support spectacular populations of marsh-orchids which, as well as being of nature conservation importance, provide a stunning visual treat in early summer for the golfers.

Where they cannot be grazed, dune grasslands can also be managed appropriately by mowing. The most important damp meadows on the coast are at Altcar Rifle Range where regular mowing takes place to give marksmen a clear view of the targets. Selected areas are left un-mowed until 15th July each year so that the huge populations of Green-winged Orchids, marsh-orchids, Cowslips, Ragged-robin and others can flower and set seed. As a result, these plants have greatly increased and are much appreciated by the many visitors on guided walks.

Grazing

Grazing with domestic stock is a traditional land-use on many British sand-dune systems but, on the Sefton Coast, it had all but died out by the 20th century, a small area only at Cabin Hill being grazed by cattle and horses until the 1980s. It is now known that controlled grazing can be an important way of managing sand-dunes, holding back succession to scrub and maintaining the open conditions required by many dune plants and animals. A particular benefit is trampling which creates small bare patches essential to reptiles and specialised dune invertebrates. Major disadvantages are the limited availability of suitable stock, the need for daily visits to oversee the animals' wellbeing, providing a water source and the expense and visual impact of fencing and stock-handling pens. Registering land on the coast under the government's Environmental Stewardship Scheme means that grants may be available to offset some of the conservation grazing costs.

At Ainsdale NNR, an experimental grazing plot of 10ha was fenced in 1990 to hold 30 Herdwick sheep from the Lake District. Hebridean sheep and other primitive breeds, together with small numbers of cattle and even pigmy goats and ponies were later trialled. Following the success of the first phase of this project, the enclosed area was extended, eventually to include areas cleared of pine woodland during the dune restoration project. Currently, between October and April, about 200 Herdwicks are grazed on 95ha of Ainsdale NNR and 50 on 15ha at Cabin Hill NNR. A 7.5ha area on Ainsdale Sandhills LNR was fenced in 1999 and has since been winter-grazed by 25 Herdwick sheep. Starting in 2004, parts of the Freshfield Dune Heath Nature Reserve have been grazed during the summer, mainly by black Hebridean sheep. In addition, the National Trust has trialled Welsh

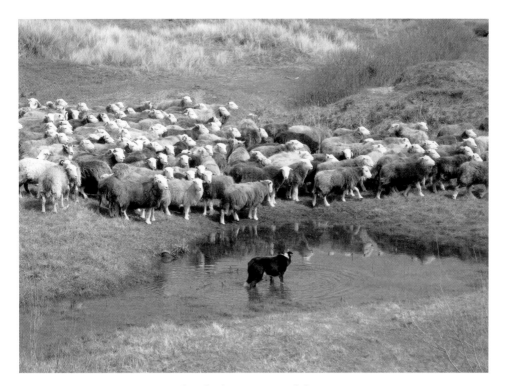

Herdwick sheep at Ainsdale NNR.

Mountain ponies on its small Larkhill Lane heathland.

Generally, the grazing regimes have worked well, controlling invasive scrub, opening up rank grassland and creating a mosaic of low vegetation and bare sand. These changes in plant communities with time are being studied. One recent study links sheep-grazing at Ainsdale NNR with reduced populations of Round-leaved Wintergreen in the slacks – a rather worrying finding. Natural England introduced a few Hebridean cattle in 2008/09. This small breed may be more effective than sheep in controlling Creeping Willow and also in creating the desired variety of sward height and bare patches.

The livestock do well on the dune herbage, their owners being happy with their condition and general health. There was concern at first about possible disturbance by people and dogs but this proved not too serious a problem, at least until 2006 when four sheep were lost to dog attacks at Cabin Hill NNR. I also had to beat off two dogs attacking the Cabin Hill sheep on 30th December 2008.

The other major grazing animal on the dunes is, of course, the Rabbit whose numbers have increased markedly in recent years, though they still suffer occasional outbreaks of myxomatosis. Moderate Rabbit grazing helps the variety of dune plant-life and invertebrates but, unlike stock grazing,

it cannot be controlled and takes place all year round. As a result, some areas of duneland are hardly grazed at all while others are over-grazed, little vegetation remaining other than distasteful plants like Common Ragwort and Hound's-tongue. Heavy Rabbit grazing may also be damaging to some dune butterflies which require at least medium-length swards for their caterpillars.

SPECIES MANAGEMENT

The Sefton Coast is home to many specialised and nationally rare species which inevitably attract the attention of conservationists and may require more fine-tuned management than the habitat approach discussed above. Outline management recommendations for many of these species are published in the Biodiversity Action Plans (BAPs).

Two of our most charismatic dune creatures, the Natterjack Toad and Sand Lizard have been the subject of Species Strategies, documents that set out targets for management and how these can be achieved on a site by site basis. The first Natterjack Strategy was written as long ago as 1984, being revised and updated in 1992. It seeks to conserve and enhance the Sefton Coast population and restore, as far as possible, the species' historical range. The idea of "key pools" was introduced to ensure that breeding sites are provided at intervals of no more than 0.5 to 1km along the entire dune coast. Ideally, these should depend on the natural water-table but, where this is not feasible, lined ponds are provided. Key pools are reprofiled as necessary, kept free of competing Common Toads and, in public areas, are fenced and signed. The Strategy also provides for management of the terrestrial habitat, including scrub-control, mowing and grazing, and aims to gain public support by means of guided walks, slide-shows, information boards and leaflets. As already mentioned (Chapter 5), monitoring population size and breeding success is crucial to judging the success or otherwise of the Strategy.

Other Sefton Coast BAP species and groups have been the subject of special monitoring and conservation programmes, including Baltic Rush and its hybrids, Common Wintergreen, Dune Helleborine, Dune Wormwood, Early Sand-grass, Grey Hair-grass, Isle of Man Cabbage, Petalwort, Sharp Club-rush, Smooth Cat's-ear, rare willows (Chapter 4), Red Squirrel, Great Crested Newt, Northern Dune Tiger Beetle, Vernal Bee and dragonflies (Chapter 5).

RECREATION MANAGEMENT

In Chapter 2, I described how, in extreme cases, the trampling of the dunes by people, horses and the actions of motor-vehicles could result in severe wind-erosion. This is because dune vegetation is easily killed by the pressure of feet, hooves or tyres and the exposed sand, previously deposited by the wind, can be blown away again. Marram-dunes are particularly susceptible to such damage, the vegetation being ten times more fragile than that of fixed-dunes, though the latter usually take longer to recover than the mobile-dunes. Heavily used areas are dissected by networks of sandy tracks which widen as people walk to the edge, seeking firmer ground. Eventually, the paths may merge to create large, fan-shaped "deflation areas" of shifting sand as, for example, between the car-parks and the beach at Victoria Road and Lifeboat Road, Formby Point, in the 1970s.

The Management Scheme tackled these problems by a combination of techniques. In the mobile-dunes, brushwood fences were erected to trap sand and rebuild dune ridges, after which Marram was planted to continue the process and help fix the sand, these areas being fenced off to protect the young plants. Eroded areas and blow-outs in the fixed-dunes had to be treated differently. Some had brushwood laid as a thatch over the surface to reduce wind-blow, after which Marram was planted or grass seed sown. A few were even covered with a shallow layer of treated sewage-sludge to mimic the organic matter layer of fixed-dune soil. These sites re-vegetated really quickly.

Two large car-parks at Formby Point were designed with bays and islands to hold the maximum number of cars. These were inexpensively surfaced with crushed sandstone. Routes from the car-parks to the beach were defined by post-and-wire fencing, surfaced with crushed stone in fixed-dune areas and with wood-chip mulch or board-walks over the mobile-dunes. The entrance and exit points on the beach were clearly signed so that visitors could find their way back to the car-parks without scrambling over the dunes. Where appropriate, wooden ramps were constructed between the high dunes and the shore. A network of surfaced footpaths through the fixed-dunes was also provided in the recreational hot-spots.

At Ainsdale and Birkdale, the beach has been used for parking over many years, accommodating large numbers of vehicles at peak times. This was not ideal but there were no other suitable areas for car-parks. To reduce trampling damage to the frontal-dunes, temporary chestnut paling fencing was erected in the 1980s in front of the first dune ridge, opposite the main parking areas. This improved the condition of embryo-dune vegetation and encouraged new dune formation.

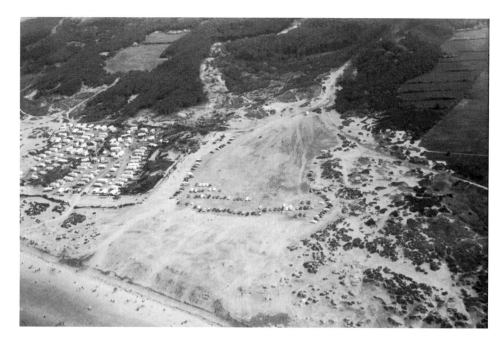

National Trust carpark before restoration, 1976.

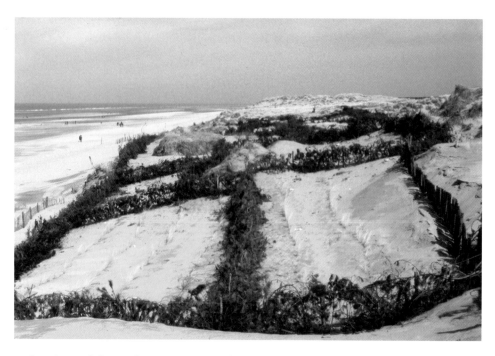

Brushwood fences for trapping sand in the mobile dunes, Formby Point 1985.

A beach zoning system was introduced in 1993 and extended in 2000, reducing further the conflict between visitor pressure and dune conservation, This restricts the area available for parking and prevents driving along the full length of the shore from Ainsdale to Southport, creating a vehicle-free zone within which it has been possible to permit minority recreational pursuits, like model aircraft flying and kite-buggying. The benefits have been a reduction in beach compaction, new dune and slack development, lower disturbance to the internationally important wintering shore-bird populations and the return of the Ringed Plover and Lapwing as breeding species. Also, mechanised beach-cleaning was modified in 1997 to encourage fore-dune growth. Within the car-parking areas, instead of the intrusive chestnut paling, the fore-dunes are now guarded by a row of short posts which prevent vehicles approaching the foot of the dunes. This simple technique has been particularly successful in promoting the growth of new sand-dunes and slacks, the posts being moved outwards several metres each year.

Since 1995, Sefton's beaches have been covered by a Beach Management Plan, updated in 2005. This seeks to balance the obligations to protect the wildlife interest of the foreshore with the popularity of the beaches for recreation and their importance for tourism. A Beach Consultation Group, representing land-owners, managers and interest groups, meets several times a year.

Increasing numbers of visitors at the National Trust, Formby Point (340,000 in 2000 and 90,000 cars per year) means the capacity of the carpark is exceeded on about 100 days each year and there is a problem of overspill into nearby residential areas. A priority for the Trust is to relocate the carpark which is being overtaken by blowing sand and coastal erosion. There is also a need to consider the future of the Victoria Road and Lifeboat Road sites together in an integrated way, despite their different ownerships. Plans for a Visitor Centre and other facilities at Lifeboat Road, which would take some of the pressure off the National Trust estate, received a boost in 2007 when lottery money became available to cover part of the project. Unfortunately, additional funds could not be found and the plans had to be put on hold.

The Sefton Coastal Path, developed in the early 1990s, has recently been re-routed and upgraded at Formby Point to take account of coast erosion and increased demand. Linked to this, a new cycleway has been developed between Hall Road and Hightown. Also, under the auspices of the Lancashire Wildlife Trust, Freshfield Dune Heath was formally opened to the public for the first time in over 60 years on 22nd August 2006. Part of the site is being used by disabled riders from the nearby riding stables.

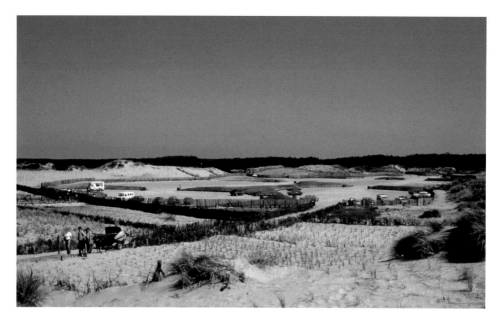

The newly restored National Trust carpark in 1981.

Although the Ainsdale Sand Dunes NNR is generally considered a quiet part of the coast, it actually receives over 55,000 visits a year. A public right of way through the reserve, Fisherman's Path, is much used but there are also 9km of permissive routes and the rest of the site is accessible on foot by permit. Over 1000 of these were issued between 2001 and 2006.

One issue still to be satisfactorily resolved is that of wildlife and livestock disturbance and fouling by dogs, the number of which using the coast seems to be rising steadily. Although a summer dog-ban has been introduced on the main bathing beaches and most of the foreshore and dunes are included in a "Poop-scoop Order" under the provisions of the Dogs (Fouling of Land) Act 1996, dog-fouling remains a problem, both from an amenity and ecological standpoint. Some owners still allow their pets to chase internationally important flocks of shore-birds on the beaches, while disturbance of ground-nesting birds and scrapes and ponds excavated for wildlife, not for dog-bathing, continues to give rise to concern. The problem of dog-attacks on sheep has already been mentioned, while attacks on people are not unknown, as I have discovered to my cost.

The Sefton Coast has one of the highest rates of visitor pressure of any major European sand-dune system. Although there are many challenges ahead, management efforts over the past 30 years have resolved many of the problems of conflicting land-uses on the coast and have built up a fund of "best practice" which is sure to stand us in good stead in the future.

Guided walk, Ainsdale NNR, 2005.

WALKING AND CYCLING ON THE SEFTON COAST

Everyone knows that outdoor activities, such as walking and cycling, can improve health and wellbeing by getting us out into the fresh-air. The Sefton Coast is ideal for this, with excellent links to centres of population and a network of routes suitable for all ages and abilities. Healthy exercise can be combined with enjoyment of the coast's superb natural environment, wildlife and its many cultural features.

Two illustrated modern booklets: *"The Walker's Guide to the Southport and the Sefton Coast"* and *"The Cycling & Walking Guide to Sefton & Southport"* (see Further Reading) provide a wealth of information on where to go and what to see.

The Sefton Coastal Walk runs for 34km (21 miles) from Crossens to the north of Southport to Crosby Marine Park at the mouth of the Mersey. It is waymarked throughout its length and takes in most of the important sand-dune areas. The Merseyrail Northern line runs parallel to the Sefton Coast with ten stations not far from the route of the walk, which can therefore easily be broken down into shorter sections. For the dedicated long-distance

walker, there is a link to the 346km (215 mile) Trans-Pennine Trail from the Southport seafront.

Other, shorter, walks link into the Sefton Coastal Path, for example at the Queen's Jubilee Nature Trail, Southport and the Velvet Trail, Birkdale. The latter, opened in 2001, recreates a nature walk of the 19th century known as the "Velvet Walk" (see Chapter 3). This includes flower-rich dune-slacks at the northern end of Birkdale Sandhills and part of Birkdale Green Beach which is one of the wildlife hotspots of the Sefton Coast.

Another path well worth trying is the Dune Trail which takes a circular route through Ainsdale Sandhills from the Discovery Centre at Ainsdale-on-Sea. This passes through one of the finest areas of mobile and fixed dunes on the coast, as well as several seasonally-flooded slacks which have splendid displays of wild flowers in the summer.

For a much shorter stroll, try the Sands Lake Nature Trail from the carpark opposite Pontins. Its surfaced path is suitable for disabled visitors. In winter, there are invariably lots of water-birds to see, including Tufted Ducks, Shovelers, Mute Swans, Moorhen and Coot, as well as a variety of gulls. In summer, the northern end of Sands Lake is excellent for dragonflies.

Another of my favourite walks crosses the less well-known Hightown sand-dunes where a slight diversion from the Coastal Path takes in the remarkable artificial shingle bank with its Sea Kale and Yellow-horned Poppies and peat deposits with 5000-year-old tree stumps.

The Coastal Path reaches its southern limit at Crosby Marine Park which was reclaimed from the Mersey Estuary in the late 1960s. This area is popular with bird-watchers checking the high-tide gull roosts for rarer species like Mediterranean and Ring-billed Gulls, while the world's smallest gull, the aptly named Little Gull, often occurs in large numbers in April and early May on passage to its Baltic breeding grounds. A famous example of public art, the iron men of Anthony Gormley's "Another Place", can be viewed from the promenade but please do not walk out to the statues on the lower beach as this is a major feeding area for waders in what is a European protected site for these birds.

Finally, do take advantage of the many guided walks that are organised throughout the year by Sefton's Coast & Countryside Service and other land-managers on the coast. These are led by experts whose local knowledge can highlight interesting features that might otherwise go un-noticed.

Peter Gateley using Global Positioning System for sand-dune National Vegetation Classification survey in 2004.

MONITORING

The success or otherwise of management actions on the coast can only be judged by recording (i.e. monitoring) their effects. We also need to maintain a body of basic information about the coast, updating it at regular intervals. Without this knowledge, management efforts may be misdirected and wasted.

There are a great many ways in which monitoring takes place. For example, Sefton Council organises at least nine different programmes designed to detect coastal change.

These include flying high-quality, vertical aerial photography in colour at about two year intervals. Such coverage, mostly in black-and-white, has been obtained every few years since 1945 and is extremely valuable for plotting trends of accretion and erosion, as well as patterns of woodland and scrub coverage and the condition of slacks and footpaths, etc. over time.

Fixed-point photography can also be useful for giving an indication of general trends. For example, in the mid-1990s the Life Project produced a

photographic record of all the golf courses, looking down the fairways from each tee.

At the habitat level, an important baseline is the National Vegetation Classification survey (described in Chapter 4), which maps the plant communities and can be repeated at intervals to detect changes. Also vital is the monthly recording of water-table trends in numerous tube-wells which has been ongoing now for over 30 years. Natural England has its own system of Common Standards Monitoring which determines, on a six-year cycle, whether or not SSSIs are in "favourable condition". The Sefton Coast SSSI is divided up into 31 units, as many as 12 of these being assessed as "unfavourable" in 2000-2005. A government target requires 95% of SSSI area to be in favourable or unfavourable recovering condition by 2010, so much remains to be done.

The well-being of several of our key species and species-groups is also monitored on a regular basis, monthly for shore-birds (the national Wetland Birds Survey), annually in the case of the Natterjack Toad and every two to five years for several plant species.

The data collected can be stored and presented in different ways. Particularly useful is the Sefton Coast Geographic Information System (GIS), a computer-based method for showing information in map form. The Council also maintains a Sefton Coast Database of over 800 reports, mostly on coastal defence and coastal processes, which is currently being digitised and will then be available free of charge. It is intended to add biological reports to this database.

Another exciting initiative, which has important implications for the Sefton Coast, is the Merseyside Biobank, supported by the Heritage Lottery Fund and the European Regional Development Fund. Employing seven staff from January 2007, the Biobank stores computerised biological information and involves amateur enthusiasts and volunteers in sampling and recording by providing appropriate training.

Finally, we need to ask questions such as "What are the gaps in our knowledge?" and "What needs to be studied in the future?" In part, these questions are being addressed by a Sefton Coast Research Network which already has contacts with about 70 individuals, ranging from professional scientists to expert amateurs. The network keeps a record of all current research projects on the coast and is actively promoting ideas for new studies.

Students at Ainsdale, 1975.

EDUCATION AND WORKING WITH THE COMMUNITY

The Sefton Coast is a wonderful outdoor laboratory for teaching, especially in the biological and earth sciences. Many local schools and colleges visit the coast and, despite recent problems with funding and "safety" preoccupations, there is no doubt that students at all levels gain enormously from field studies in such a stimulating environment.

The National Trust at Formby Point has catered for increasing numbers of school children, rising from 16,000 in 1997 to 26,000 in 2005. A key factor in this trend was the building of public toilets in 1995, these being an essential requirement for school visits. Seven environmental study projects are offered, mainly at Key Stages 1 and 2 of the National Curriculum. From 2007, the Trust had to reduce the number of school bookings in June and July due to limited parking space and pressure on the sensitive dune landscape at this peak period.

Natural England's Ainsdale Sand Dunes property is mainly used by higher education students and research workers, while the many organised wildlife walks for the general public are often over-booked. Sefton Council's Coast & Countryside Service offers educational visits, for infants to "A" level students, based at their Ainsdale Discovery Centre, which provides indoor facilities

The first volunteer: F. W. Holder, Ainsdale shore 23rd March 1932.

when the weather is bad. Here, there is a valuable Resource Centre of literature relating to biology, geography, tourism and coastal management. A popular programme of guided walks is also organised throughout the year.

It is vital that local people identify with the coastal area and feel that they can get involved as "stakeholders". One way of doing this is by volunteering; indeed, 2005 was the "Year of the Volunteer". The first volunteer on the Sefton Coast was probably the great Southport naturalist, F.W. Holder (1891-1963), whose evocative diaries are held by the World Museum Liverpool. He made his first visit to Ainsdale dunes in 1897 to collect birds' eggs but later became an avid recorder of wildlife. In 1921, he joined forces with Wilfred Clarke, a "watcher" employed by the RSPB to warden the Common Tern colony on the dunes at Freshfield.

In more recent times, a great many local people have volunteered to work on the coast, often as wardens working in conjunction with the staff of the National Trust, Natural England, Sefton Coast & Countryside Service, RSPB and the Wildlife Trust. For example, there are currently 42 registered volunteers at Ainsdale NNR. Ten are voluntary wardens, helping with patrol operations. Others assist with practical tasks, such as fencing, scrub control, Marram planting or checking the sheep in winter. Overall, about 250-300 volunteer man-hours are donated each year, two contributors receiving Year of the Volunteer awards in 2005. The Sefton Coast Partnership has also given volunteer awards annually since 2005.

THE FUTURE OF THE DUNE-SYSTEM

There are still some threats to the dunes and their wildlife. Thus, marine erosion is continuing at Formby Point, though as we have seen, accretion elsewhere is just about balancing this loss. The major problem of over-stabilisation of the sand-dunes, with the associated spread of scrub and rank grassland is still with us, although solutions are being found, including

grazing with livestock which seems likely to be extended. Recreational visits to the coast (over 1.4 million in 2000) are probably going to increase in the future but the expertise to cope with this is in place.

A serious issue that is not going away and which will test coastal managers for the foreseeable future is climate change. The government has stated "*It is now widely accepted that some degree of climatic change is inevitable, regardless of our efforts to reduce greenhouse gas emissions.*" Current predictions are for an annual temperature rise in the UK of 2-3°C by 2080 but it could be as much as 5°C. Coupled with this may be more frequent summer heat-waves and droughts, wetter winters, increased storminess and extreme weather events. The early changes are already with us; over the last 100 years, global temperatures have risen by about 0.7°C and, in England, the 1990s was the warmest decade since records began. The mean central England temperatures for 2003 and 2004 were 10.50 and 10.51°C respectively, compared with 9.05°C and 9.77°C in 1987 and 1988. Warmer seas and melting ice mean higher sea-levels, the UK Climate Impact Programme predicting a sea-level rise for the north-west of 1-11cm by 2020 and 3-63cm by 2080. However, several studies have failed to find any evidence for an increased number of severe storms over recent decades.

What does all this mean for our sand-dunes and their wildlife? As temperatures rise, more people may take their holidays in Britain, increasing visitor-pressure on the dunes. Even the lower estimates of sea-level rise could accelerate the rate of coast erosion at Formby Point. Some species may do well – particularly those which, like many insects, respond to warmth. Already, we are seeing dragonflies and butterflies which, a decade ago, were rarely found north of the Midlands. Similarly, southern plants may increase, perhaps at the expense of northerners. A recent national study has shown that, between 1987 and 2004, Bee and Pyramidal Orchids expanded their ranges northwards and westwards by 48% and 42% respectively. Maybe this is why we are now seeing more of these plants on the Sefton Coast. However, the same research points to losses of species associated with infertile habitats, such as calcareous dune-grassland, probably due to pollution by nitrogen from agricultural or industrial sources which is still increasing. This may account for the spread here of coarse grasses at the expense of more typical sand-dune plants. Several recently introduced alien plants are also showing rapid rates of increase nationally and a few of these may give us problems in the future. Will Japanese Rose, Montbretia (*Crocosmia* x *crocosmiiflora*) or Russian Vine eventually require control on the coast?

A particular concern is the possible impact of changes in rainfall on the wet-slack habitat which is so important to many of our special fauna and

flora. Derek Clarke has been researching the dune water-table for over 30 years and has recently developed computer models to predict the impact of changing climate. These suggest that, there will be periods of high and low water-level in the future, as in the past, but that, overall, we can expect a decrease of 0.8m to 1.2m in the dune water-table by 2080. Clearly, this would have serious implications for slack species like the Natterjack Toad and many rare plants.

These, and other problems not yet predicted, will need to be addressed by the next generation of dune managers, assisted by biological and earth scientists, their students and the many amateur enthusiasts which the Sefton Coast will hopefully continue to attract as it has done in the past.

In 2005, the Sefton Coast Partnership set out its vision for the future of nature on the coast by instigating a new Nature Conservation Strategy and Biodiversity Delivery Plan. This will address the challenges already identified and seek solutions over a time scale of about 50 years.

In 1975, I wrote a report on the natural resources of Sefton Borough for the Lancashire Naturalists' (now Wildlife) Trust. It concluded with the following paragraph.

"It is clear that a sand-dune system can only be retained and effectively managed on the basis of sound ecological principles and through a high standard of practical expertise. These standards should be applied throughout the dune complex, rather than on the basis of artificial ownership boundaries. Some areas within the dunes are capable of withstanding considerable public pressure without serious deterioration, others are more sensitive and a zoned approach to take account of these differences is necessary. Management objectives in many parts of the dune system will clearly be compatible with wildlife conservation but it is important that particularly valuable sites for conservation and educational purposes are recognised early in the formulation of plans. The planning and management of land-use in the sand-dune system will be a demanding task but ... there would seem to be a better opportunity than ever before to remedy the situation and ensure that future generations will be able to enjoy the unique character of this fine coastline."

Thirty-four years later, these sentiments still apply. But, although much work remains to be done, this generation is handing over the Sefton coast in a much better condition that could possibly have been predicted all those years ago.

FURTHER READING

My aim with this bibliography is not to present a comprehensive list of references but rather to provide the reader with reasonably accessible general background reading on coastal dune ecology, management and local history, the emphasis being on the Sefton Coast.

Atkinson, D. & Houston, J. (eds.) (1993). *The Sand Dunes of the Sefton Coast*. National Museums & Galleries on Merseyside.

Aughton, P. (1988). *North Meols and Southport: A History*. Carnegie Publishing.

Bailey, F. A. (1992). *A History of Southport*. Cromwell Press.

Bannon, J. K. (undated). *The Walker's Guide to Southport and the Sefton Coast*. Sefton Tourism Department.

Bannon, J. K. (undated). *The Cycling & Walking Guide to Sefton & Southport*. Sefton Tourism Department.

Bannon, J. K. (undated). *Birder's Guide to Southport and the Sefton Coast*. Sefton Tourism Department.

Cook, A. L. M. (1989). *Altcar: The Story of a Rifle Range*. TAVR Association for the North West of England and Isle of Man.

Cowell, R. W. & Innes, J. B. (1994). *The Wetlands of Merseyside*. North West Wetlands Survey 1. Lancaster University Archaeology Department. Lancaster.

Dempsey, D. (2009). *Wild Merseyside*. Trinity Mirror Merseyside, Liverpool.

Edmondson, S. E. (1997). *Key to Plants Common on Sand Dunes*. Aidgap Guide, Field Studies Council, Shrewsbury.

Foster, H. (1995). *New Birkdale: The Growth of a Lancashire Seaside Suburb 1850-1912*. Birkdale and Ainsdale Historical Research Society.

Foster, H. (1996). *Links along the Line: The Story of the Development of Golf between Liverpool and Southport*. Birkdale and Ainsdale Historical Research Society. Southport.

Foster, H. (2000). *New Ainsdale: The Struggle of a Seaside Suburb 1850-2000*. Birkdale and Ainsdale Historical Research Society. Southport.

Foster, H. (2008). *Southport: A History*. Phillimore, Chichester.

Greenwood, E. F. (ed.) (1999). *Ecology and Landscape Development: A Natural History The Mersey Basin*. Liverpool University Press/National Museums & Galleries on Merseyside.

Gresswell, R. K. (1953). *Sandy Shores in South Lancashire: the Geomorphology of South-west Lancashire*. Liverpool University Press.

Harrop, S. (1985). *Old Birkdale and Ainsdale: Life on the south-west Lancashire Coast 1600-1851*. Birkdale and Ainsdale Historical Research Society. Southport

Houston, J. (1994). *Walks on the Sefton Coast. A Guide to the Sefton Coastal Footpath And Other Popular Walks on the Sefton Coast*. Sefton Metropolitan Borough Council, Southport.

Houston, J. A., Edmondson, S. E. & Rooney, P. J. (2001). *Coastal Dune Management: Shared Experience of European Conservation Practice*. Liverpool University Press.

Houston, J. (1994). Conservation management practice on British dune systems. *British Wildlife* 8: 297-307.

Jacson, C. (1897). *Formby Reminiscences*. Sefton Council, Southport; facsimile reprint 1997.

Kelly, E. (1982). *Viking Village: The Story of Formby*. E. Kelly, Formby.

Lewis, J. M. & Stanistreet, J. E. (eds.) (2008). *Sand and Sea. Sefton's Coastal Heritage.* Sefton Council Leisure Services Department (Libraries), Bootle.

McNicholl, E. D. (ed.) (1883). *Handbook for Southport.* 3rd edition. Robert Johnson, Southport.

Packham, J. R. & Willis, A. J. (1997). *Ecology of Dunes, Salt Marsh and Shingle.* Chapman & Hall, London.

Ranwell, D. S. (1972). *Ecology of Salt Marshes and Sand Dunes.* Chapman & Hall, London.

Rodwell, J. S. (ed.) (2000). *British Plant Communities Volume 5. Maritime communities and vegetation of open habitats.* Cambridge University Press, Cambridge.

Savidge, J. P., Heywood, V. H. & Gordon, V. (1963). *Travis's Flora of South Lancashire.* Liverpool Botanical Society, Liverpool.

Smith, P. H. (1999). *The Sands of Time: An introduction to the Sand Dunes of the Sefton Coast.* National Museums & Galleries on Merseyside, Liverpool.

Smith, P. H. (2000). Classic wildlife sites: The Sefton Coast sand-dunes, Merseyside. *British Wildlife* 12 (1): 28-36.

Smith, P. H. (2007). The Birkdale Green Beach – a sand-dune biodiversity hotspot. *British Wildlife* 19 (1): 11-16.

Van der Meulen, F., Jungerius, P.D. & Visser, J. H. (eds.) (1989). *Perspectives in Coastal Dune Management.* SPB Academic Publishing, The Hague, Netherlands.

White, S., McCarthy, B. & Jones, M. (2008). *The Birds of Lancashire and North Merseyside.* Hobby Publications, Southport.

Whittle, P. (1831). *Marina; or a historical and descriptive account of Southport, Lytham and Blackpool, situate on the western coast of Lancashire.* P. & H. Whittle, Preston.

Yorke, B. & Yorke, R. A. (1982). *Britain's First Lifeboat Station at Formby, Merseyside 1776-1918.* The Alt Press, Formby, Liverpool.

Yorke, B. & Yorke, R. A. (1999). *Images of England: Formby, Freshfield and Altcar.* Tempus Publishing, Stroud, Gloucestershire.

Useful websites (many of these have links to other sources of information)

Botanical Society of the British Isles	www.bsbi.org.uk
British Dragonfly Society	www.dragonflysoc.org.uk
British wild flowers	www.british-wild-flowers.co.uk
Butterfly Conservation Lancashire Branch	www.lancashire-butterflies.org.uk
Environment Agency	www.environment-agency.gov.uk
Formby Civic Society	www.formbycivicsociety.org.uk
Joint Nature Conservation Committee	www.jncc.gov.uk
Lancashire Moth Group	www.lancashiremoths.co.uk
Lancashire Wildlife Trust	www.lancswt.org.uk
Lancashire & Cheshire Fauna Society	www.lacfs.org.uk
Merseyside Biobank	www.merseysidebiobank.org.uk
Merseyside Biodiversity Group	www.merseysidebiodiversity.org.uk
Mersey Forest	www.merseyforest.org.uk
National Biodiversity Network Gateway	www.searchnbn.net
National Trust	www.nationaltrust.org.uk
Natural England	www.naturalengland.org.uk
RSPB	www.rspb.org.uk
Sefton Coast Partnership	www.seftoncoast.org.uk
The British Association of Nature Conservationists	www.banc.org.uk
UK Coastal Dunes & Shingle Network	www.hope.ac.uk/coast

GLOSSARY

Annuals: Plants that complete their life-cycle within one year.

Artefact: Object made by human workmanship.

Biodiversity: The whole variety of life, including all species of animals, plants and micro-organisms, their genetic variation and the complex ecosystems of which they are part. It is not restricted to rare or threatened species but includes the whole of the natural world from the commonplace to the critically endangered.

Bronze Age: Period of human cultural history from about 2400 to 750BC.

Calcareous: Rich in calcium carbonate or lime, particularly appertaining to soils.

Capillary action (in soils): The attraction of water molecules to soil particles, due to adhesion and surface tension, leading to the movement of groundwater from wet to dry areas in the soil.

Clone: A group of genetically identical individuals resulting from asexual reproduction.

Community: A grouping of plants, animals and micro-organisms occupying a particular habitat.

Countryside Commission: A former statutory agency for countryside conservation and recreation in England. In 1999, became part of the Countryside Agency and, in 2006, Natural England.

Endemic: An organism whose natural distribution is confined to a single country or region.

Evapotranspiration: The total loss of water from a land surface, including both losses from living creatures and from surface evaporation.

Faggot: A bundle of sticks used to trap sand in dune reclamation works.

Geographic Information System (GIS): A computer system that can store, display and manipulate data and images on a map.

Gley: A type of soil formed under waterlogged conditions.

Green Belt: Designated land around an urban area which is protected from most forms of development.

Habitat: Combination of biological and physical features which make up the area where particular animal and plant species are found.

Hectare: Metric measure of area, equivalent to 2.47 acres.

Hindshore dune system: Largest type of dune system formed on extensive sandy coasts where masses of sand are driven inland for considerable distances by the prevailing wind.

Hybrid: The offspring of reproduction between two or more species.

Hydrology: The science of ground-water, its movements and effects.

Ice Age: Period in pre-history when very cold conditions prevailed, leading to the formation of glaciers in Britain. The last glaciation lasted from about 100,000 to 10,000BC.

Invertebrates: Animals without backbones; e.g. molluscs, worms, insects etc.

Iron Age: Period of human cultural development lasting, in England, from about 750BC to AD40.

Layering: Process by which branches of trees or shrubs root into the soil when they touch the ground.

LIDAR: "Airborne scanning laser altimetry": A method for recording surface topography from an aircraft or satellite at high resolution, typically 15-20cm vertical accuracy.

Links: A stretch of flat or undulating sandy ground near the coast, often associated with the playing of golf.

Local Nature Reserve: Area of conservation importance statutorily designated and

usually managed by a local authority.

Melanistic: Variety of animal having a preponderance of brown or black pigment (melanin) in the skin.

Mesolithic (Middle Stone Age): A period of human cultural development lasting from about 10,000 to 4500BC.

Microbial: Appertaining to small life-forms, usually only visible using a microscope.

Micro-organisms: Very small creatures; e.g. bacteria, algae, amoebae, etc.

Myxomatosis: A virus disease of Rabbits introduced into Britain in the 1950s.

National Nature Reserve: Site of national importance for nature conservation, statutorily designated.

National Vegetation Classification (NVC): A standardised method for describing and classifying vegetation types in Great Britain.

Natura 2000: A network of sites, incorporating Special Protection Areas and Special Areas of Conservation, intended to protect European biodiversity and habitats.

Neolithic (New Stone Age): A period of human cultural development lasting from about 4500 to 2000BC and characterised by the development of agriculture.

Organic: Originating from living creatures.

Perennial: A plant that lives more than two years.

pH: Measure of acidity or alkalinity; pH 7 being neutral, lower values acidic and higher values alkaline.

Post-glacial: Period after the end of the last Ice Age.

Ramsar Convention: International agreement of 1971 which seeks to protect internationally important wetlands, especially as waterfowl habitat.

Revetment: Wall or embankment, usually designed to control the flow of a river.

Rhizome: An underground plant stem.

Ruderal: Applied to plants adapted to growing in open or disturbed habitats; also known as "weeds".

Shingle: Coarse gravel, consisting of rounded water-worn stones.

Site of Special Scientific Interest (SSSI): Area statutorily notified as being of special interest by reason of its fauna, flora, geological or physiographic features. Most of the Sefton Coast sand-dune system is an SSSI.

Special Area of Conservation (SAC): Area designated by the government in accordance with the EU Habitats Directive to protect habitats and species of European importance.

Special Protection Area (SPA): Area designated in accordance with the EU Birds Directive for the specific protection of migratory and rarer breeding bird species.

Spring tide: Tide with a relatively large range, usually occurring in two sequences per month (opposite of neap tide).

Storm surge: Sea-level higher than predicted due to low atmospheric pressure and/or strong onshore winds.

Structure Plan: A statutory land-use development plan prepared by a County Council (e.g. the former Merseyside County Council).

Succulent: Fleshy and juicy or pulpy, referring to a plant; often an adaptation to surviving dry or saline conditions.

Taxonomic: Appertaining to taxonomy – the science of naming and classifying plants, animals and micro-organisms.

Training wall: Wall of stones for channelling a river or channel in an estuary.

Transect: Line along which records or measurements are taken, e.g. of plants or animals.

Tundra: Treeless landscape produced by cold conditions, as in the high Arctic.

Umbellifer: Plant of the carrot family (Apiaceae), formerly known as Umbelliferae.

Unitary Development Plan: A statutory land-use development plan prepared by Metropolitan District or Borough Councils (e.g. Sefton), replacing the former system of Structure and Local Plans.

Vice County (v.c.): All or part of a County, based on pre-1974 boundaries, used for biological recording. E.g. v.c.59 (South Lancashire) is that part of the old County of Lancashire between the rivers Ribble and Mersey.

Waterfowl: Collective term for wading birds, ducks, geese, swans, grebes and coot.